Schwalbe

LIFE

100
Photographs
THAT CHANGED
THE WORLD

LIFE

100
Photographs
THAT CHANGED
THE WORLD

LIFE

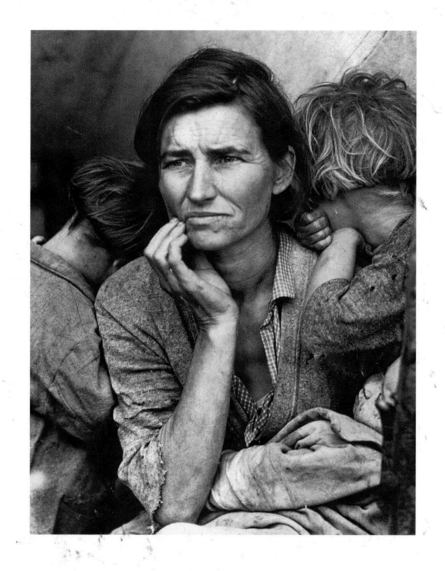

100 Photographs
THAT CHANGED THE WORLD

LIFE

Editor Robert Sullivan
Creative Director Ian Denning
Picture Editor Barbara Baker Burrows
Executive Editor Robert Andreas
Associate Picture Editor Christina Lieberman
Senior Reporter Hildegard Anderson
Writer-Reporter Carol Vinzant
Copy JC Choi (Chief), Mimi McGrath, Wendy Williams
Production Manager Michael Roseman
Picture Research Lauren Steel
Photo Assistant Joshua Colow
Consulting Picture Editors
Suzanne Hodgart (London), Tala Skari (Paris)

Publisher Andrew Blau
Director of Business Development Marta Bialek
Business Manager Craig Ettinger
Assistant Finance Manager Karen Tortora

Editorial Operations Richard K. Prue (Director), Richard Shaffer
(Manager), Brian Fellows, Raphael Joa, Stanley E. Moyse
(Supervisors), Keith Aurelio, Gregg Baker, Charlotte Coco,
Scott Dvorin, Kevin Hart, Rosalie Khan, Po Fung Ng, Barry Pribula,
David Spatz, Vaune Trachtman, Sara Wasilausky, David Weiner

Time Inc. Home Entertainment

President Rob Gursha
Vice President, Branded Businesses David Arfine
Vice President, New Product Development Richard Fraiman
Executive Director, Marketing Services Carol Pittard
Director, Retail & Special Sales Tom Mifsud
Director of Finance Tricia Griffin
Assistant Marketing Director Ann Marie Doherty
Prepress Manager Emily Rabin
Book Production Manager Jonathan Polsky
Associate Product Manager Jennifer Dowell

Special thanks to Bozena Bannett, Robert Dente,
Gina Di Meglio, Anne-Michelle Gallero, Peter Harper,
Suzanne Janso, Robert Marasco, Natalie McCrea,
Mary Jane Rigoroso, Steven Sandonato

Published by

LIFE Books

Time Inc.
1271 Avenue of the Americas,
New York, NY 10020

ISBN: 1-931933-84-7
Library of Congress Control
Number: 2003104204

"LIFE" is a trademark of
Time Inc.

We welcome your comments
and suggestions about LIFE
Books. Please write to us at:
LIFE Books, Attention:
Book Editors, PO Box 11016,
Des Moines, IA 50336-1016

If you would like to order any
of our hardcover Collector's
Edition books, please call us
at 1-800-327-6388 (Monday
through Friday, 7:00 a.m.–
8:00 p.m. or Saturday, 7:00
a.m.–6:00 p.m. Central Time).

Please visit us, and sample
past editions of LIFE, at
www.LIFE.com.

Iconic images from the LIFE Picture Collection are now available
as fine art prints and posters. The prints are reproductions
on archival, resin-coated photographic paper, framed in black
wood, with an acid-free mat. Works by the famous LIFE
photographers—Eisenstaedt, Parks, Bourke-White, Burrows,
among many others—are available. The LIFE poster collection
presents large-format, affordable, suitable-for-framing
images. For more information on the prints, priced at $99 each,
call 888-933-8873 or go to www.purchaseprints.com. The
posters may be viewed and ordered at www.LIFEposters.com.

Joe Rosenthal/AP: previous pages: Dorothea Lange/Library of Congress

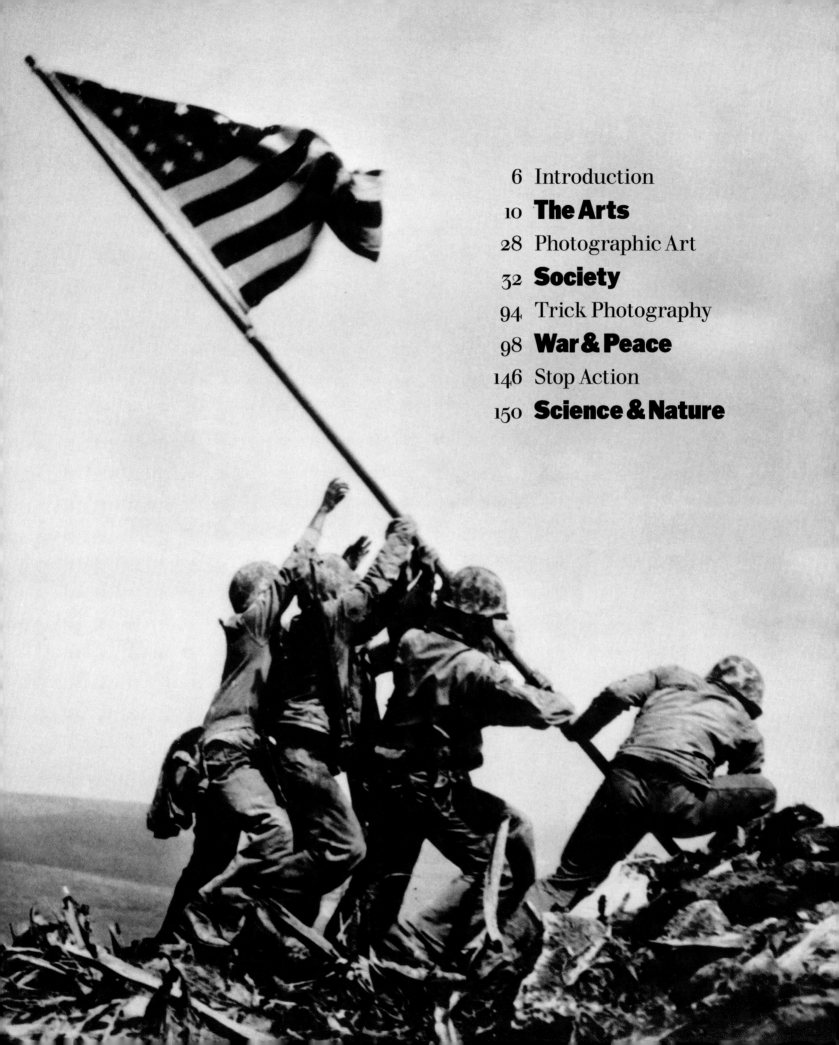

The Premise Behind These Pictures

Let us first pose a question: Is it folly to nominate 100 photographs as having been influential to world events, or is this a valid historic inquiry? LIFE will, here and in the following pages, put forth its argument. You be the judge.

Having been in the business of presenting stirring, revelatory photography since 1936, LIFE has a vested interest in claiming for photojournalism a place of high importance. Given its preferences and an endless page count, LIFE would put forth a thousand and more photos of substance, each of them worth at least a thousand words.

Words. Ever since chisel was taken to slate, it has been accepted that words can and do change the world. Whether it be the Torah, the New Testament or the Koran, the Magna Carta or the Declaration of Independence, *J'Accuse, Oliver Twist* or *Catch-22, Common Sense* or *Silent Spring,* the effect of words can reach so many hearts and minds that it impacts the human condition and the course of mankind. Speeches incite, editorials persuade, poems inspire.

Can photographs perform similarly?

For several weeks in the spring of 2003, LIFE solicited answers to that question on its own Web site (www.LIFE.com) and that of the highly regarded *Digital Journalist* (www.digitaljournalist.org), an online publication affiliated with the University of Texas. We received many opinions, most of which supported our conceit that a photo could change the world—music to our ears—along with one detailed, intelligent rebuttal. "I really do not believe that photographs actually change anything, least of all the 'World,'" wrote Joshua Haruni. "To suggest that photographs, like the written word, have had a profound effect on our lives is simply wrong. Just imagine suggesting that *Picture Post* or *Time* or LIFE had as much impact on our lives as *Das Kapital, Mein Kampf* or the Bible . . . Photographs can be very beautiful, informative, ugly or anything else the photographer chooses to show. Photographs can definitely inspire us, but the written word has the ability to spark the imagination to greater depths than any photograph, whose content is limited to what exists in the frame." Mr. Haruni is, by the way, a documentary photographer.

His argument forced us to once again confront our premise. We compared Mr. Haruni's thoughts and those of other respondents and finally determined: A collection of pictures that "changed the world" is a thing worth contemplating, if only to arrive at some resolution about the influential nature of photography and whether it is limited, vast or in between. We do not claim that LIFE's 100 are *the* 100 or the *top* 100, but that they, and the other related landmark images presented here, argue on behalf of the power of pictures.

Not every iconic image will be found here. Many nominated the 1937 crash of the *Hindenburg.* We looked hard at the picture, the event and the aftermath, and decided against. We may be remiss about the *Hindenburg,* and we may be wrong about excluding our friend Alfred Eisenstaedt's picture of the sailor kissing the nurse in Times Square. Some of you will, no doubt, be disappointed by some choices and omissions. But many who answered our query will be pleased to see their passions shared. "The lone Chinese demonstrator as he stops a column of advancing tanks in Beijing was a person of steel," wrote Maek Lester S. Cayabyab, a journalism student in Manila. Jacob Meade, a "photo fan" from Amherst, N.H., won't find his *Hindenburg,* but he offered a compelling argument for "the portrait of Anne Frank: The poignancy of her gaze haunts the world to this day, pointing up the horror of Hitler's genocide and making us wonder how many brilliant young women such as herself were lost."

We took all nominations seriously, added our own, and then solicited the advice of some old LIFE hands. Renowned photographers such as John Loengard and Gordon Parks, who writes the evocative introduction immediately following, contributed their expertise. And then, just before we closed the book on this book, an E-mail came from Gary and Anita Fender of Celina, Ten., that put the project in perspective. Attached was a photo of their infant grandson, Caden Zane Brown, born March 16, 2003. "He's changed our world," the Fenders wrote, implying a truth that underlies every picture in these pages. It is, in the end, a personal relationship between viewer and image. The power of a picture is in the mind of the beholder.

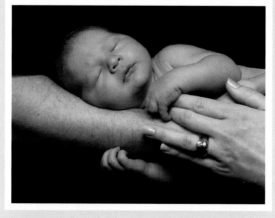

A world-changing portrait of Caden Zane Brown

This **Rare** Collection

An essay, poetry and pictures by Gordon Parks

LIFE *asked one of our longtime friends and associates, the storied photographer, filmmaker, painter, writer and poet Gordon Parks, to provide the introduction to this special volume. Happily, Mr. Parks consented, and crafted an essay both moving and characteristically selfless. Then we went back to Mr. Parks and asked him to meditate just a bit further on any of his own images that might have effected change. He chose two. When Mr. Parks's portrait of Ella Watson, a government cleaning woman in Washington, D.C., was published in 1942, it focused attention on continuing inequities in the land of the free. And when he produced a story in 1961 on Flavio da Silva, an impoverished 12-year-old dying in a favela in Rio, a flood of contributions washed over Flavio and his family. The boy lived.*

Change has spread itself graciously over the centuries. Mankind, living in the middle of this vast uncertain space, has always been around to record the light, or darkness, hovering over it—but even during the very darkest of times, change somehow manages to arrive, leaving us in awe. Bewildering, at times enlightening, change moves in to alter the course of our lives.

Without doubt, words have helped influence universal thought and action. As was cited in the précis on the opposite page, a glance back to the words in the Bible, the Koran, the Magna Carta or the Declaration of Independence instantly proves the point. Sculptors and painters, with their particular poetry, have also established new attitudes down through the years.

But I have come to believe that no art form transforms human apathy quicker than that of photography. Having absorbed the message of a memorable photograph, the viewer's sense of compassion and newfound wisdom come together like two lips touching. And it is an extraordinary thing when an unforgettable photograph propels you from an evil interlude to the conviction that there must come a better day.

Let us give thought to those who distinguish themselves with cameras. They are no ordinary lot. In publications, they don't show up as the heroes, but they are the ones who put themselves in the position to find the memorable images of the maimed or dead, and thus try to help pull together a broken world. Hoping to make that world weary of disasters, certain photographers attack scenes of overwhelming emotion. They allow their cameras to become swords in their hands. When scanning the pages ahead, one should not grow tired of witnessing these things—corpses stacked, awaiting the fire of a Holocaust oven; two young black lynch victims, dead before a cheerful white mob; a Viet Cong guerrilla, his eyes tightly shut, grimacing as a policeman fires a bullet into his head—for that is the photographer's charge to us, that we never forget. Recalling such shocking tragedies makes our thoughts burn as if doused with oil, and we no longer walk around forgetful. We remember the black hours with fury and shame, and we are changed. The cameras keep watch as mankind goes on filling the universe with its behavior, and they change us.

The photographs that take their rightful place in this rare collection come wrapped in a kind of mystery. Perhaps providence intended these things to be photographed, at just that instant. Or maybe the camera lenses that captured these instances on these particular days did so purely by chance. This mystery applies equally to a photograph recording the moment the Beatles arrive in New York City as it does to that when pro-

American Gothic

I'm tired of everything.
I'm tired of waking up
and remembering things
I know I oughta forget,
and of smellin' food
too rich for my cupboard
or those plates on my table.
I ain't crying about nothin'.
That's just how things are.
I'm alive and movin' around
and my toe nails keep growin'.
So weepin's a waste of time.
I just hope time ain't growin' tired
of hanging around here with me.

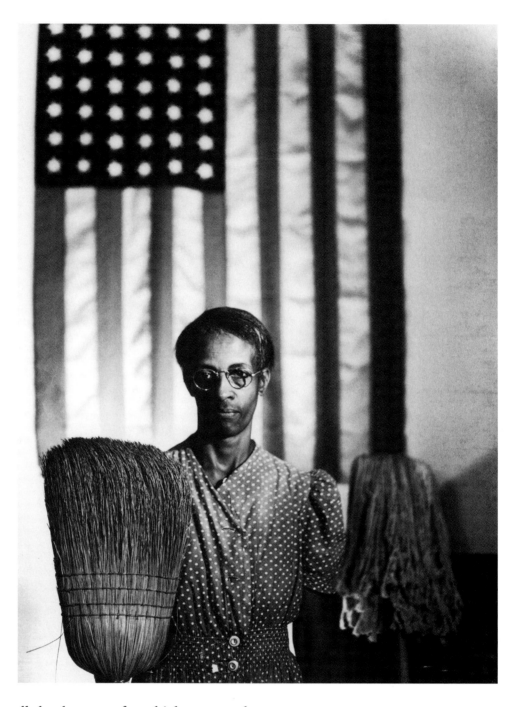

testers were slammed against brick walls by the water from high-pressure hoses.

As to the cruel imagery, that which was born in darkness, I have a curious question: What sorts of feelings grasped the photographers' hearts as they recorded the horrible scenes? The options, ranging from pangs of sorrow to shocking numbness to awe to despair to anger, are plentiful. Perhaps their reactions depended upon where their own lives had been or where their lives were going. How did they do it? For the execution of any of these photographs, a finger and an instinct joined forces for a split second. The combat photographer's life, clothed in danger and uncertainty, might vanish in any moment. How did they do it? Larry Burrows, Robert Capa and all the many others who have perished in war zones could speak with authority on this question, but they chose instead to speak to us with their cameras, telling us how certain men have murdered

Flavio

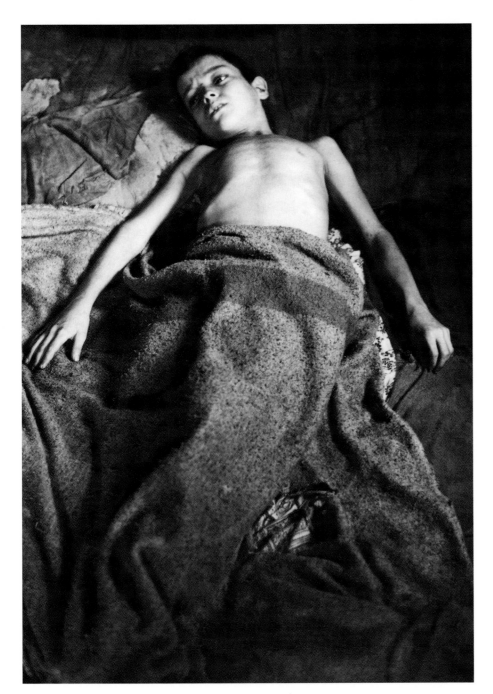

From stony heights I first saw him
climbing beneath cloudless clouds
floating the mountain's hot air.
His face, shrunken by furious hunger,
was colored with amber and honey.
His neck, akin to a leaning tower,
was drowning in rivers of sweat.
Time had screwed his broom-stick legs
into his bony disgruntled feet.
There, with death hiding inside him
at the mid-point of blistering day,
he smiled a smile I'll never forget.
Then, on a mountainside of silence,
Flavio da Silva became my friend.

other men over a bucket of dirty drinking water.

If you were to ask me to explain my own absence from some of these places, I would say, "Maybe I should have been there, but I'm glad I was not there. I loathe photographing death." But we are fortunate that others were there for the terrible moments as well as the good, because as we look at their pictures an indisputably important fact emerges: These images helped push us toward a change.

You might say the world still suffers gunfire and terrorist bloodletting, that there is still smoke everywhere. But take another glance at these photographs. The cameras have observed our lives in order to get us to tomorrow. The cameras have observed our lives in search of hope. Photography, as it appears in this memorable collection, nourishes hope. Without hope, contentment is impossible in our world.

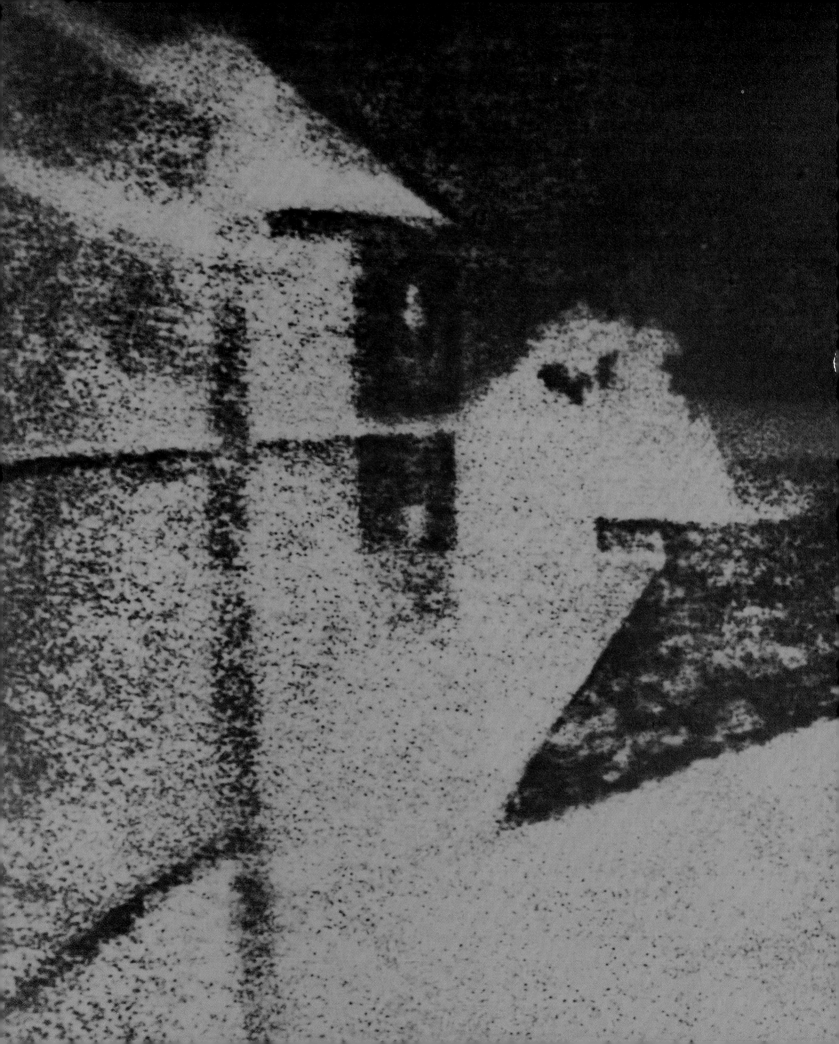

The Arts

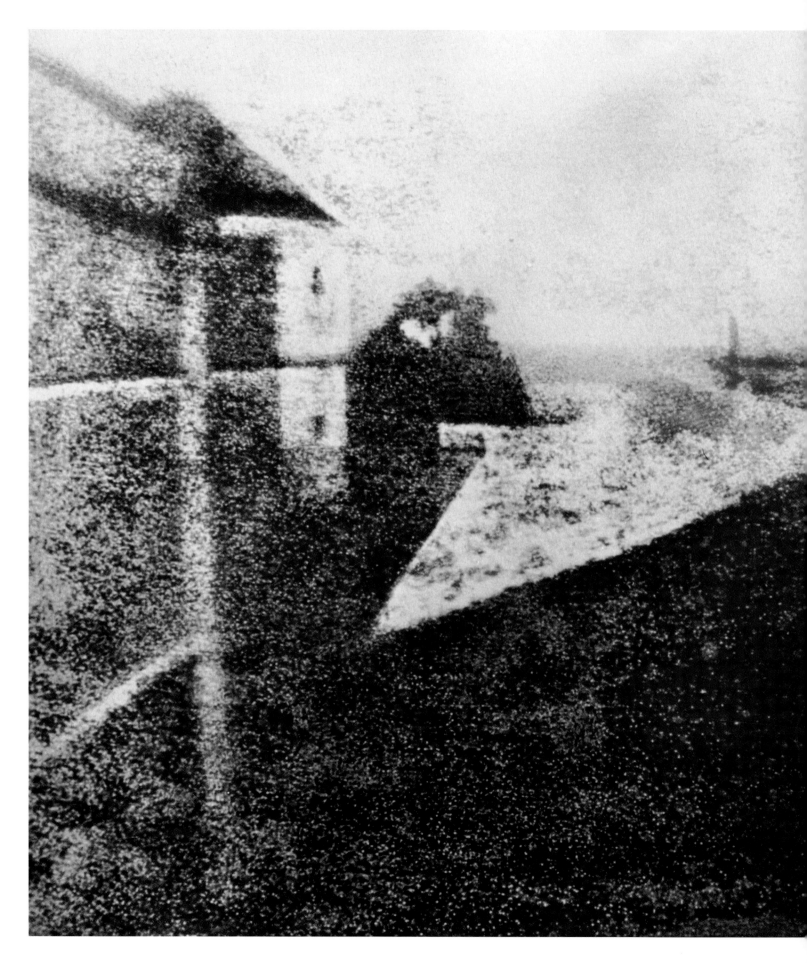

Pigeon House and Barn 1827

As early as 1793, Frenchman Nicéphore Niépce and his brother Claude imagined a photographic process, and over the next several years, Nicéphore experimented with various light-sensitive substances and cameras. In 1824 he produced a view from his window on a metal plate covered with asphalt. That and most other pictures fashioned by Niépce in the 1820s no longer exist, but the fuzzy image of a pigeon house and a barn roof taken in the summer of 1827 is a good representation of Niépce's art. To make what he called a "heliograph," or sun drawing, Niépce employed an exposure time of more than eight hours. Photography, if not yet practical, had been invented.

Photograph by **Nicéphore Niépce**

Another Landmark Image

British philosopher and scientist William Henry Fox Talbot was a dabbler of renown. In 1833, while on holiday in Italy, he wondered if images his camera threw against paper could be made to imprint themselves. Talbot's experiments led to the first paper negatives and greatly reduced the exposure time required to make a picture.

Lacock Abbey, 1835
Photograph by **William Henry Fox Talbot**
National Museum of Photography, Film & Television

A Still Life 1837

In 1826, Parisian stage designer Louis Daguerre learned of Nicéphore Niépce's heliography and promptly importuned Niépce to share his ideas. The men partnered in 1829, but Niépce died in '33. By 1837, Daguerre had developed a process by which an image could be frozen with exposures of minutes rather than hours. The daguerreotype led to a boom in photography; in an 1840 magazine account, Edgar Allan Poe said it "must undoubtedly be regarded as the most important, and perhaps the most extraordinary triumph of modern science."

Photograph by **Louis Daguerre**

An Autochrome 1909

Early efforts to render photographs in color, at first using plates coated with silver chloride, date to 1848; they were generally unsuccessful. Two decades later, drawing from ideas about color decomposition forwarded by Scottish scientist James Clerk Maxwell, Louis Ducos du Hauron made a color picture by superimposing three photos of one subject, shot through different filters. It was left to the Lumière brothers, famous as pioneering filmmakers, to develop a single-plate color process, which they did in 1904. Below: a Paris aircraft exhibit shot in Autochrome, the Lumière method.

Photograph by **Léon Gimple** Société Française de Photographie, Paris

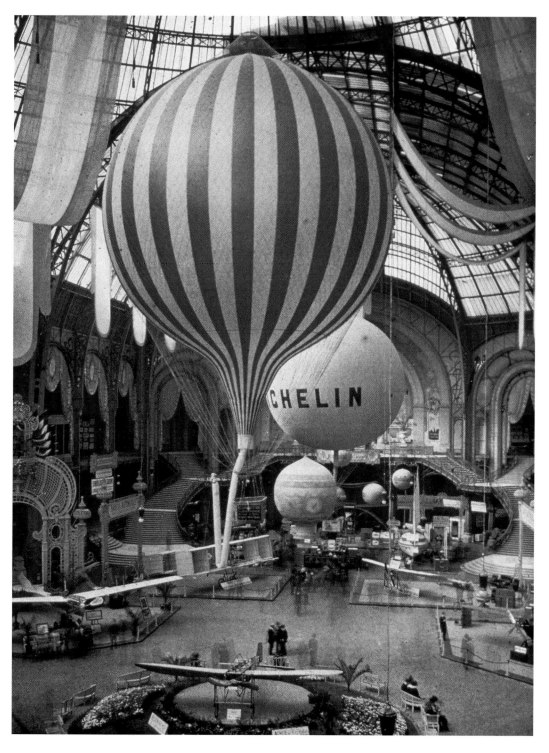

Uncut Sheet of Cartes de Visite c.1860

In the 1850s, the calling card changed when *cartes de visite*—2 ¹/₂" by 4" albumen prints mounted on cards—became de rigueur in French society, then in the U.S. "Card portraits, as everybody knows, have become the social currency, the 'green-backs' of civilization," wrote Oliver Wendell Holmes in 1863. The photo ID is a must-have for coming and going in today's world.

Photograph by **André Adolphe Disdéri** Gernsheim Collection, The University of Texas at Austin

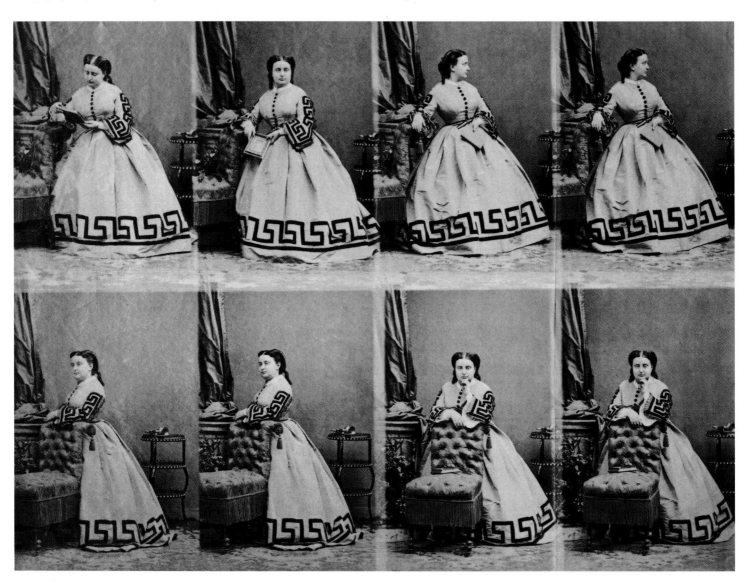

Sarah Bernhardt 1864

The Divine Sarah was but 20, and just on her way to becoming one of the theater's immortals, when she persuaded the French photographer Nadar to preserve her delicate beauty on film. Nadar's Parisian studio was a magnet for such luminaries as Baudelaire and Delacroix, who wanted to pose in the informal Nadar manner. Of course, those seeking fame would ever more find the camera irresistible, except, perhaps, when paparazzi became so intrusive as to menace. The need to be photographed and the apparent human need to see these photos has led to the present, disturbing cult of celebrity.

Photograph by **Nadar**

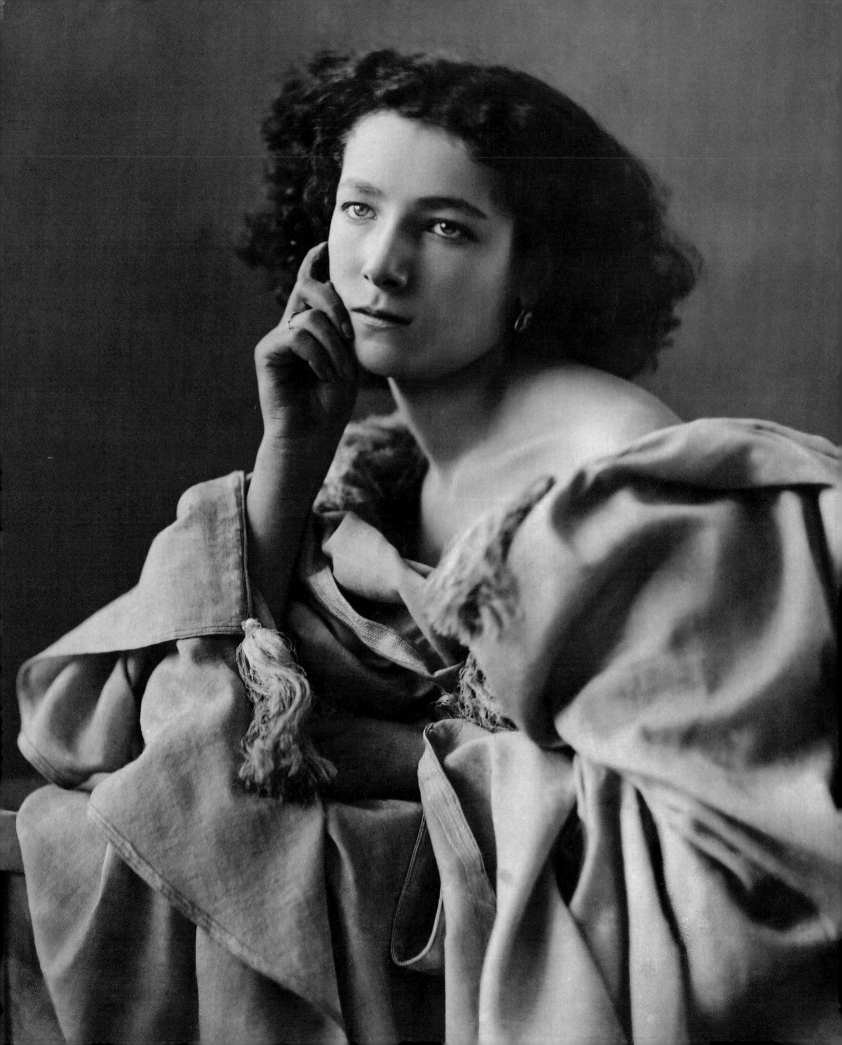

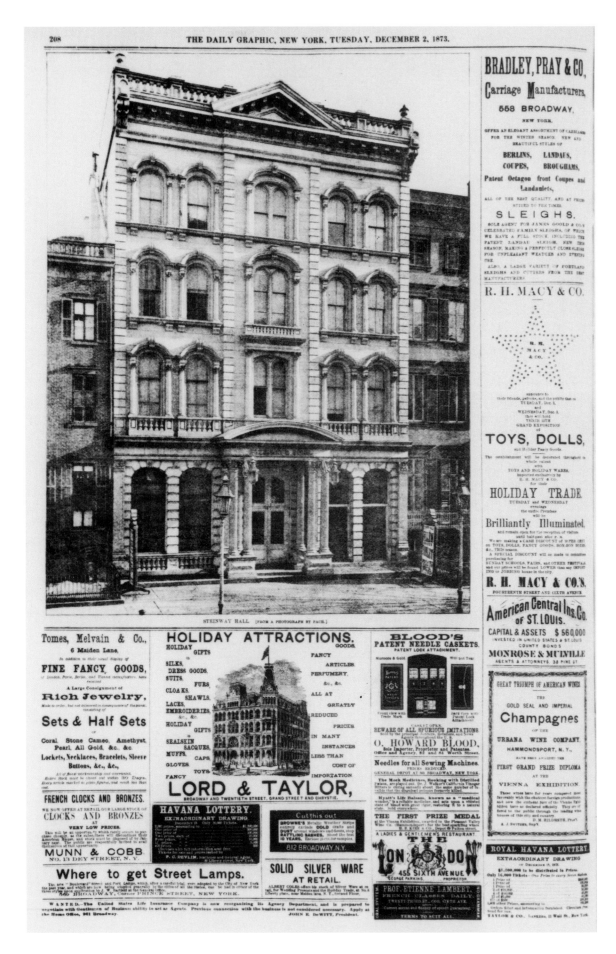

First Printed Photograph

1873

The halftone process to print photos was used for the first time in America in New York's *Daily Graphic*: The subject was Manhattan's Steinway Hall. Newspaper photography, static at the outset, grew to become the liveliest part of many journals, and in 1942 its importance was officially recognized in the U.S. when the Pulitzer Prize board began citing photos as well as reportage in its journalism-awards program. That year, a photograph of a fight on the picket line during a 1941 United Auto Workers' strike at a Ford plant in Detroit won the prize, and since then, Pulitzers have gone to pictures depicting racism, crime, poverty, heroism, terrorism and war, among other things.

Photograph from The New York Daily Graphic

Another Landmark Image

In 1935 the photograph of a plane crash in the Adirondacks was sent from New York to 25 other cities, and Associated Press Wirephoto was born. The '30s saw a boom in mass media photography, as transmitted images let people see within hours what they previously only imagined from newspaper or radio accounts, and new magazines like LIFE and *Look* showed Americans scenes from faraway lands within a week.

First Wirephoto, 1935
Photograph from AP

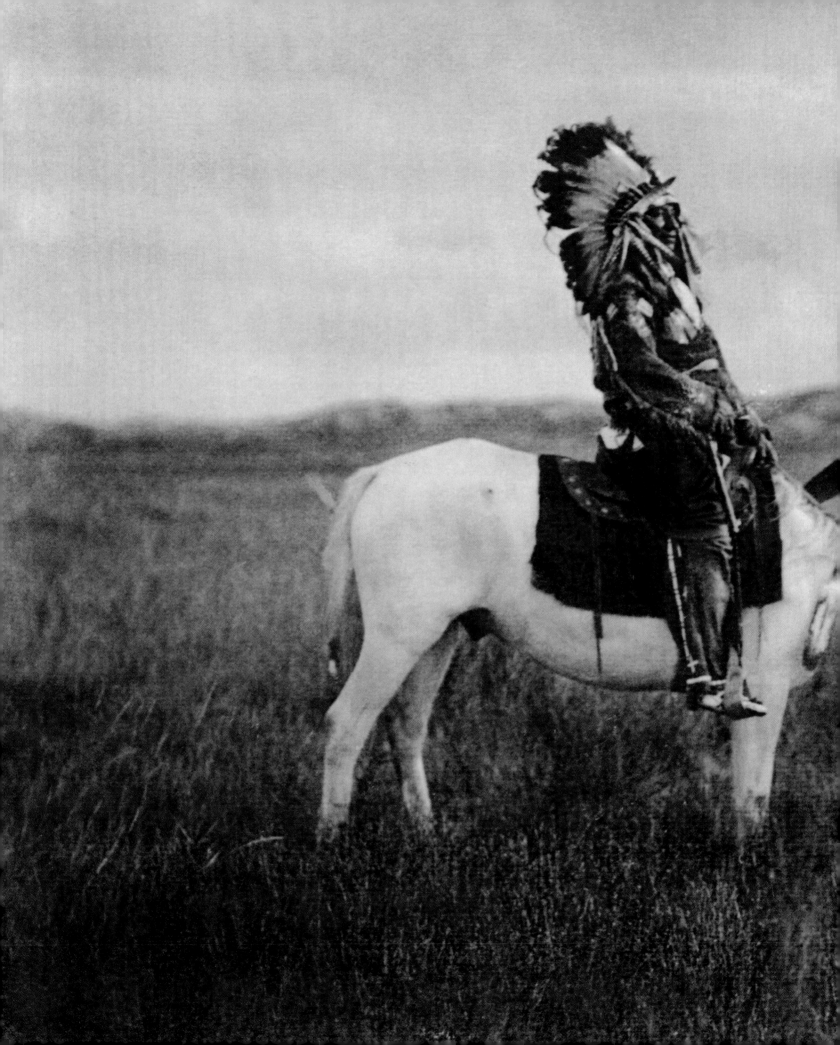

An Oasis in the Badlands
1905

When this picture was taken, the vast majority of easterners in the United States were of European heritage. Their view of Indians in the American West was, by and large, contemptuous, considering them little more than inferior obstacles. When the photographs of Edward Curtis appeared, most people were entirely unprepared for the obvious dignity and humanity of these native Americans. Here, Red Hawk, an Oglala Sioux, is clad in tribal garb as his horse drinks on the plains of South Dakota.

Photograph by
Edward S. Curtis
N.Y. Public Library

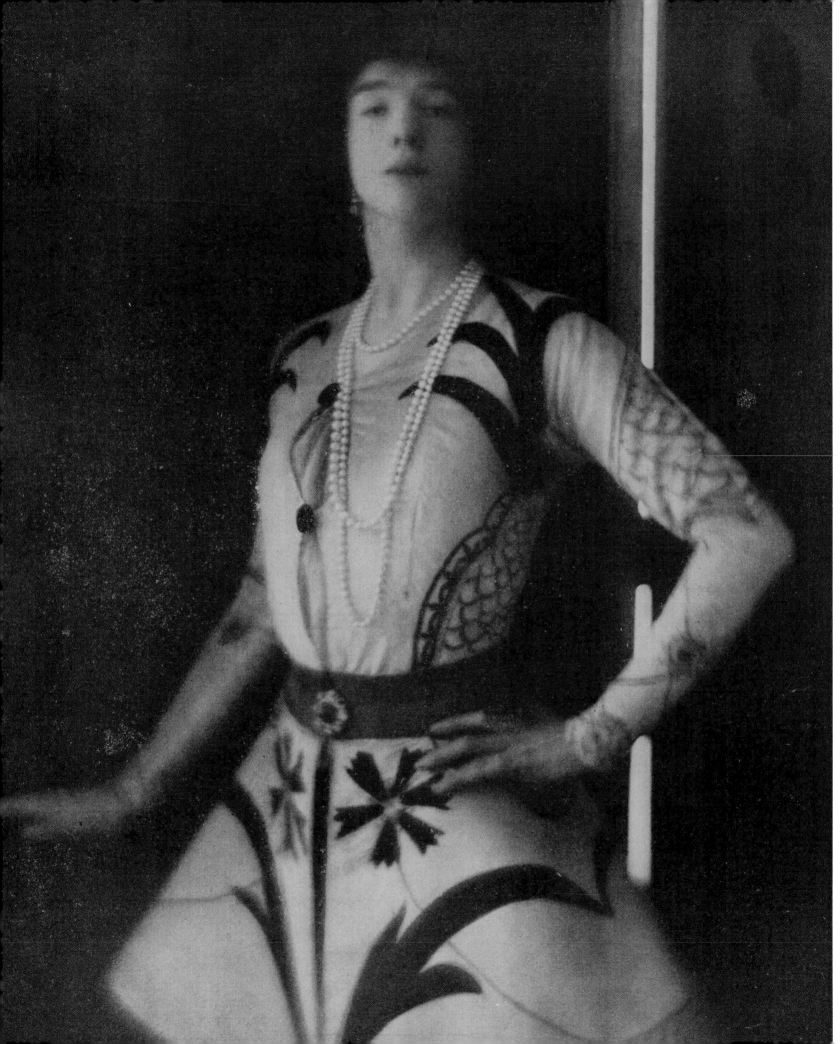

Gertrude Vanderbilt Whitney 1913

The earliest fashion photography consisted mostly of portraits of stylish aristocrats, and the first fashion photographer of note was Baron Adolphe de Meyer, who was hired to shoot for *Vogue* in 1913, the year he took this picture. In the '20s, the tradition of the artistically adventurous, stylized fashion photograph began in earnest when such as Edward Steichen and the art deco–influenced George Hoyningen-Huene entered the game. That tradition remained strong from Man Ray and Horst P. Horst through to the Avedons of today.

Photograph by **Baron Adolphe de Meyer** Vogue, Condé Nast Publications, Inc.

Another Landmark Image

France and England quarreled about many things through the centuries, but in certain areas they were not competitive, nor would they ever be. Immutable truth held that the English would always make a better ale, the French a better wine. London could do a splendid tea but could mount no challenge to Paree when it came to fine cuisine or haute couture. Then, in the mid-1960s, Mary Quant introduced the miniskirt at her Carnaby Street boutique, and soon the mods of London, personified by a skinny teenage model called Twiggy, were setting the standards in style.

Twiggy, 1967 Photograph from Dalmas/Sipa

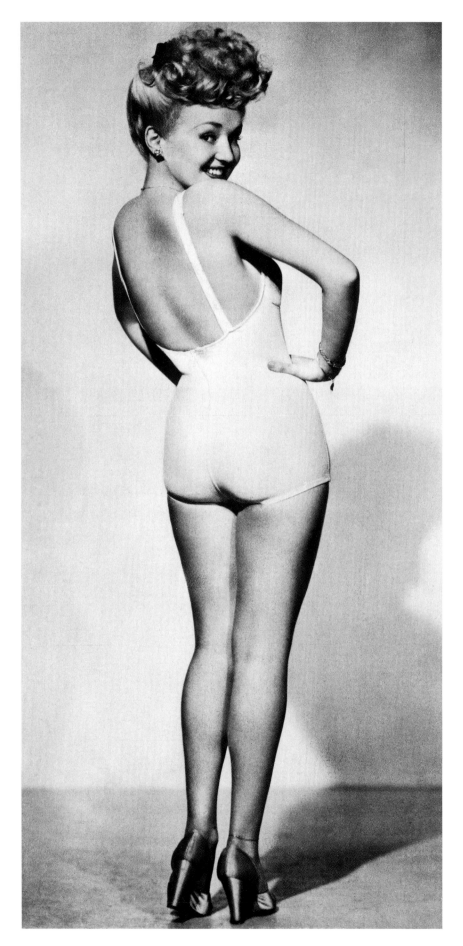

Betty Grable
1942

World War II took American boys to far-flung places and some rough duty. For many, mail came infrequently at best, and at times it held only a Dear John letter. The troops were desperate for some link to home, some reminder of what they were fighting for. Betty Grable and her million-dollar legs were the perfect balm for what ailed 'em, and this 1942 pinup of the easygoing girl with oodles of back-home charm, and other assets, made the war seem a little more bearable. Sexy pinups later grew to poster size, perhaps most memorably in the endlessly reproduced portrait of Farrah Fawcett.

Photograph distributed by 20th Century Fox

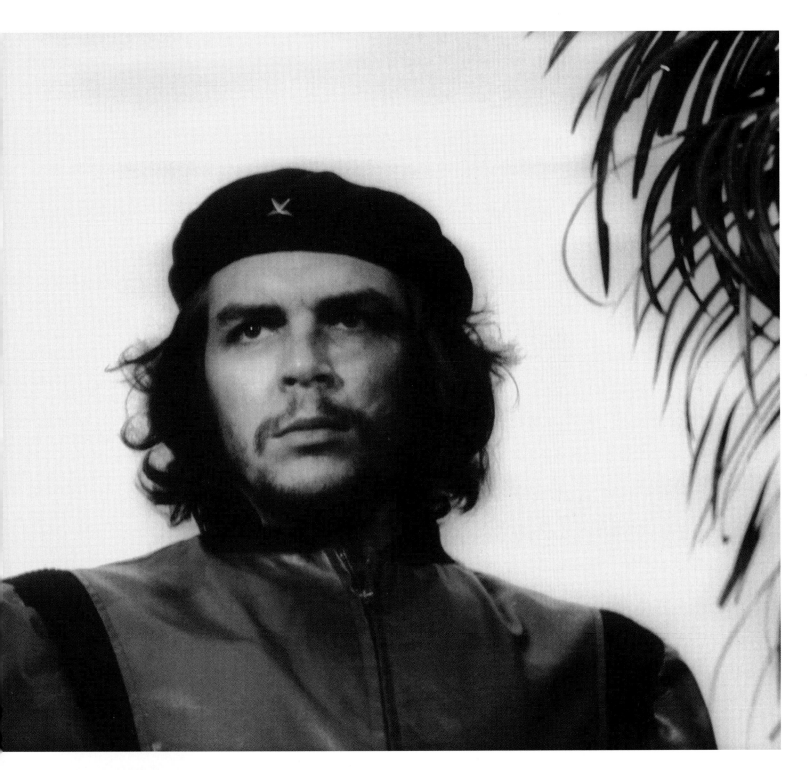

Che Guevara 1960

Cuban revolutionary Ernesto "Che" Guevara had just been killed in Bolivia in 1967 when, as if on cue, this epitomic portrait of a left-wing firebrand was released to the world in many forms, especially posters. Its romantic bravado captured the hearts and minds of young people everywhere. Korda's photo *Guerrillero Heroico* had been taken in 1960 at a service for slain Cuban revolutionaries, and Korda later gave the picture to an Italian publisher who, after Guevara's death, made it into a poster. If Grable's is the archetypal pinup, then Guevara's, which sold millions, is the quintessential poster. Korda never got a penny.

Photograph by **Alberto Korda** Courtesy Couturier Gallery, Los Angeles

Dead Sea Scrolls 1947

This picture stands for a library's worth of images that illustrate photography's power and reach today. In 1947 the first of the Dead Sea Scrolls, written between 200 B.C. and 68 A.D., were found near Jerusalem. By 1956, pieces of 870 scrolls had been discovered in 11 caves. It was clear that the scrolls, which contained much from the Hebrew Bible but also new prophecies and psalms, could illuminate Old Testament scholarship and perhaps early Christianity. But for decades, the scrolls were withheld from the public and even most scholars. Then, in 1991, the Huntington Library in California said that it would allow access to its microfilm files of all scroll photographs.

Photograph by **Larry Burrows**

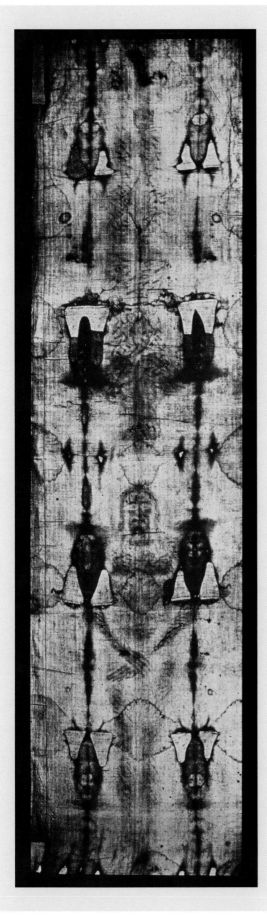

Other Landmark Images

Without entering into the debate as to whether the Shroud of Turin is the authentic burial cloth of Jesus Christ or a fake manufactured centuries later, it is true that the Shroud has moved many—and has reached and impressed millions throughout the world—because of the science of photography. The shadowy image on the Shroud is difficult to discern as human; in fact, the closer you get to the Shroud, the harder the task becomes. But when seen in a photographic negative, the face, hands, beard and other details of a man are immediately, stunningly distinct.

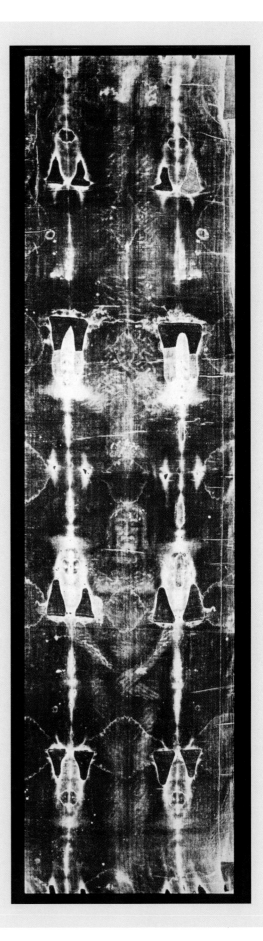

Positive and Negative Photographs of the Shroud of Turin, 1982
Photograph by
Vernon Miller

Photographic Art

Ever since Daguerre first composed a still life, photography has had the dual purpose of not only recording a scene but also of rendering it. As with painters, there have been, down through the decades, masters of the photographic medium, stylists whose work thrills and inspires us. The Roman poet Horace said, "A picture is a poem without words," and the aesthetes of the camera are stellar exemplars of this sentiment.

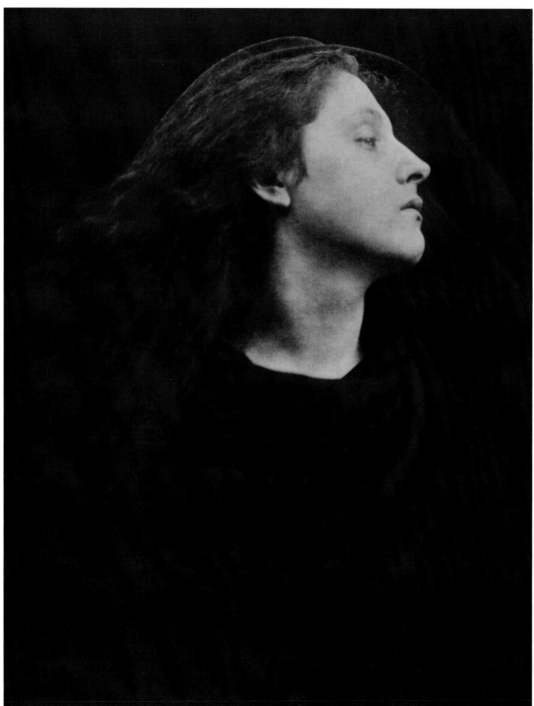

Julia Margaret Cameron
Call, I Follow, I Follow,
Let Me Die! c. 1867

The Victorian-era portraitist considered herself, rather than a photographer, an artist who made pictures. Influenced by pre-Raphaelite painters, she produced soft-focus images that are beautiful and beguiling.

Royal Photographic Society

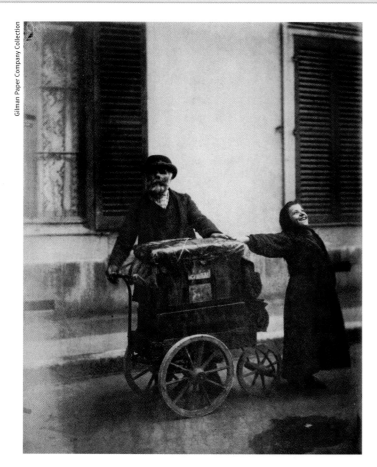

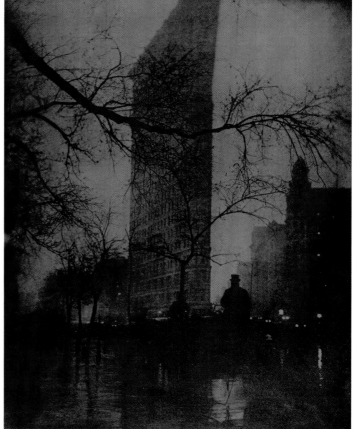

Eugène Atget
Organ Player and Singing Girl
1898

A frustrated actor, Atget considered turning to painting. But he took up the camera instead and quickly showed himself to be a genius of composition. For 30 years, Atget's grail was to capture all that was picturesque in the city he loved, Paris.

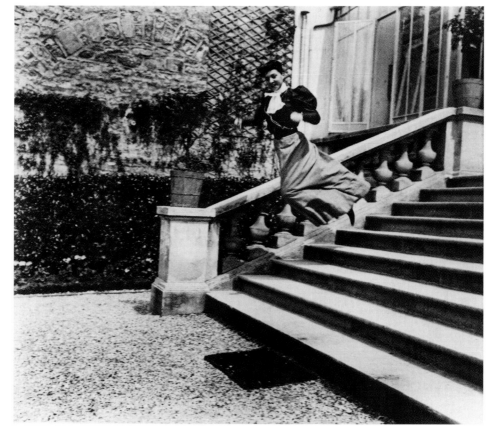

Edward Steichen
The Flatiron, Evening 1905

He did portraits, landscapes, fashion photography, even advertising work, all of it marked by by a strong sense of design.

Jacques-Henri Lartigue
Bichonnade in Flight 1905

Given a camera at eight, the French boy wasn't yet a teen when he took this typically gay, bright, airy picture.

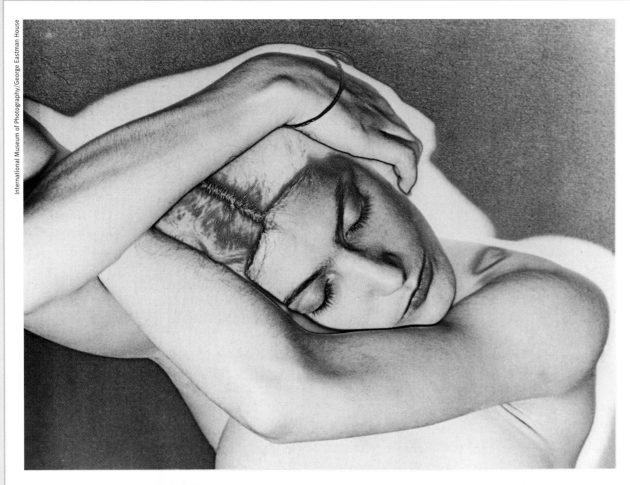

Man Ray
Solarization
1929

An early devotee of Dada and Surrealism, he took up photography to pay for his painting. Experimenting tirelessly, he used the camera in wildly exciting ways, and was a master of fashion and portrait photography.

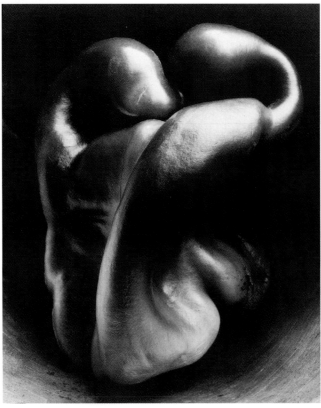

Edward Weston
Pepper #30 1930

Weston was obsessed with creativity, and his natural-form closeups, nudes and landscapes reveal precisely his desire to show the subject in its "deepest moment of perception."

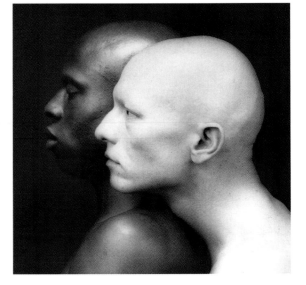

Robert Mapplethorpe
Ken Moody and Robert Sherman 1984

From his early work with Polaroids to his later platinum prints on linen, this exacting iconoclast shot still lifes, portraits and nudes. His flagrant eroticism elicited passionate responses.

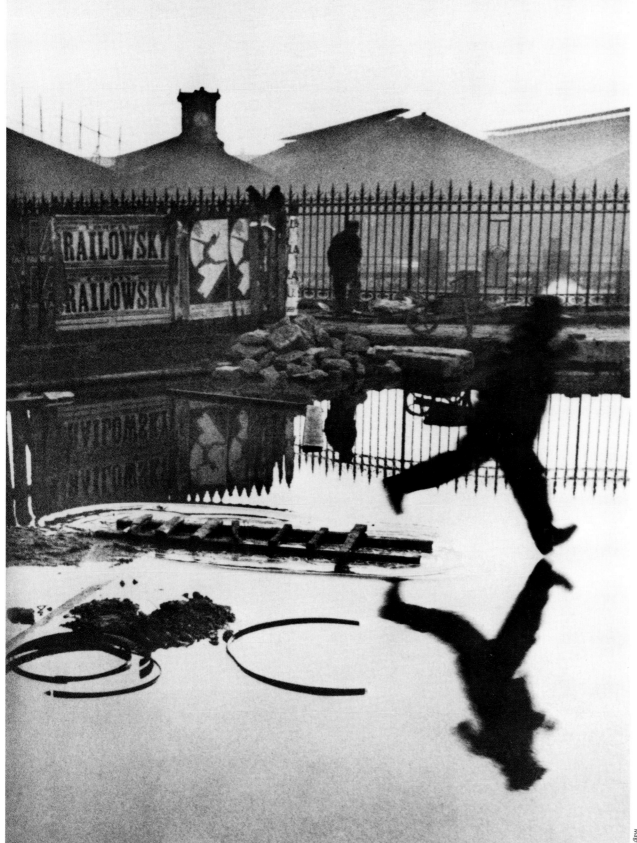

Henri Cartier-Bresson
The Decisive
Moment **1952**

A sharpshooter
with a 35mm, he
"prowled the
streets . . .
determined to
trap life, to
preserve life in
the act of living."
One of the
foremost
photojournalists,
his pictures were
crisp, essential,
insightful, artful.

Magnum

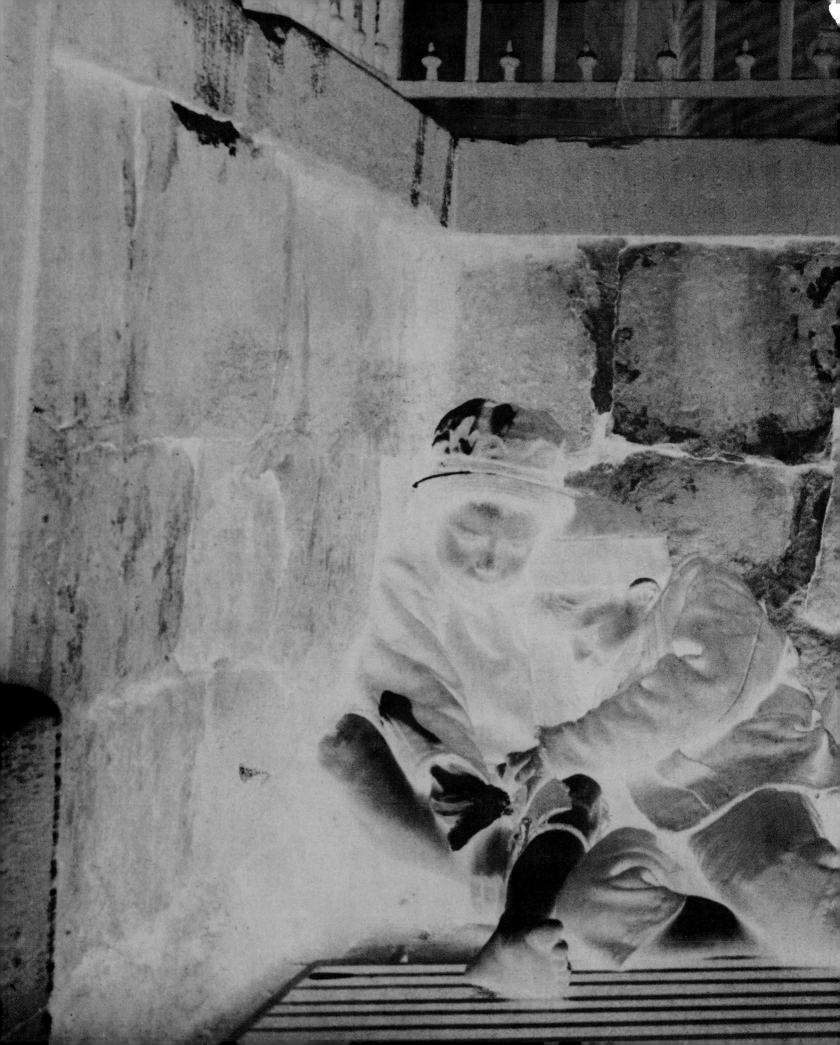

Society

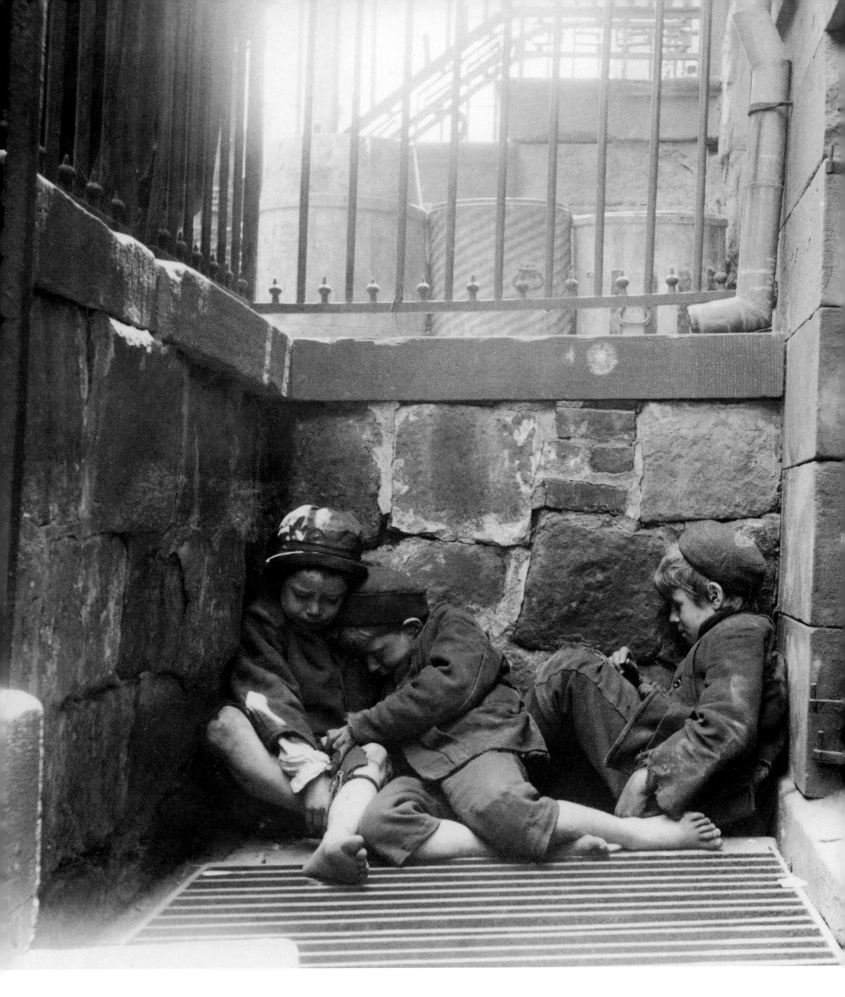

Glasgow 1868

When Glasgow's City Improvement Trust wanted a photographer to document condemned slums, they picked Thomas Annan, a portrait artist who rejected the typical props of the day. (He even converted a hansom cab into a darkroom.) Annan was among the very first to chronicle the life of the urban poor in photos such as the one below. Critics say he concentrated more on buildings than on the souls within, but his images tell a clear, sad tale.

Photograph by **Thomas Annan**
International Museum of Photography, George Eastman House

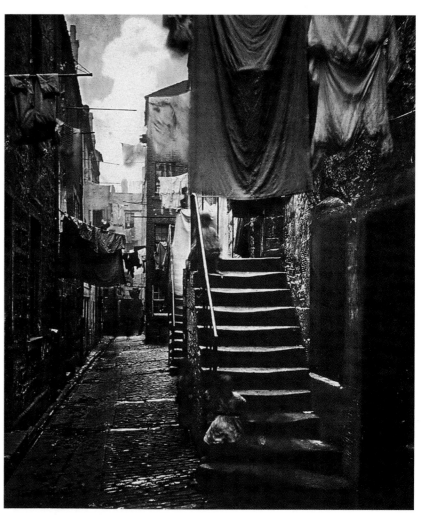

New York City c. 1880

Muckrakers were busy on both sides of the Atlantic in the late 1800s. While Annan was chronicling Glasgow and John Thomson was exposing the down-and-out in his *Street Life in London,* Jacob Riis was cataloguing the lives of "street arabs," nomadic children in New York City who had been abandoned or neglected in ways people are ashamed to treat dogs today. Riis's *How the Other Half Lives,* a sensation in 1890, remains a classic.

Photograph by **Jacob Riis**
The Jacob A. Riis Collection, Museum of the City of New York

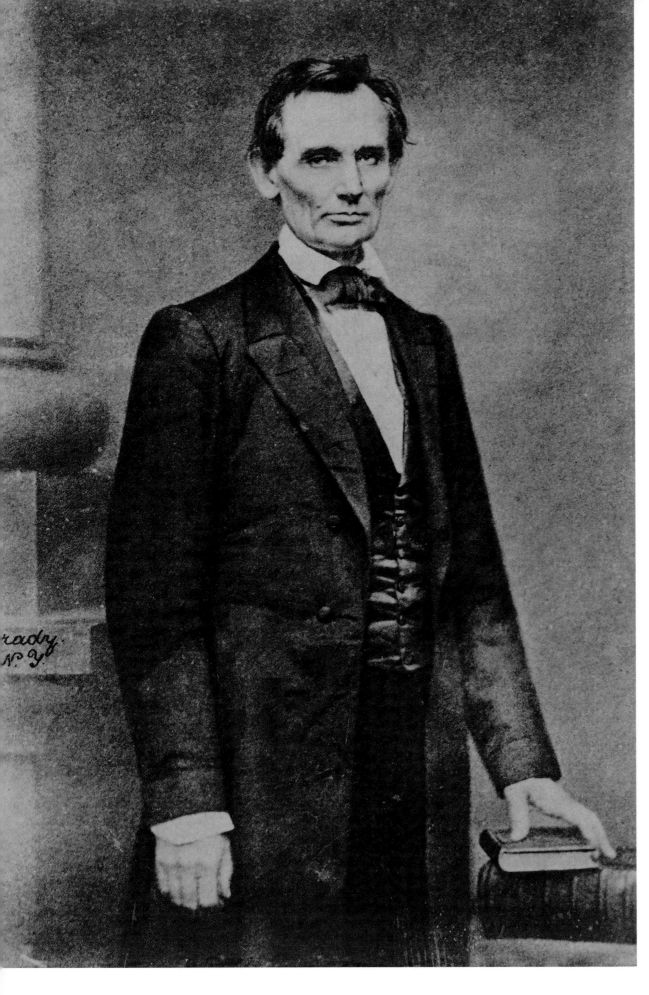

rady.
N.Y.

Abraham Lincoln
1860

Mathew Brady took this picture on February 27, 1860, the day Abraham Lincoln gave a rousing antislavery speech at a New York City institute known as Cooper Union. The photo and the speech were then widely circulated during Honest Abe's presidential campaign. Brady, who claimed his portrait won Lincoln the election, said he made the tall man look less gangly through the sophistry of pulling Lincoln's collar high to make his neck look shorter. Brady went further, by removing some of the great man's deep facial furrows and doctoring his drifting left eye. The President himself recognized the importance of the photo: "Brady and the Cooper Institute made me President." This print was the humble progenitor of today's image-based political campaigns.

Photograph by
Mathew Brady

Other Landmark Images

Brady's wizardry may have saved the day for Lincoln, but for two pols in the 1988 election, pictures proved their undoing. Gary Hart, a Colorado Democrat, was a front-runner for his party's nomination when *The Miami Herald* ran this photo of the married man and model Donna Rice, taken during a cruise on the *Monkey Business*. A week later, Hart dropped out of the race. The field open, Michael Dukakis, governor of Massachusetts, became the Democratic choice against George Bush. At a General Dynamics plant in Michigan, the Duke wanted to show he wasn't soft on defense, so he took a spin in a tank. Compared with WWII pilot Bush, the little Dukakis came off a clown. To firmly seal the deal, Bush supporters ran ads featuring the visage of Willie Horton, a hardened con who, while at liberty under the Massachusetts "weekend pass" program, had committed rape.

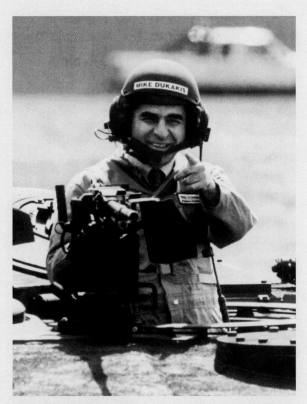

Michael Dukakis, 1988
Photograph from AP

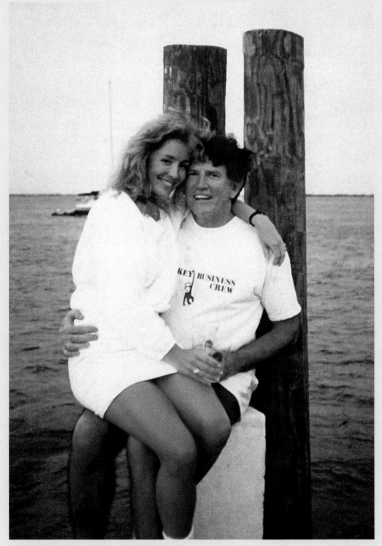

Gary Hart and Donna Rice, Bimini, 1987
Photograph by **The National Enquirer** Gamma Liaison

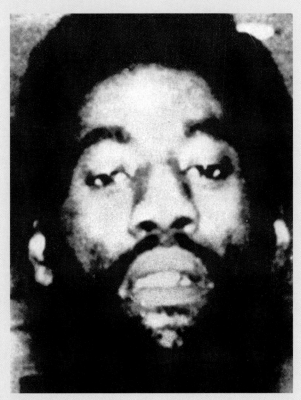

Willie Horton, 1987
Photograph from AP/Lawrence Eagle Tribune

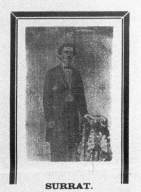
SURRAT.

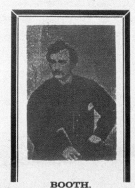
BOOTH.

HAROLD.

War Department, Washington, April 20, 1865,

$100,000 REWARD!

THE MURDERER

Of our late beloved President, Abraham Lincoln,

IS STILL AT LARGE.

$50,000 REWARD

Will be paid by this Department for his apprehension, in addition to any reward
offered by Municipal Authorities or State Executives.

$25,000 REWARD

Will be paid for the apprehension of JOHN H. SURRATT, one of Booth's Accomplices.

$25,000 REWARD

Will be paid for the apprehension of David C. Harold, another of Booth's accomplices.

LIBERAL REWARDS will be paid for any information that shall conduce to the arrest of either of the above-
named criminals, or their accomplices.

All persons harboring or secreting the said persons, or either of them, or aiding or assisting their concealment or
escape, will be treated as accomplices in the murder of the President and the attempted assassination of the Secretary of
State, and shall be subject to trial before a Military Commission and the punishment of DEATH.

Let the stain of innocent blood be removed from the land by the arrest and punishment of the murderers.

All good citizens are exhorted to aid public justice on this occasion. Every man should consider his own conscience
charged with this solemn duty, and rest neither night nor day until it be accomplished.

EDWIN M. STANTON, Secretary of War.

DESCRIPTIONS.—BOOTH is Five Feet 7 or 8 inches high, slender build, high forehead, black hair, black eyes, and
wears a heavy black moustache.

JOHN H. SURRAT is about 5 feet, 9 inches. Hair rather thin and dark; eyes rather light; no beard. Would
weigh 145 or 150 pounds. Complexion rather pale and clear, with color in his cheeks. Wore light clothes of fine
quality. Shoulders square; cheek bones rather prominent; chin narrow; ears projecting at the top; forehead rather
low and square, but broad. Parts his hair on the right side; neck rather long. His lips are firmly set. A slim man.

DAVID C. HAROLD is five feet six inches high, hair dark, eyes dark, eyebrows rather heavy, full face, nose short,
hand short and fleshy, feet small, instep high, round bodied, naturally quick and active, slightly closes his eyes when
looking at a person.

NOTICE.—In addition to the above, State and other authorities have offered rewards amounting to almost one hun-
dred thousand dollars, making an aggregate of about TWO HUNDRED THOUSAND DOLLARS.

Wanted Poster
1865

Six days after the assassination of Abraham Lincoln, in the midst of a frantic two-week search, the War Department hung Wanted posters with an innovation: Pasted on were photographs of John Wilkes Booth and two of his suspected conspirators. After seeing Booth's picture, fishermen pointed soldiers in the right direction, and they located the assassin in a Virginia tobacco barn; they burned the barn and found the suspect had been shot through the neck. This Wanted poster proved so effective that using a photograph became a fixture of law enforcement.

Photographer Unknown

Passport
1914

Passports date to 450 B.C., but France's King Louis XIV popularized them when he personally signed requests that his subjects be given safe passage through ports, or *passe port*. By the mid-1800s, growing masses of travelers were overwhelming authorities, and countries stopped issuing the documents. With the advent of World War I, nations started demanding them again. In 1914 the United States began requiring a passport photo, turning the once whimsical ID portrait—the charming *carte de visite*—into a grim instrument of official identification. Who could have guessed in 1916 that a certificate for transit such as this one, which belonged to the famous, globe-trotting dancer Isadora Duncan, would one day be a staple of American—indeed, global—life?

Copied by Brad Trent

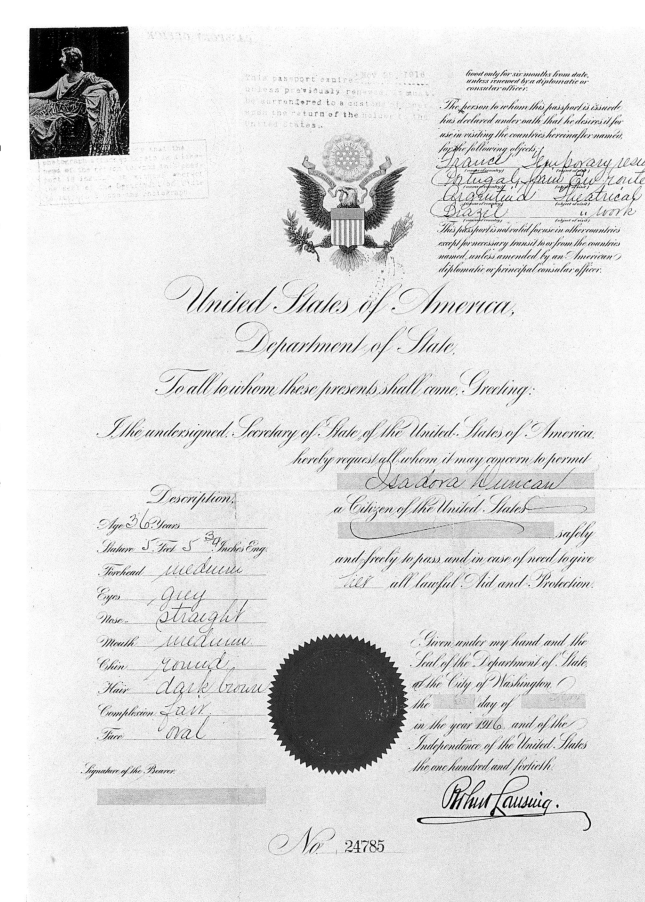

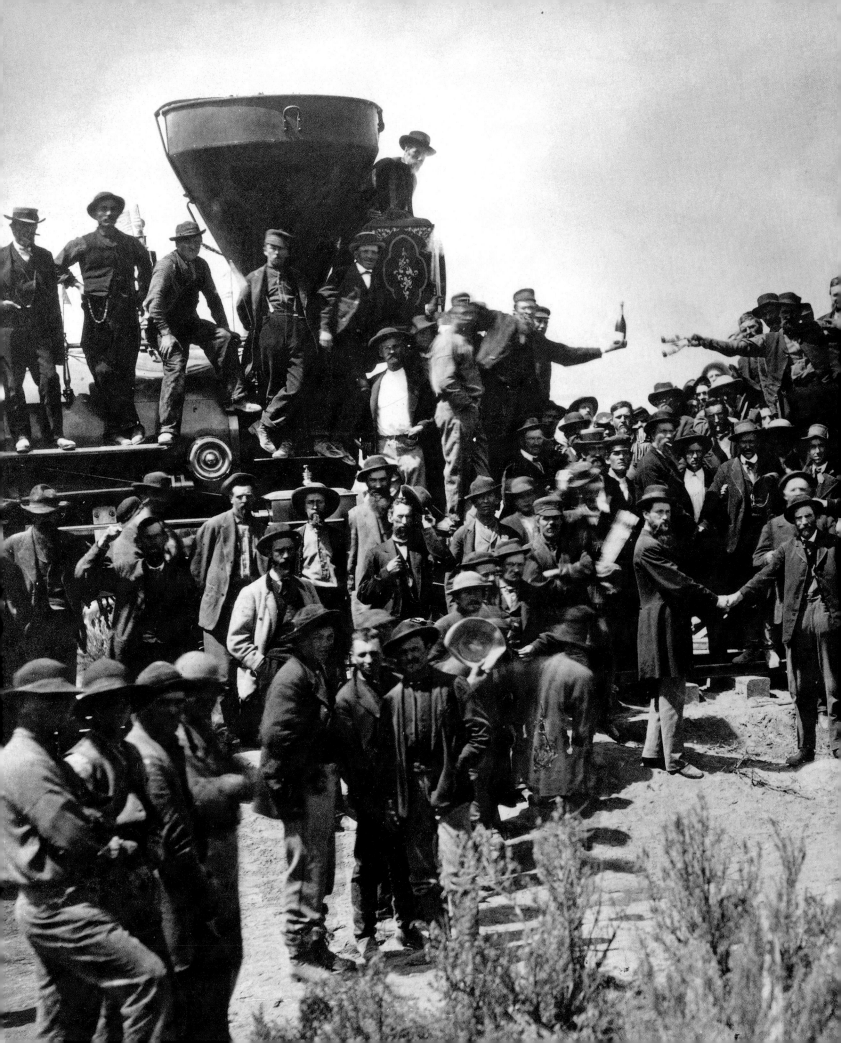

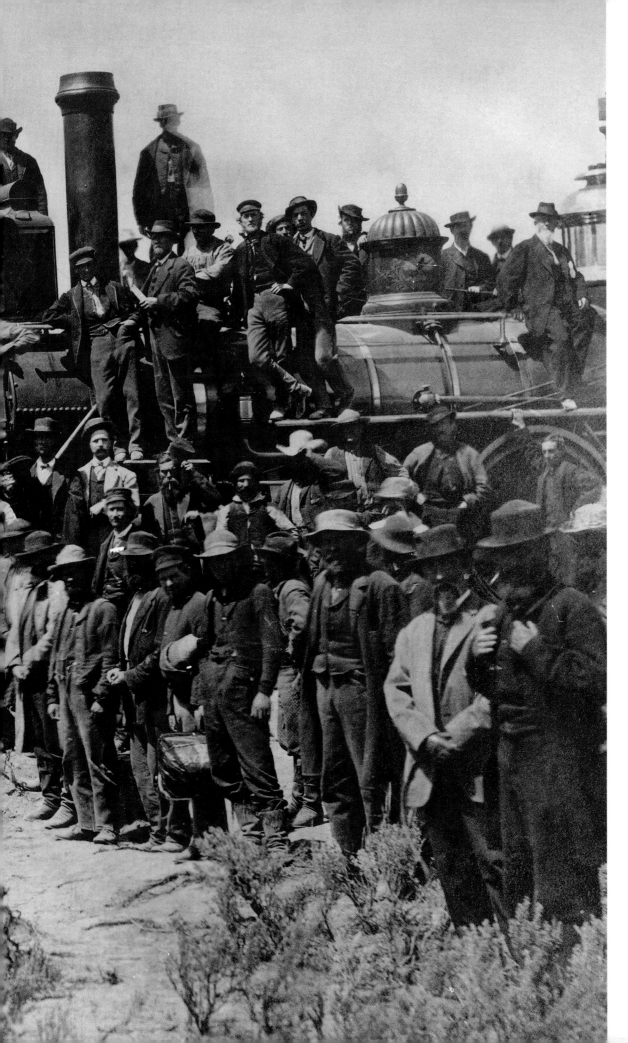

Promontory Point 1869

The ceremony begins on May 10, 1869, as an eastbound Central Pacific locomotive and a westbound Union Pacific locomotive meet in Promontory Point, Utah, marking the completion of the first transcontinental railroad. The men on the cowcatchers are ready to toast the driving of the golden spike. The work had been brutal. At one stage, efforts to tunnel through the marble spine of a Sierra Nevada mountain consumed an entire year, as only eight inches a day of progress was possible. So: a fabulous accomplishment. But this is also an early example of a photo op—the use of a picture as a means to an end. Folks back East could see, plain as day, that a train could take them all the way to California, where businessmen anxiously awaited their commerce.

Photograph by
Charles Phelps Cushing

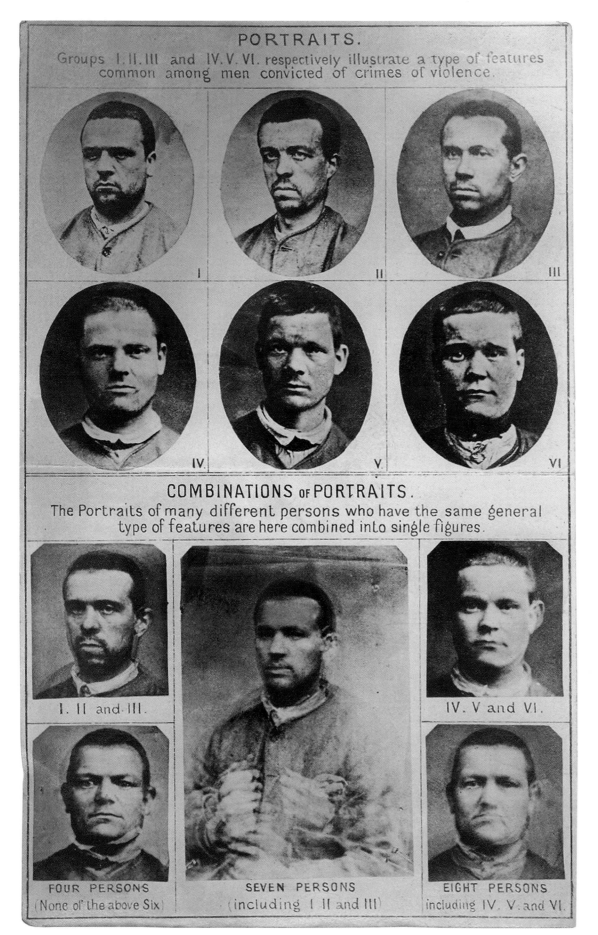

PORTRAITS.

Groups I. II. III and IV. V. VI. respectively illustrate a type of features common among men convicted of crimes of violence.

I II III

IV V VI

COMBINATIONS OF PORTRAITS.

The Portraits of many different persons who have the same general type of features are here combined into single figures.

I. II and III. IV. V and VI.

FOUR PERSONS
(None of the above Six)

SEVEN PERSONS
(including I. II and III)

EIGHT PERSONS
including IV. V. and VI.

Eugenics
c.1890

The highborn Englishman Francis Galton, a cousin of Charles Darwin, was the father of eugenics, an unsavory and ultimately fatal misunderstanding of hereditary traits that had a strong vogue in the Victorian era before the term "genetics" was coined. Derived from the Greek word meaning "wellborn," eugenics maintained that genius, strength and other physical characteristics, as well as various weaknesses and a propensity for crime, were not only inherited but discernible. Galton, who was knighted in 1909, said that "a highly gifted race of men" could be produced through selective breeding, and that those unfit for procreation should refrain or be regarded as "enemies to the State, and to have forfeited all claims to kindness." Galton also believed in photography's ability to tell absolute truth. Many found his composite images of criminal types persuasive.

Photograph by
Francis Galton
Courtesy Special Collections, University College, London

Another Landmark Image

Eugenics traveled well, gathering adherents from India and Japan to the U.S., Canada and, especially, Germany. American eugenicists had by the late 1920s successfully lobbied for laws mandating sterilization of the "unfit" in 24 states. In Germany, Dr. Alfred Ploetz's Society for Racial Hygiene, founded in 1905, opposed charitable programs to protect the ill, and approved of infanticide of the weak. In 1910, Sir Francis Galton graciously received Ploetz in London. Later, Ploetz ardently backed Hitler. It took something as dire as the Holocaust to destroy the credibility of eugenics.

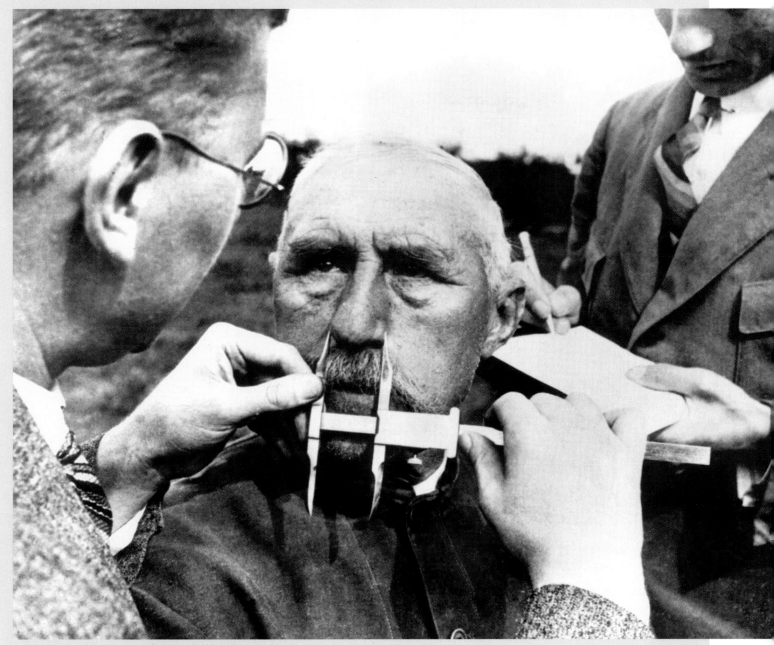

Aryan Race Determination Tests, Germany, c. 1940
Photograph from Hulton Archive/Getty

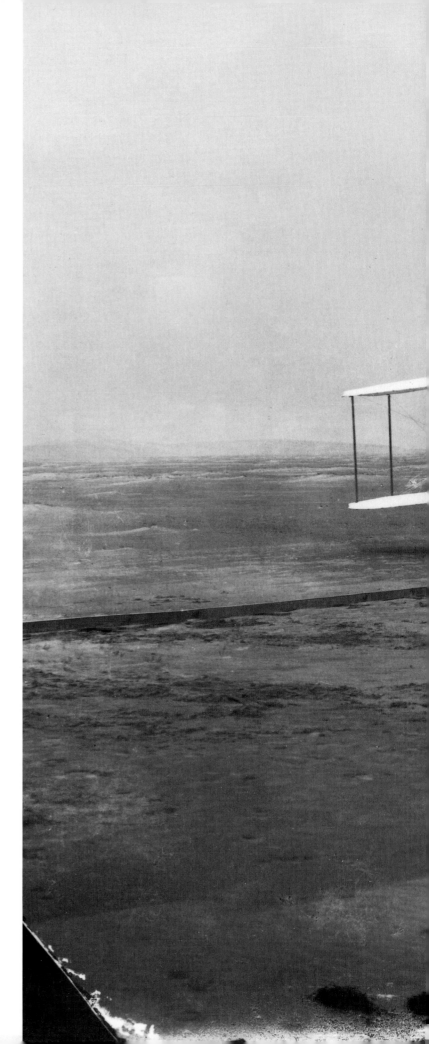

Flight 1903

On December 17, 1903, two bicycle mechanics from Ohio realized one of humanity's wildest dreams: For 12 seconds they were possessed of true flight. Before the day ended, Orville and Wilbur Wright would keep their wood-wire-and-cloth *Flyer* aloft for 59 seconds. Sober citizens knew that only birds used wings to take to the air, so without being at the site, near Kitty Hawk, N.C., or seeing this photo, few would have believed the Wrights' story. Although it had taken ages for humans to fly, once the brothers made their breakthrough, the learning curve reached the heavens. Within 15 years of this critical moment, nearly all the elements of the modern airplane had been imagined, if not yet developed.

Photograph from Library of Congress

Another Landmark Image

The world became a much smaller place on May 21, 1927, when Charles Lindbergh, a.k.a. the Flying Fool, touched down in France after crossing the Atlantic alone and nonstop. To spur himself, the modest midwesterner chanted en route, "There's no alternative but death and failure." A victory tour took Lucky Lindy to London, where he and the *Spirit of St. Louis* were greeted by 150,000 admirers at Croydon Aerodrome (below). Long-distance commercial aviation would soon alter human movement.

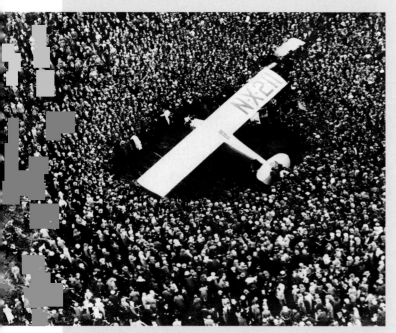

Charles Lindbergh, Croydon Aerodrome, England, 1927
Photograph from Brown Brothers

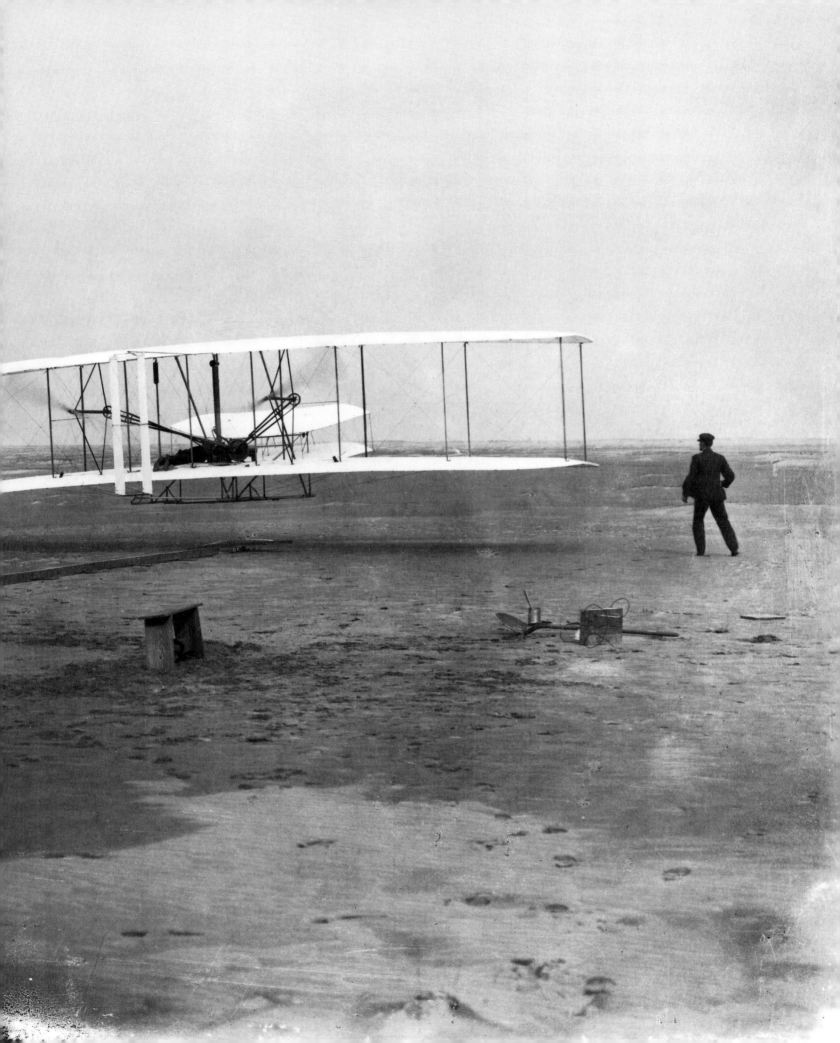

Breaker Boys
1910

What Charles Dickens did with words for the underage toilers of London, Lewis Hine did with photographs for the youthful laborers in the United States. In 1908 the National Child Labor Committee was already campaigning to put the nation's two million young workers back in school when the group hired Hine. The Wisconsin native traveled to half the states, capturing images of children working in mines, mills and on the streets. Here he has photographed "breaker boys," whose job was to separate coal from slate, in South Pittston, Pa. Once again, pictures swayed the public in a way cold statistics had not, and the country enacted laws banning child labor.

Photograph by **Lewis W. Hine**
National Archives

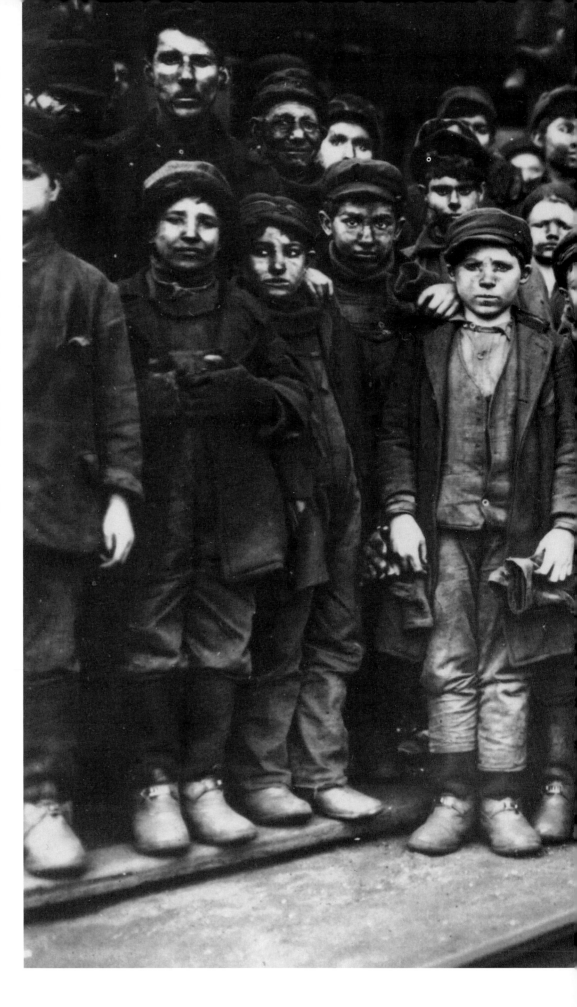

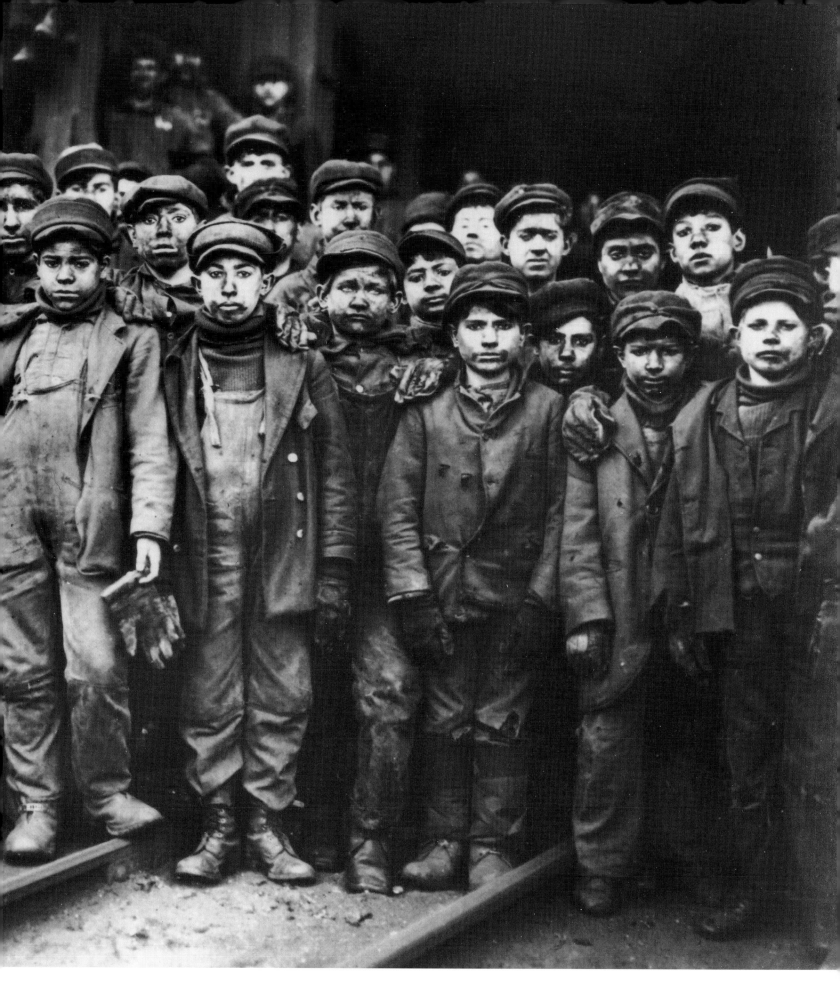

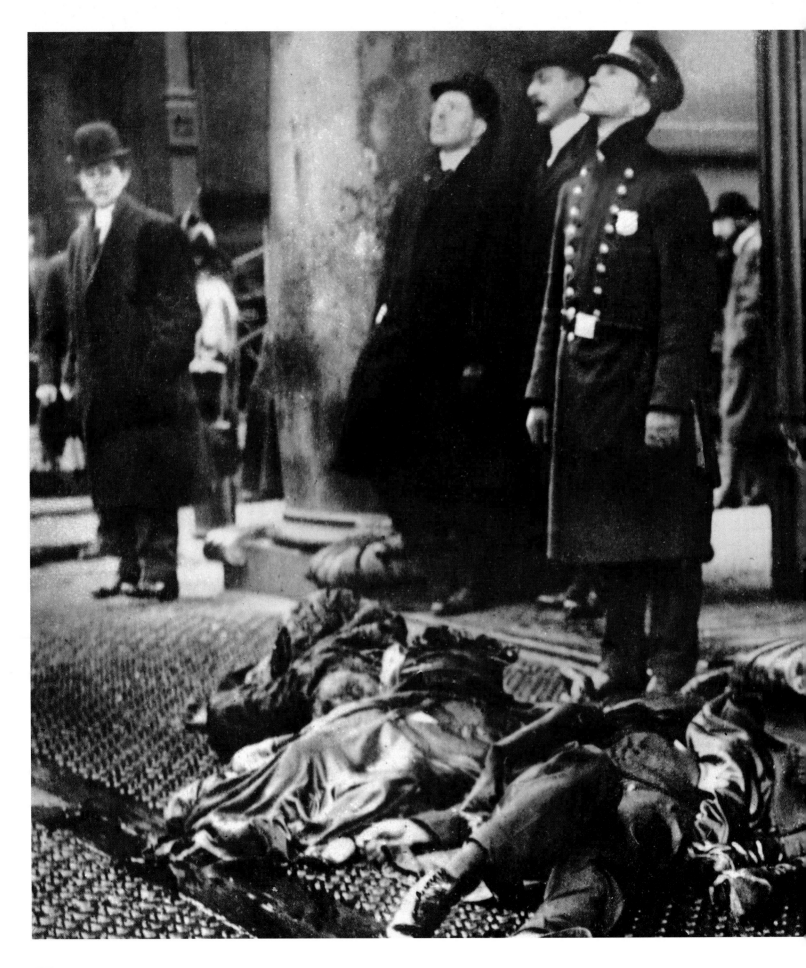

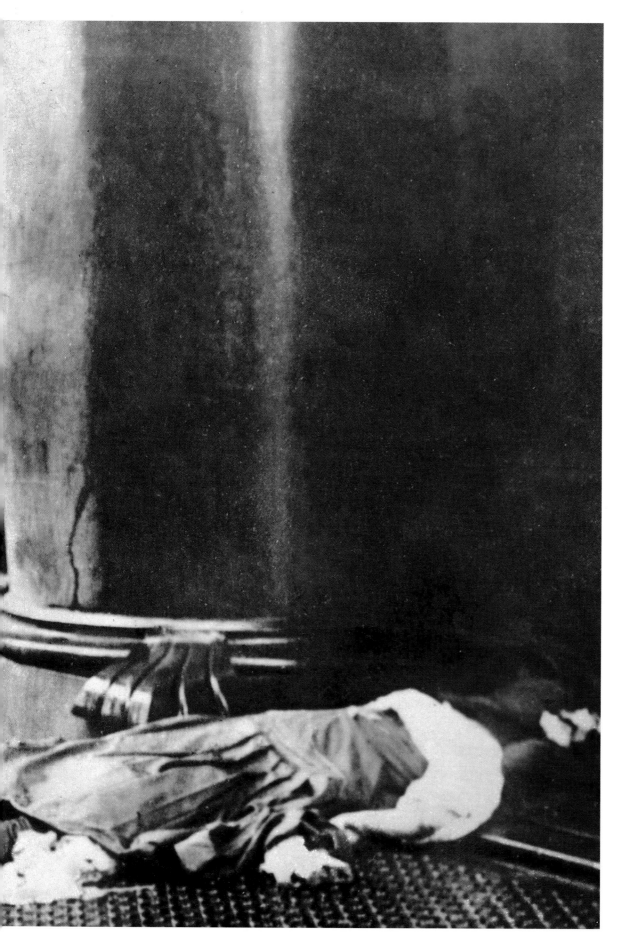

Triangle Shirtwaist Company Fire
1911

The Triangle Shirtwaist Company always kept its doors locked to ensure that the young immigrant women stayed stooped over their machines and didn't steal anything. When a fire broke out on Saturday, March 25, 1911, on the eighth floor of the New York City factory, the locks sealed the workers' fate. In just 30 minutes, 146 were killed. Witnesses thought the owners were tossing their best fabric out the windows to save it, then realized workers were jumping, sometimes after sharing a kiss (the scene can be viewed now as an eerie precursor to the World Trade Center events of September, 11, 2001, only a mile and a half south). The Triangle disaster spurred a national crusade for workplace safety.

Photograph by the
International Ladies' Garment Workers' Union

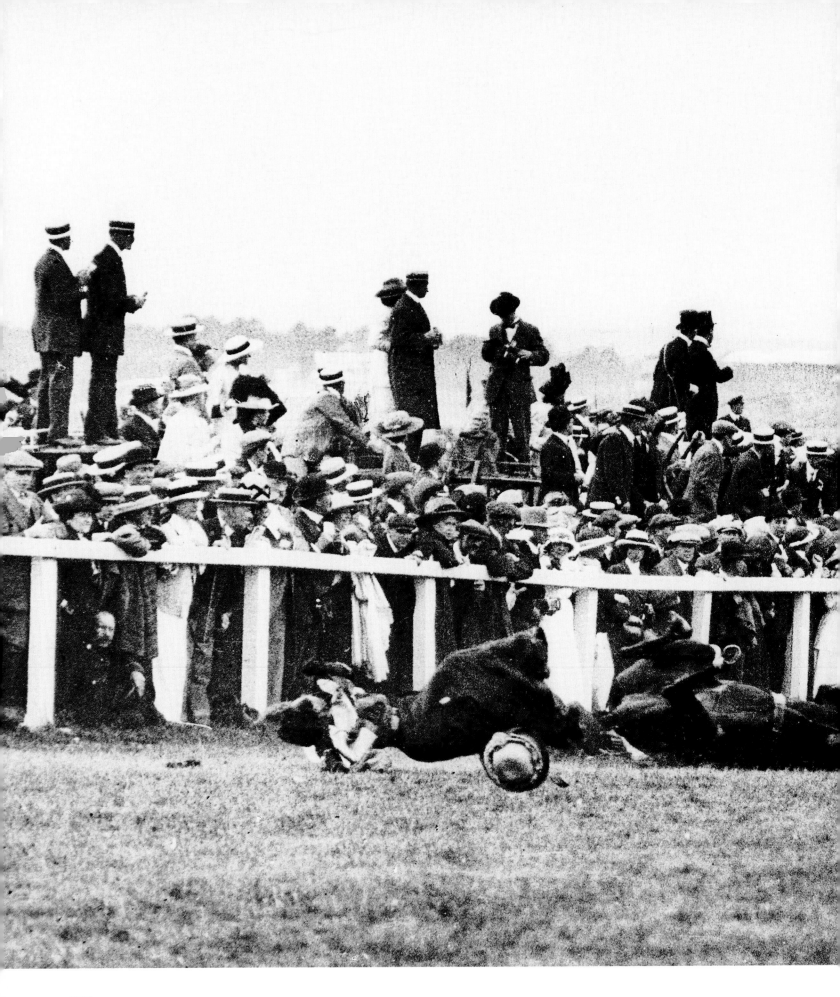

Trampled by the King's Horse 1913

By the 19th century, it finally became a public issue that females were not allowed to participate in national elections. The struggle for woman suffrage took many forms but often played out as an exercise in civil disobedience, in the U.K. and U.S. especially. Emily Davison was born in England in 1872 and graduated from London University. By 1909 she was immersed in women's rights to the extent that she was repeatedly imprisoned, then released after hunger strikes. In 1913, before half a million people, she threw herself at Anmer, the king's horse that was running in the Epsom Derby, in a final, fatal act of protest. Many thought her insane. Others considered her a martyr.

Photograph from Hulton Archive/Getty

Another Landmark Image

The Title IX legislation of 1972, which banned sexual discrimination in education programs receiving federal funds, led to a boom in schoolgirl sports. When a U.S. team of women raised on Title IX won the 1999 soccer World Cup final, still more girls were inspired to lace up their sneakers. Brandi Chastain said that she ripped off her shirt in celebration because guys had been doing it for years.

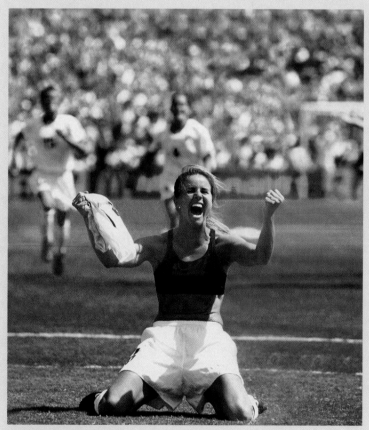

Brandi Chastain, 1999
Photograph by **Robert Beck** Sports Illustrated

Lynching 1930

A mob of 10,000 whites took sledgehammers to the county jailhouse doors to get at these two young blacks accused of raping a white girl; the girl's uncle saved the life of a third by proclaiming the man's innocence. Although this was Marion, Ind., most of the nearly 5,000 lynchings documented between Reconstruction and the late 1960s were perpetrated in the South. (Hangings, beatings and mutilations were called the sentence of "Judge Lynch.") Some lynching photos were made into postcards designed to boost white supremacy, but the tortured bodies and grotesquely happy crowds ended up revolting as many as they scared. Today the images remind us that we have not come as far from barbarity as we'd like to think.

Photograph from Bettmann/Corbis

Another Landmark Image

Blacks had been taking it on the chin in America for a long time. But that didn't stop most all of America, black and white, from cheering when Joe Louis knocked out Max Schmeling at Yankee Stadium in 1938. The German, Hitler's favorite, had beaten Louis two years earlier, but this time the Brown Bomber took revenge 2:04 into the fight. The hypocrisy of a nation honoring a black man for beating an Aryan, yet persecuting his brethren, was lost on too many.

Louis Knocks Out Schmeling, 1938
Photograph from AP

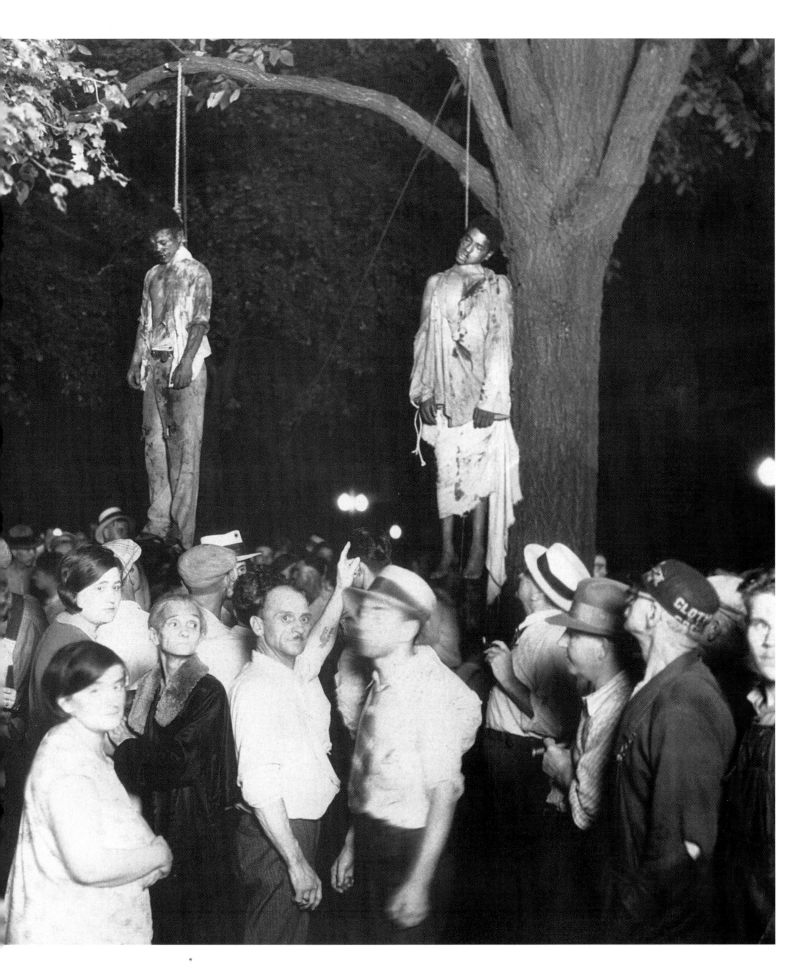

Bonnie and Clyde 1933

The Depression was in full swing in the early '30s, and its Grim Reaper's scythe cut a terrible swathe through Middle America. Farmers lost their fields, and families their homes; the banks would wait only so long before foreclosing. It was a perfect incubator for crime, and if the likes of John Dillinger and Pretty Boy Floyd stole from the banks, and maybe some mortgage papers got destroyed along the way, well, that didn't bother folks much. Many of the antiheroes assumed a Robin Hood persona, and their styles were widely imitated. Here, America's favorite crime couple, Bonnie Parker and Clyde Barrow, strike a pose.

Photograph from the Granger Collection

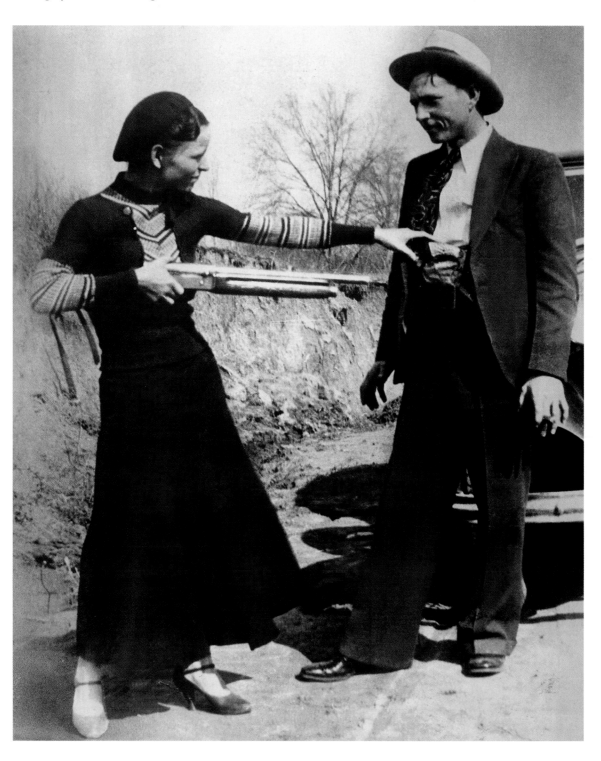

Migrant Mother 1936

This California farmworker, age 32, had just sold her tent and the tires off her car to buy food for her seven kids. The family was living on scavenged vegetables and wild birds. Working for the federal government, Dorothea Lange took pictures like this one to document how the Depression colluded with the Dust Bowl to ravage lives. Along with the writing of her economist husband, Paul Taylor, Lange's work helped convince the public and the government of the need to help field hands. Lange later said that this woman, whose name she did not ask, "seemed to know that my pictures might help her, and so she helped me."

Photograph by
Dorothea Lange
Library of Congress

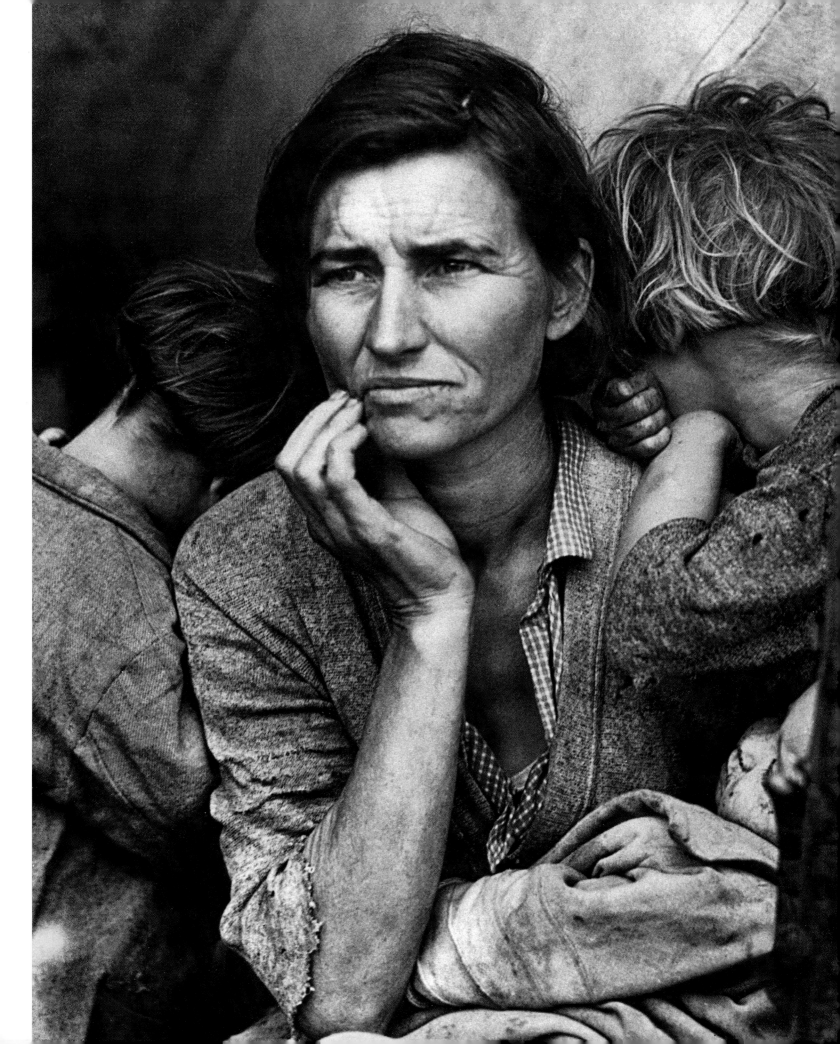

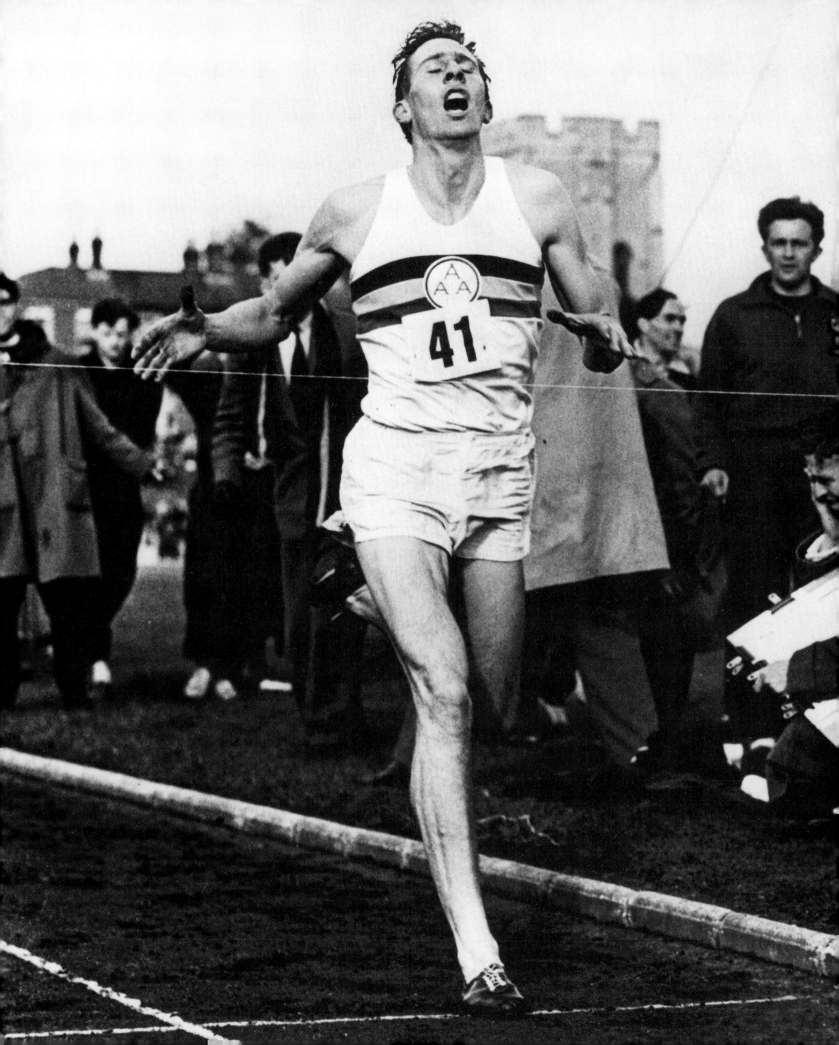

Roger Bannister
1954

There are certain givens for people, certain things we know we just can't do. In 1954, it was gospel to one and all that a human being simply could not cover a one-mile distance in less than four minutes. It was impossible. To John Landy, who had run 4:02 a few times, it was "like a wall." The one nonbeliever was a British medical student who took up track while studying at Oxford and developed scientific training regimes to try to achieve the unachievable. On May 6, Roger Bannister ran the mile in 3:59.4. His historic portrait made front pages around the globe, and his feat redefined what was possible. Two months later, in a changed world, Landy, too, broke the unbreakable four-minute mile.

Photograph from AP

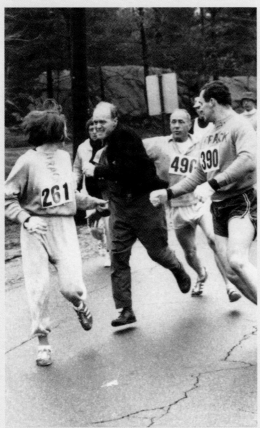

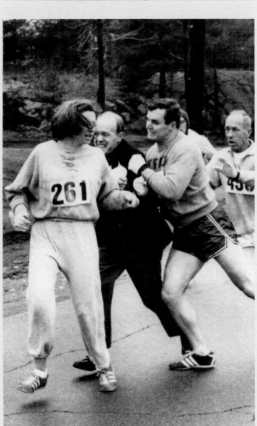

Other Landmark Images

Twenty-year-old Kathy Switzer crashes the men-only 1967 Boston Marathon, and race official Jock Semple tries to run her off the course—then promptly gets bounced for his trouble by Switzer's boyfriend, Tom Miller. The photos ran worldwide, along with the news that Switzer finished the 26.2-mile race. Women kept the heat on in Boston, and five years later they were allowed to compete. In 1984 the women's Olympic marathon debuted in Los Angeles.

The Boston Marathon, 1967
Photographs from AP

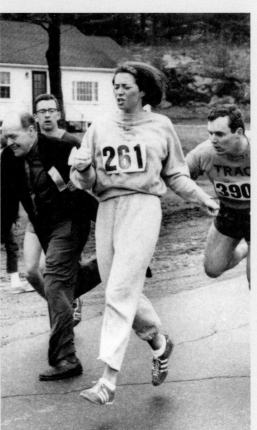

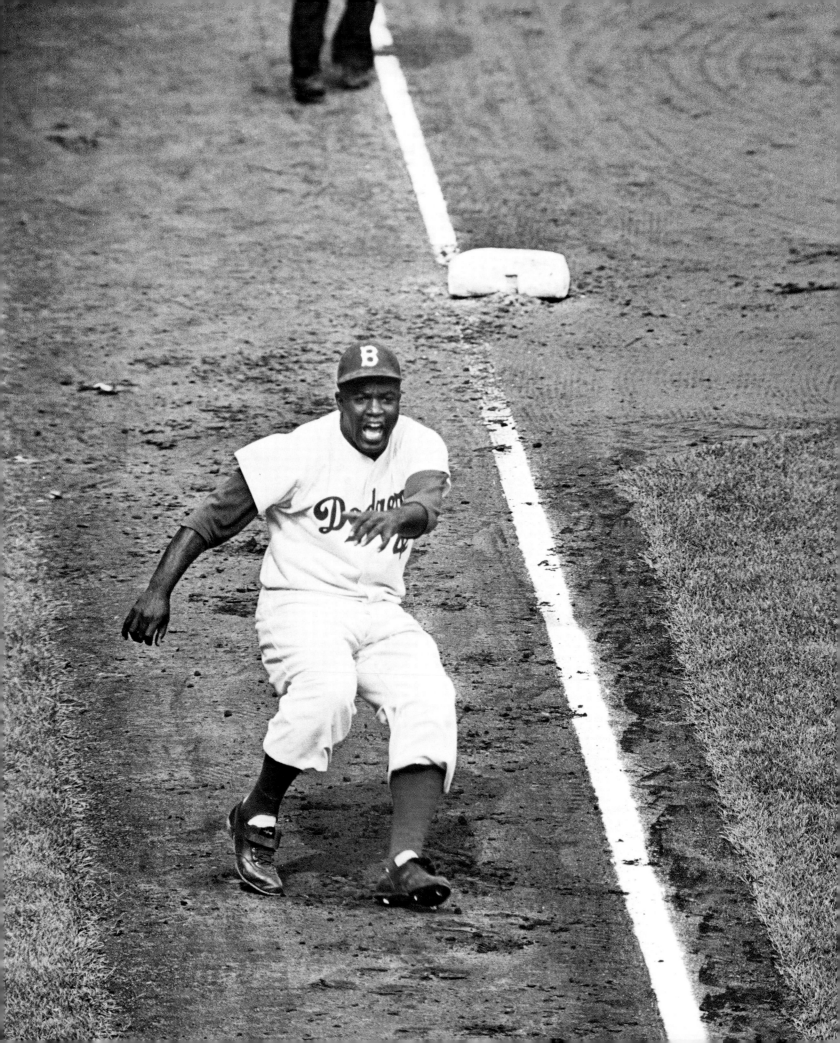

Jackie Robinson 1955

Everything he did in his Brooklyn Dodgers uniform was electrifying, designed to keep the opposition off-balance, ill at ease, on the defensive. It was a mirror image to everything society was laying on him, every pitch, every game, every morning, every night, every day of his life. The first black major leaguer had to turn the other cheek, and it made him tired but tougher; it made him a bigger man, but to a lot of whites and to every black he was already bigger than life, this person who tore himself apart that others might someday find completeness. Here, in the third game of the 1955 World Series, Jackie Robinson terrorizes the Yankees en route to a world championship.

Photograph by **Ralph Morse**

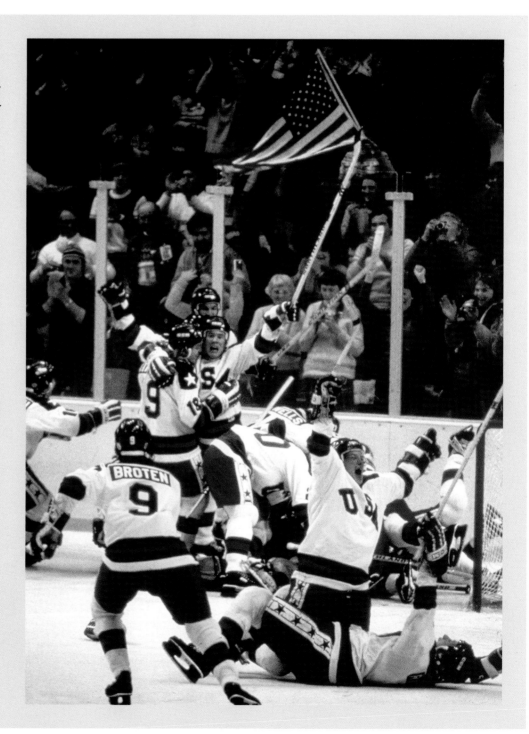

Another Landmark Image

Sports can transcend the arena. Jesse Owens embarrassed Hitler in 1936. In a 1956 Olympic water polo match held only a month after the U.S.S.R. sent 200,000 troops to quash a Hungarian revolt, Hungary beat the Soviet Union every which way; the violent game was halted with Hungary ahead 4–0. And at the 1980 Winter Games, a bunch of scrappy college kids and recent grads from across America pulled together to defeat the mighty Soviet machine 4–3 in a thrilling ice hockey game. There was more than just the usual cold war tension in the air: In late 1979 the U.S.S.R. had invaded Afghanistan, and U.S. President Jimmy Carter was already talking about a boycott of the upcoming Moscow Olympics. Carter made good on his threat in the summer of 1980, and the Soviets returned the favor by forgoing the 1984 Games in Los Angeles.

U.S.A. vs. U.S.S.R., 1980
Photograph by
Heinz Kluetmeier
Sports Illustrated

Massacre at Sharpeville 1960

To control the passage of blacks through white areas, South African law required them to carry a passbook at all times. On March 21, some 20,000 gathered in the township of Sharpeville to protest the rule. Police opened fire, killing 69 and injuring some 180, most of them shot in the back as they tried to flee. Said Police Commander D.H. Pienaar, "If they do these things, they must learn their lessons the hard way." This image of random carnage forced other nations to heed the vile injustices there.

Photograph from Hulton Archive/Getty

Another Landmark Image

The world recoiled in 1976 upon seeing this photo of 13-year-old Hector Peterson, slain by South African police during protests in Soweto.

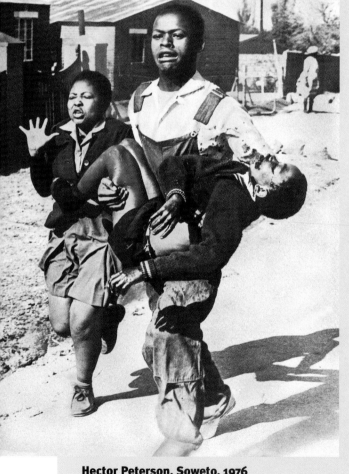

Hector Peterson, Soweto, 1976
Photograph from AP

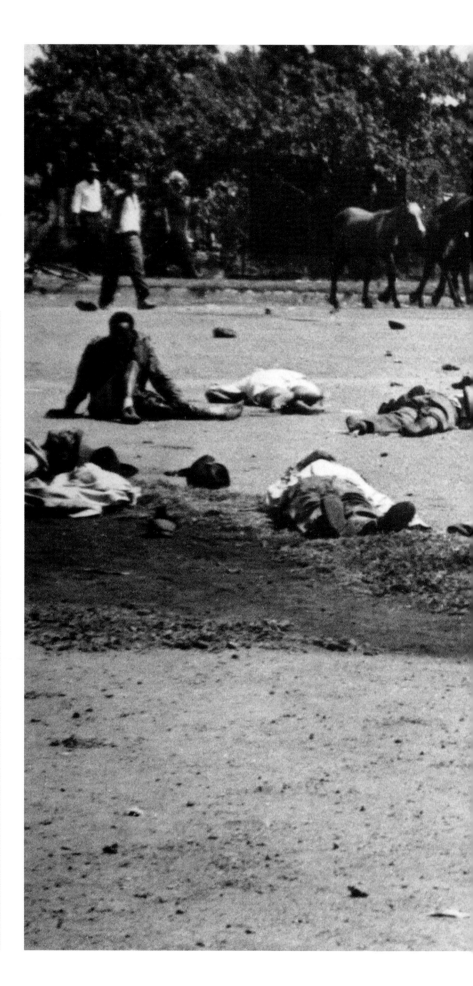

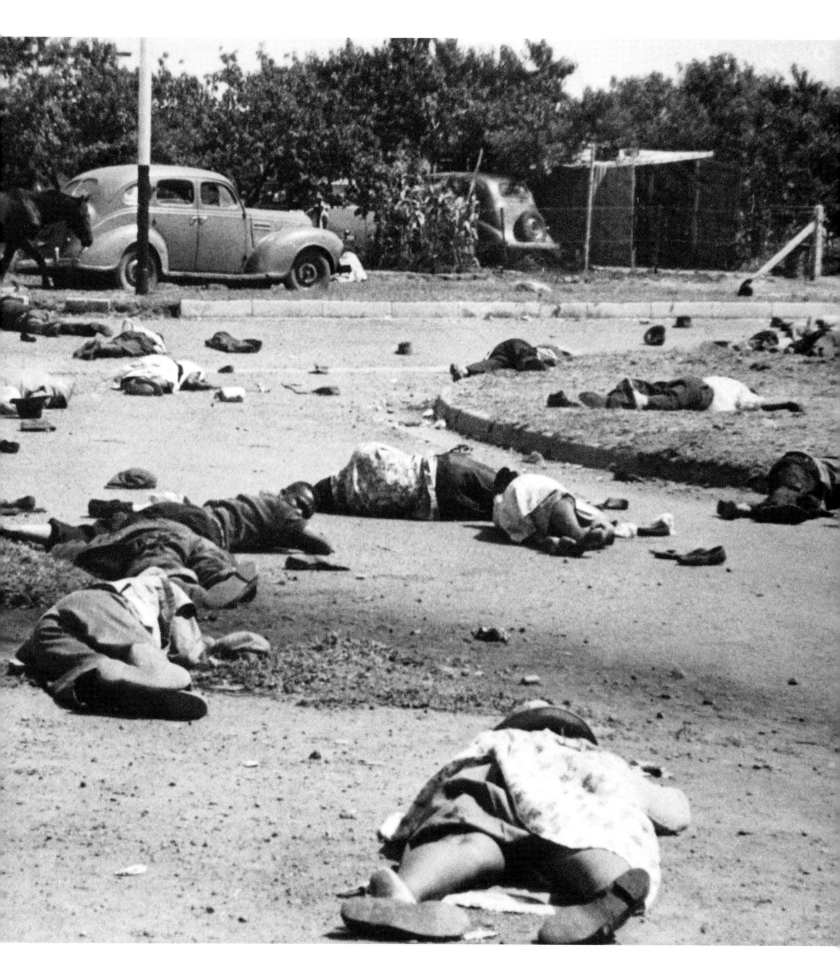

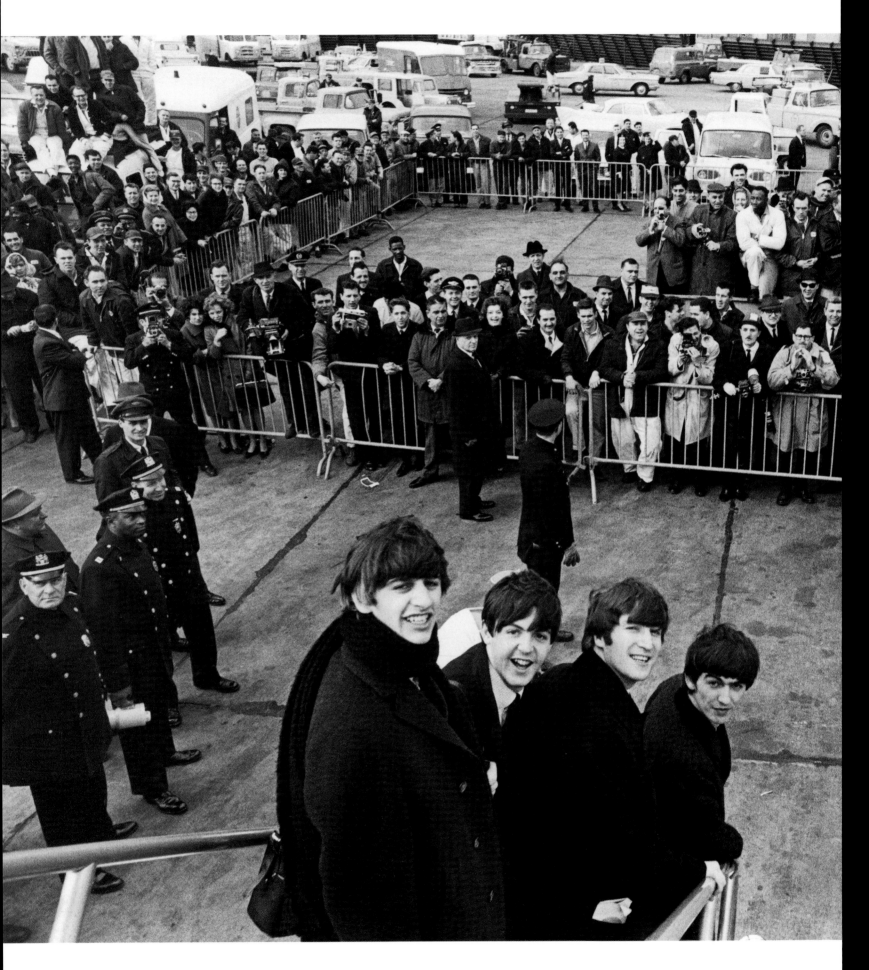

Johnson Is Sworn In 1963

Lyndon Baines Johnson takes the presidential oath of office on November 22 as *Air Force One* carries his wife, Lady Bird, Jacqueline Kennedy and several White House aides back to Washington from Dallas. Earlier, President John F. Kennedy had been assassinated, and the speed with which this ceremony was arranged—and the photo released—was purposeful. Johnson and his advisers wanted to assure a shocked nation that the government was stable, the situation under control. Images from the Zapruder film of the shooting, which would raise so many questions, would not be made public for days.

Photograph by **Cecil W. Stoughton**

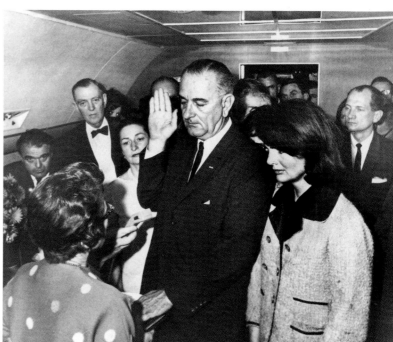

The Beatles Arrive 1964

Two veteran photogs, Bill Eppridge and Eddie Adams, were in the throng at New York's JFK Airport, waiting for the lads to land and comparing notes on where to best position themselves. "Well," one said, "the best spot's in the plane." Finally, the plane alit, the door opened, the Beatles popped out, and there, up above, was young Scotsman Harry Benson, directing the Fabs' historic arrival on American soil. Yes, it was the music, yes, it was the hair, yes, it was Ed Sullivan. But it was also the vibrant photography, particularly Benson's, that helped create the mania, setting off a seismic shift in American culture.

Photograph by **Harry Benson**

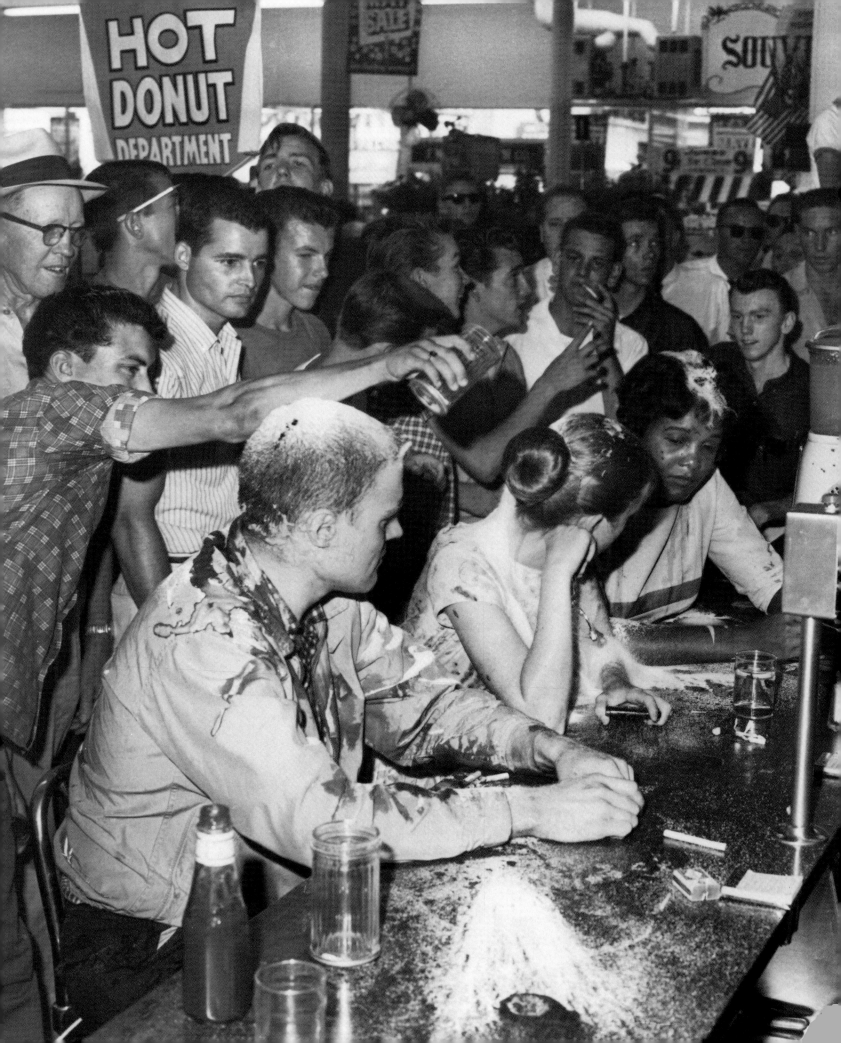

Jackson, Mississippi 1963

Traditions, rules, laws: Like everywhere else, the American South had its own. But in most other places on May 28, 1963, the law did not exclude black people from drinking the same water, using the same seat, sleeping in the same hotel. Nor did it exclude blacks from sitting at a lunch counter, like the one at Woolworth's in downtown Jackson, Miss. The positive message that some people were able to draw from this unspeakable moment is that two white kids had the decency to help a fellow human endure the taunts of a mob.

Photograph by **Fred Blackwell**

Another Landmark Image

It was the fourth school year since segregation had been outlawed by the Supreme Court. Things were not going well, and some southerners accused the national press of distorting matters. This picture, however, gave irrefutable testimony, as Elizabeth Eckford strides through a gantlet of white students, including Hazel Bryant (mouth open the widest), on her way to Little Rock's Central High.

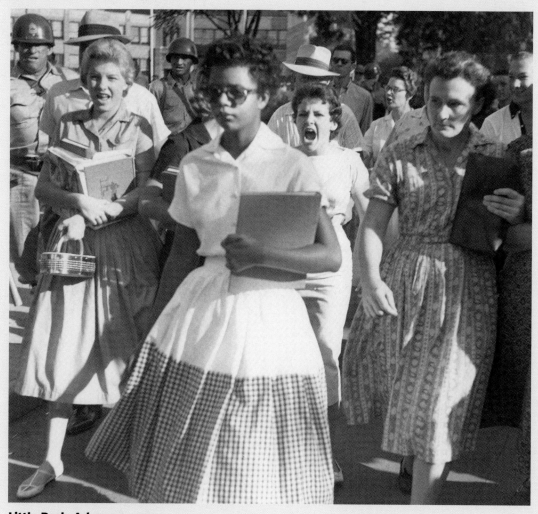

Little Rock, Arkansas, 1957
Photograph from Bettmann/Corbis

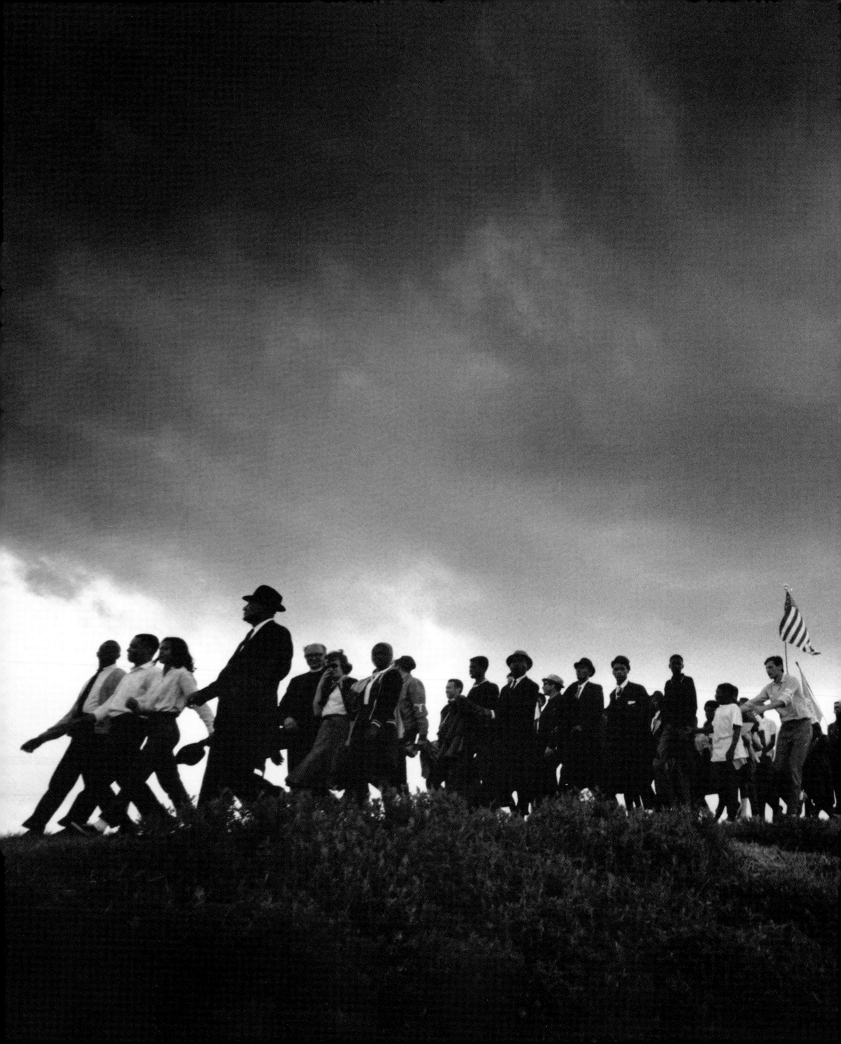

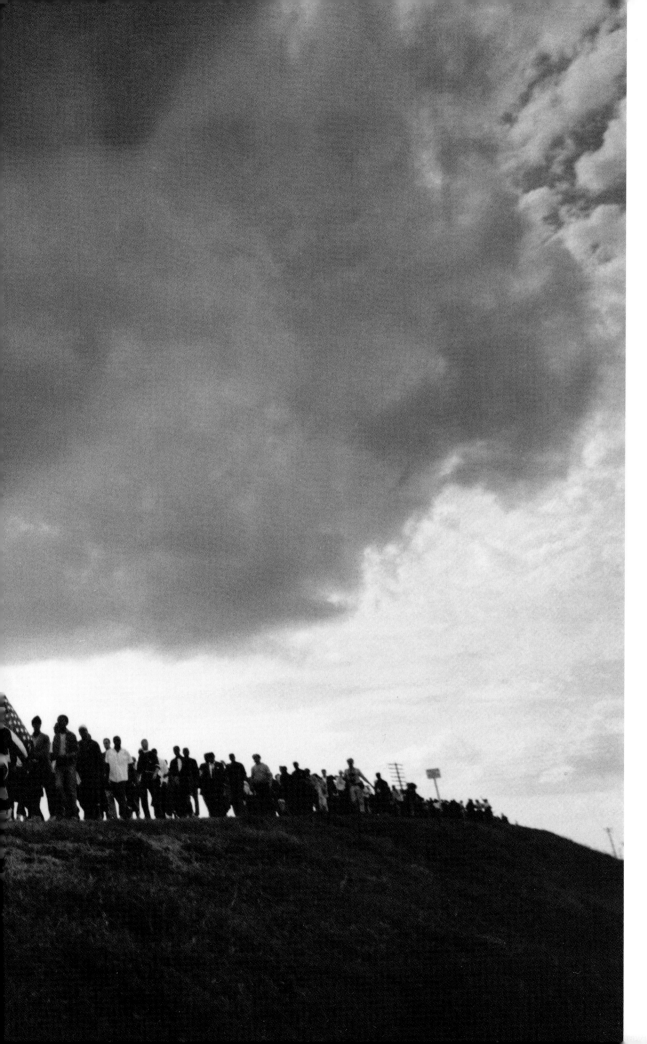

Selma March 1965

Racial strife in the American South grew steadily hotter after school segregation was outlawed in 1954. Blacks fought for their rightful, equal status, with the lunch-counter sit-in, the Montgomery bus boycott, the Freedom Rides. To protest for voting rights throughout the South, Rev. Martin Luther King Jr. organized a nonviolent march in 1965 that was to proceed from Selma, Ala., to the state capital in Montgomery. King himself had to be in Washington, but the marchers gathered in Selma and set off on March 7. Along the way, state troopers used tear gas to drive the demonstrators into a housing project, then beat them savagely. "Bloody Sunday" shocked a nation and led to the Voting Rights Act of 1965.

Photograph by
James H. Karales

Birmingham 1963

For years, Birmingham, Ala., was considered "the South's toughest city," home to a large black population and a dominant class of whites that met in frequent, open hostility. Birmingham in 1963 had become the *cause célèbre* of the black civil rights movement as nonviolent demonstrators led by Rev. Martin Luther King Jr. repeatedly faced jail, dogs and high-velocity hoses in their tireless quest to topple segregation. This picture of people being pummeled by a liquid battering ram rallied support for the plight of the blacks.

Photograph by **Charles Moore** Black Star

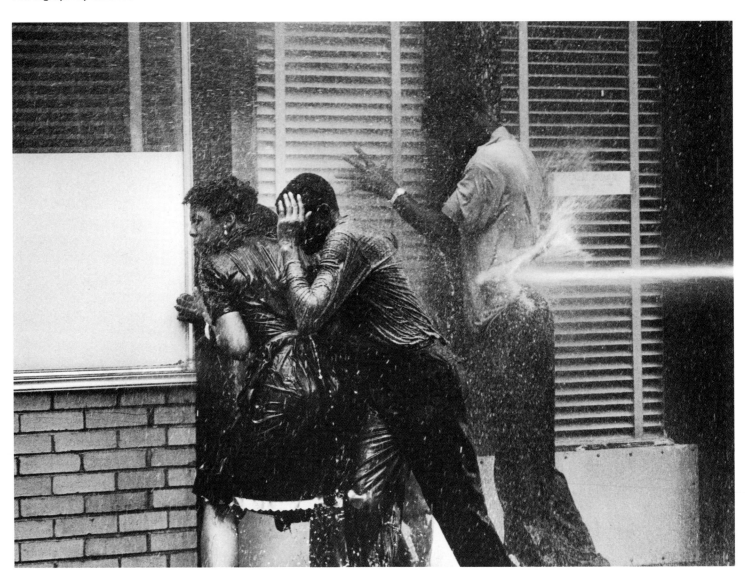

Chicago Democratic Convention 1968

"The whole world is watching!" was the chant that filled the streets that August, as—not to put too fine a point on it—Mayor Richard J. Daley's police batoned the daylights out of peaceniks trying to wrest control of the streets of his city. It was not, however, only leftist intellectuals and conscientious objectors who wanted their message heard; there were many drawn to the streets by the prospect of inciting further an already inflamed police force. Americans were stunned that all this was happening in their country.

Photograph by **Perry C. Riddle** Chicago Daily News

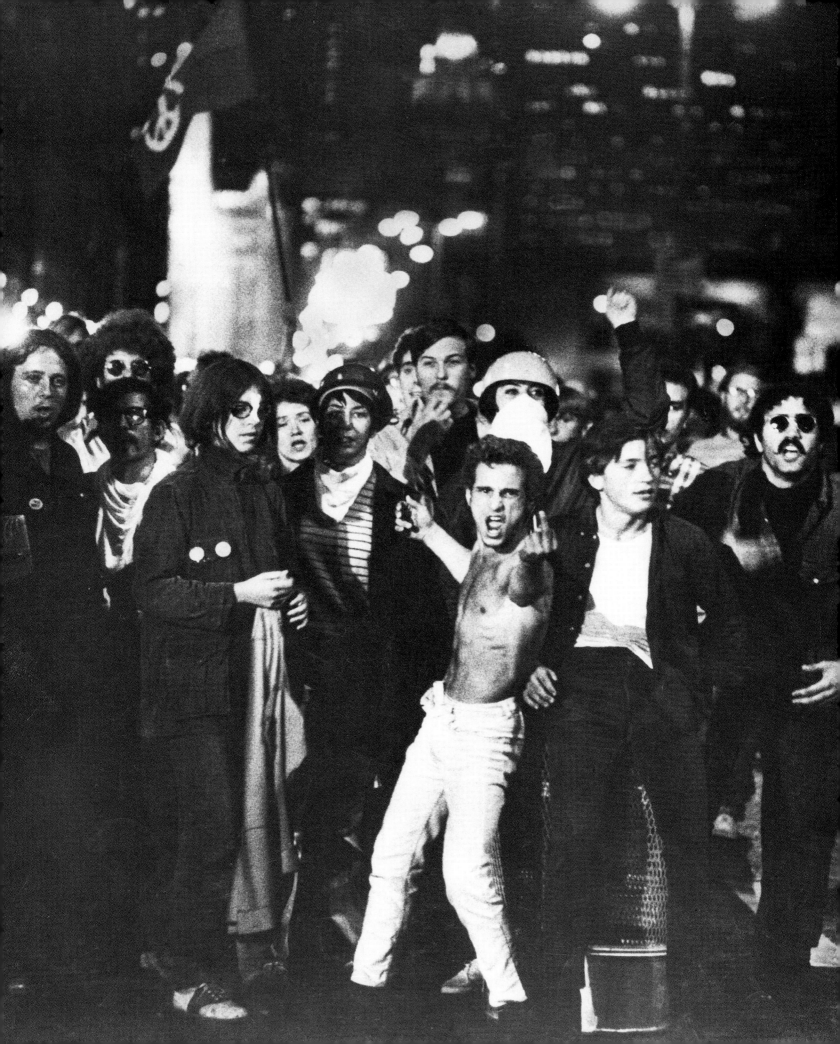

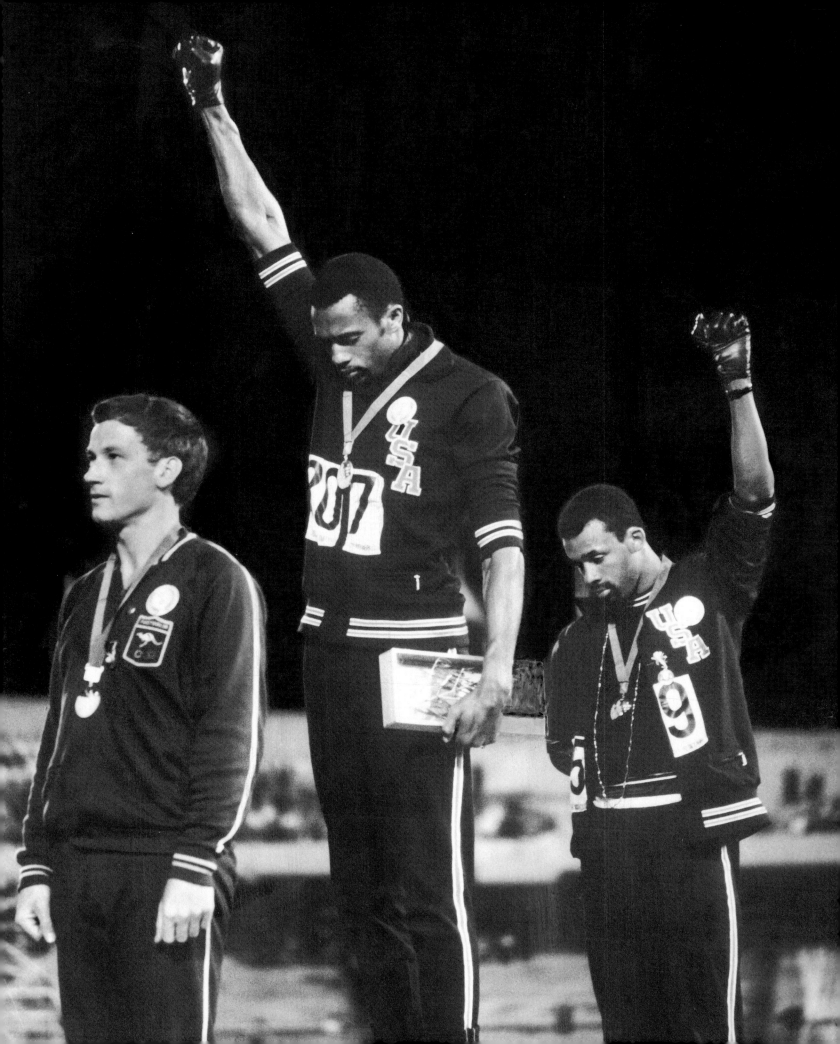

Mexico City Olympics 1968

Sociologist Harry Edwards had been urging black athletes to boycott the Olympics to protest civil rights inequities in the U.S. The boycott didn't happen, but Edwards struck a chord with many, including San Jose State teammates Tommie Smith and John Carlos. After finishing first and third in the 200-meter sprint, they mounted the podium shoeless, wearing buttons supporting Edwards's Olympic Project for Human Rights. As the national anthem played, they held up their gloved fists. The runners were booted from the Games, but their gesture resonated. Note: Runner-up Peter Norman of Australia wore an OPHR button too.

Photograph by **John Dominis**

Another Landmark Image

Adolf Hitler fervently hoped the Berlin Olympics of 1936 would be a showcase of "Aryan supremacy." But American blacks, led by Jesse Owens, who won four gold medals, became the story of the Games. After the first day, during which the talent of the American team was evident, Hitler decided not to shake hands with medal winners. Minister of Propaganda Joseph Goebbels, while publicly insisting that German newspapers treat all visiting athletes courteously, wrote in his private diary after Day Two, "We Germans won a gold medal, the Americans three, of which two were Negroes. That is a disgrace." Right: Owens salutes his flag after winning the long jump, while second-place Luz Long salutes the Reich, as all German athletes were instructed to do.

Berlin Olympics, 1936
Photograph from AP

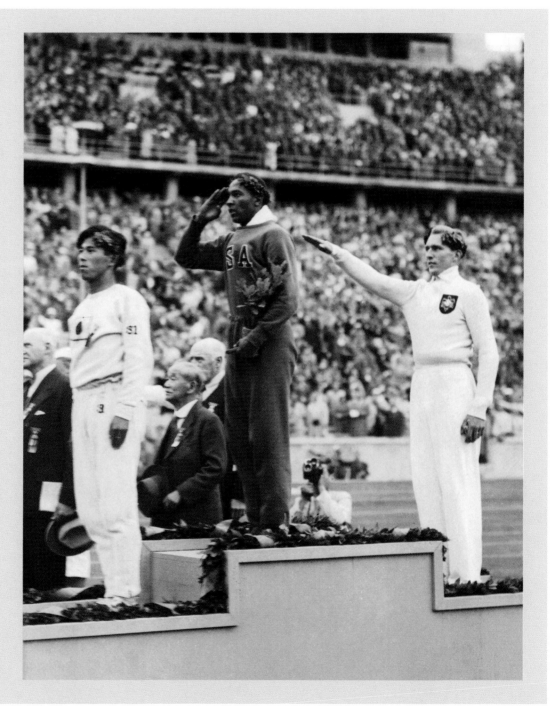

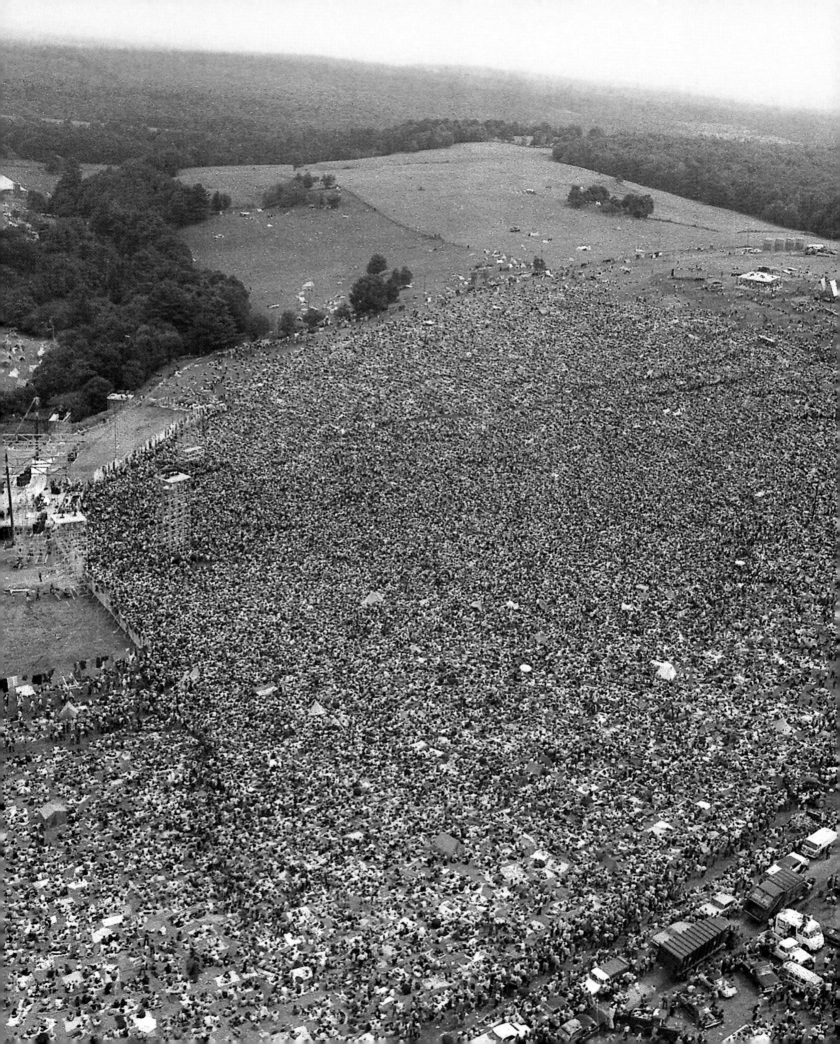

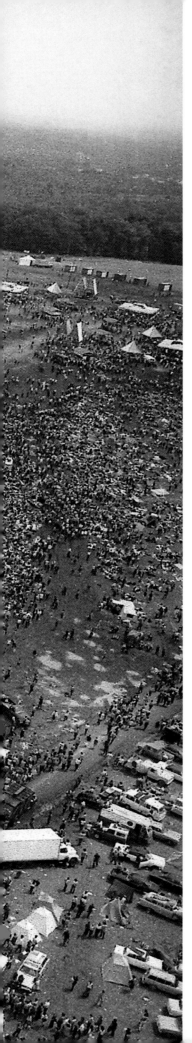

Woodstock 1969

They went to a psychedelic pasture (really in Bethel, N.Y., not Woodstock) to listen to their music, to be with people who dressed like them and talked like them and played like them. There was a shared bond on a cosmic scale, and their elders marveled that all these kids could be in one place for three days without violence or mayhem, despite pitifully inadequate facilities and food supplies, and despite rains that fell so long and hard they would have drowned any other party. The lesson was simple: These long-haired, antiwar bra-burners and boys with beads had created a field of dreams, and perhaps from it would rise something bright and beautiful for the future.

Photograph from AP

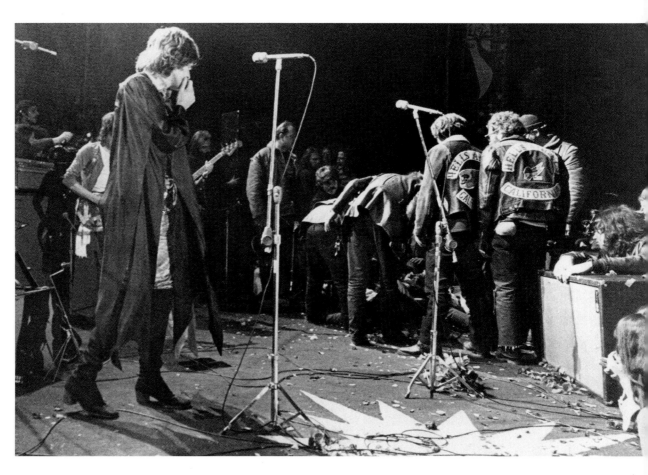

Altamont 1969

The crescendo of hope that came with Woodstock had its coda a mere four months later when violence and mayhem defined the Altamont Rock Festival in Livermore, Calif. The Rolling Stones, who had hired some Hell's Angels to police the concert, were in the middle of an incendiary set when the bikers began to feverishly assault a black man (who had a weapon). Mick Jagger pleaded with the Angels to stop, but they killed the man. It was a scary event, as the Stones' fierce, exotic sound conspired nightmarishly with obscene hatred, drowning out the blissful, harmonious chords of Woodstock.

Photograph from AP

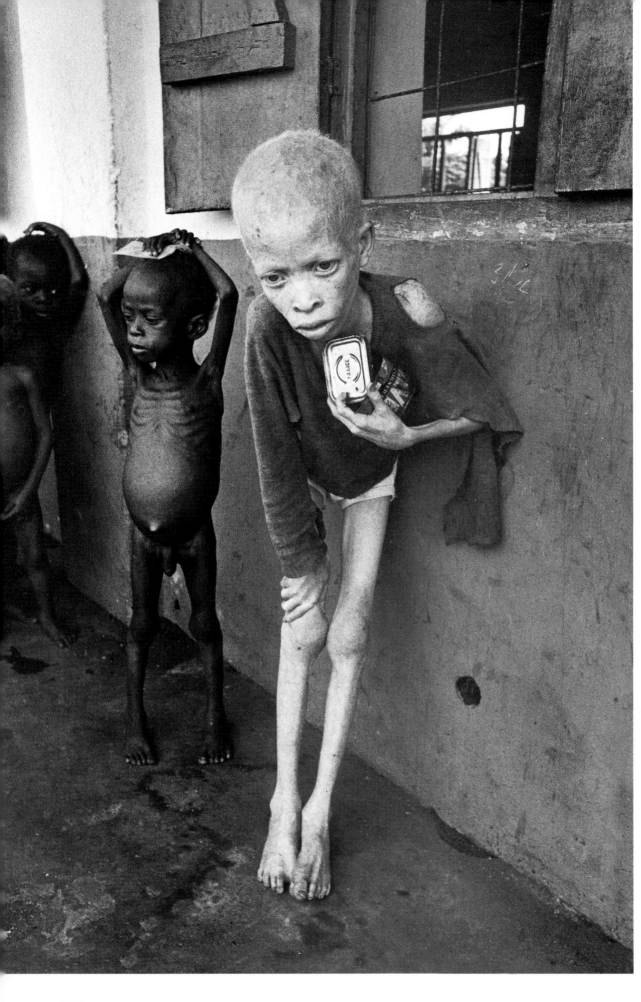

Biafra
1969

When the Igbos of eastern Nigeria declared themselves independent in 1967, Nigeria blockaded their fledgling country— Biafra. In three years of war, more than one million people died, mainly of hunger. In famine, children who lack protein often get the disease kwashiorkor, which causes their muscles to waste away and their bellies to protrude. War photographer Don McCullin drew attention to the tragedy. "I was devastated by the sight of 900 children living in one camp in utter squalor at the point of death," he said. "I lost all interest in photographing soldiers in action." The world community intervened to help Biafra, and learned key lessons about dealing with massive hunger exacerbated by war— a problem that still defies simple solutions.

Photograph by
Don McCullin
Contact Press

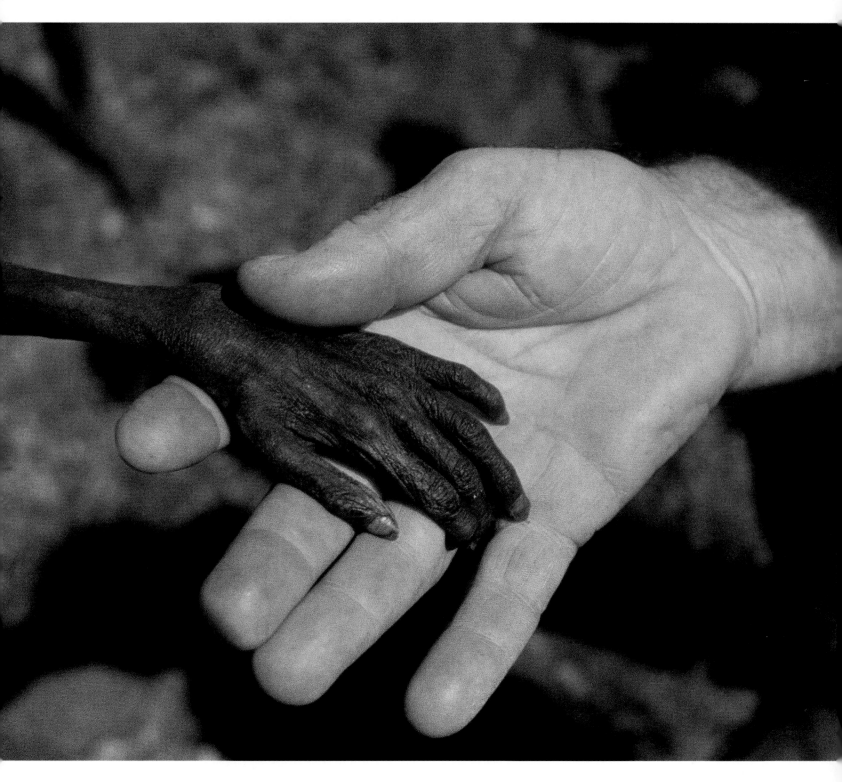

Uganda 1980

Nearly the entire Horn of Africa was parched by drought in 1980. Ethiopia, Djibouti, Eritrea, Somalia, Sudan and Uganda were all in trouble. In Uganda alone, half a million people were affected, including most newborns and many young children. Those who managed to survive barely looked human, with withered, discolored skin. They faced a life of developmental problems. Pictures like this one, of a priest holding the hand of a starving child, moved the United Nations and private groups to send food to the suffering Africans.

Photograph by **Mike Wells** Aspect Picture Library

Minamata
1971

In the 1950s and '60s, Japanese living in the coastal fishing village of Minamata complained of *itaiitabyo* ("ouch ouch disease"), which is marked by tremors and bad sight and hearing. Later the cause emerged: Chisso, a chemical company, was dumping mercury in the water. Fish and shrimp formed a large part of the local diet, and many villagers were suffering or dying. Tomoko Uemura, seen here in 1971 being bathed by her mother, was poisoned in the womb and born blind, mute and with mangled limbs. W. Eugene Smith's famous *Tomoko Uemura in Her Bath* gave a face to the effects of industrial mercury poisoning and led to the company's allocating funds for the victims.

Photograph by
W. Eugene Smith
Black Star

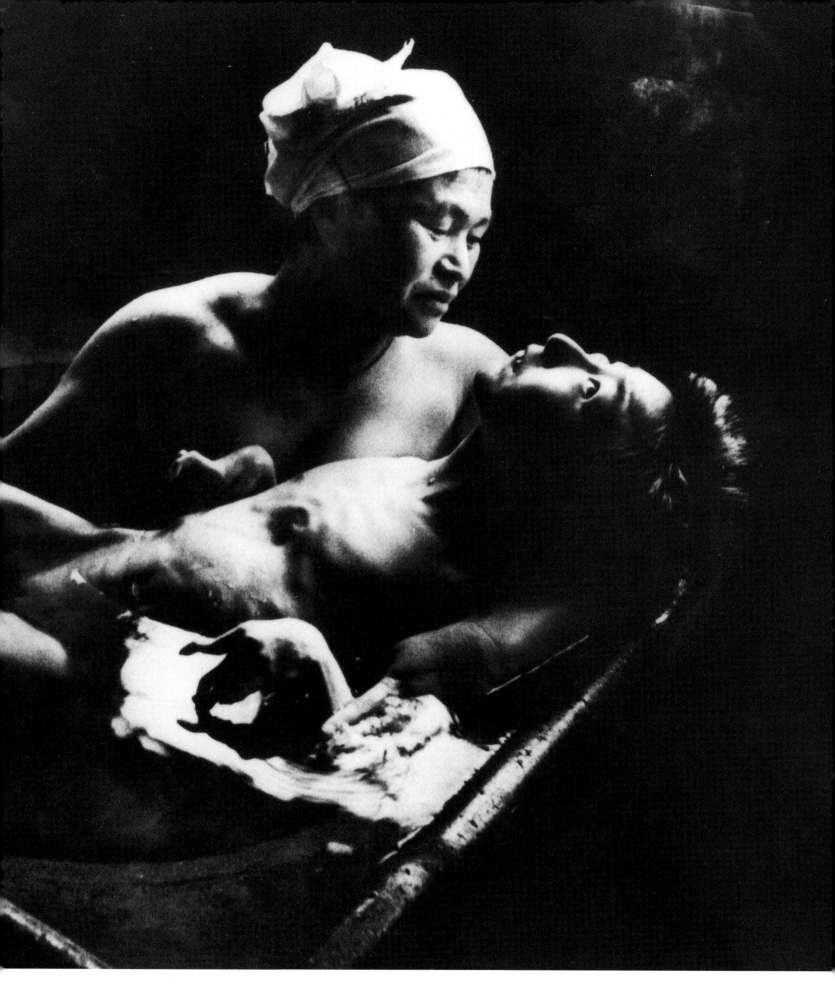

Munich Olympic Village 1972

Terrorism is always disturbing, but when it plays out in an arena whose purpose is to augment global peace, it seems yet more ghastly. The athletes from 121 nations had assembled in Munich for the 1972 Olympics when, on September 5 at 4:30 a.m., five men dressed in tracksuits toting weapons in their gym bags scaled the fence of the Olympic Village and joined up with three others already inside. They rapped on the door of the Israeli wrestling coach, shot him and a weightlifter dead, then took nine Israelis hostage. The abductors, who claimed to be from a Palestinian guerrilla group called Black September, demanded that Israel release 200 Arab prisoners. By three o'clock the next morning, after hours of tenterhook negotiations, a botched rescue attempt left the nine Israelis dead, along with five terrorists and a policeman. Three terrorists were captured. This portrait of a goon haunts anyone who remembers the scene, and, for those who were born later, displays all too well the dark hand of terrorism.

Photograph by **Kurt Strumpf** AP

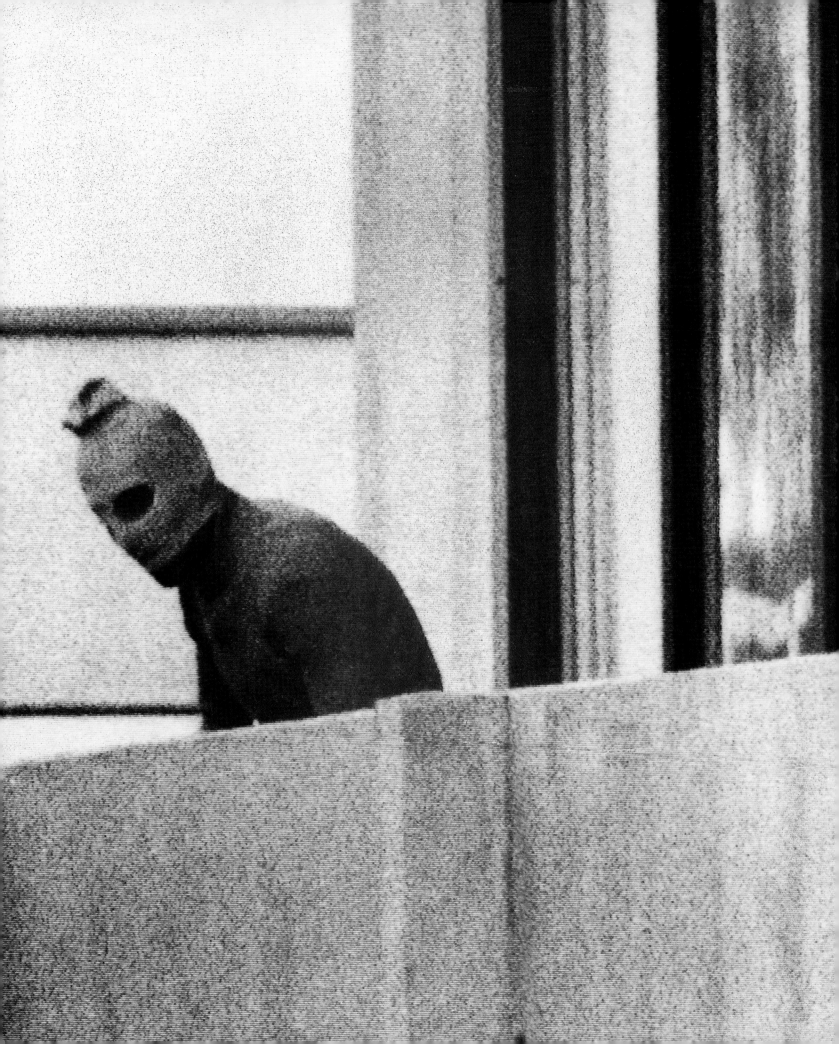

Canadian Seal Hunt 1969

The annual spring seal-hunting season in far northern Canada was shown to the wider world beginning in the mid-'60s. Images such as this one from Northumberland Strait, which shows a mother seal in the background watching her offspring being killed, ran everywhere and caused a collective outrage. Many consumers stopped buying fur, and some countries banned seal-fur imports from Canada. An unintended consequence: Certain indigenous peoples, hurt by the falloff in a longtime livelihood, sold oil-drilling rights to petroleum companies in order to survive, leading to wanton environmental degradation in Canada.

Photograph by **Duncan Cameron** Capital Press

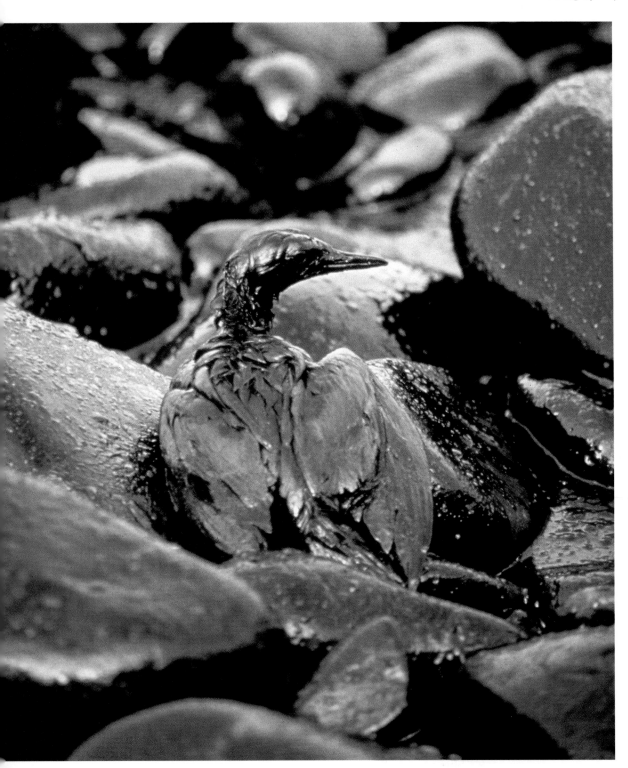

Exxon Valdez Oil Spill 1989

On March 24, the *Exxon Valdez* ran aground in Alaska's Prince William Sound, and 10.8 million gallons of crude flowed into the bay, causing the worst maritime environmental disaster in U.S. history. A quarter million seabirds, 2,800 sea otters, 300 harbor seals, 250 bald eagles and more than 20 killer whales died, and 1,300 miles of shoreline was fouled. The public outcry led to a U.S. law demanding double-hull construction in future tankers, and a jury ordered Exxon to pay billions, a verdict the company is still fighting. Meanwhile, in Alaska, more oil washes up every year.

Photograph by
John S. Lough
Department of
Environmental Conservation

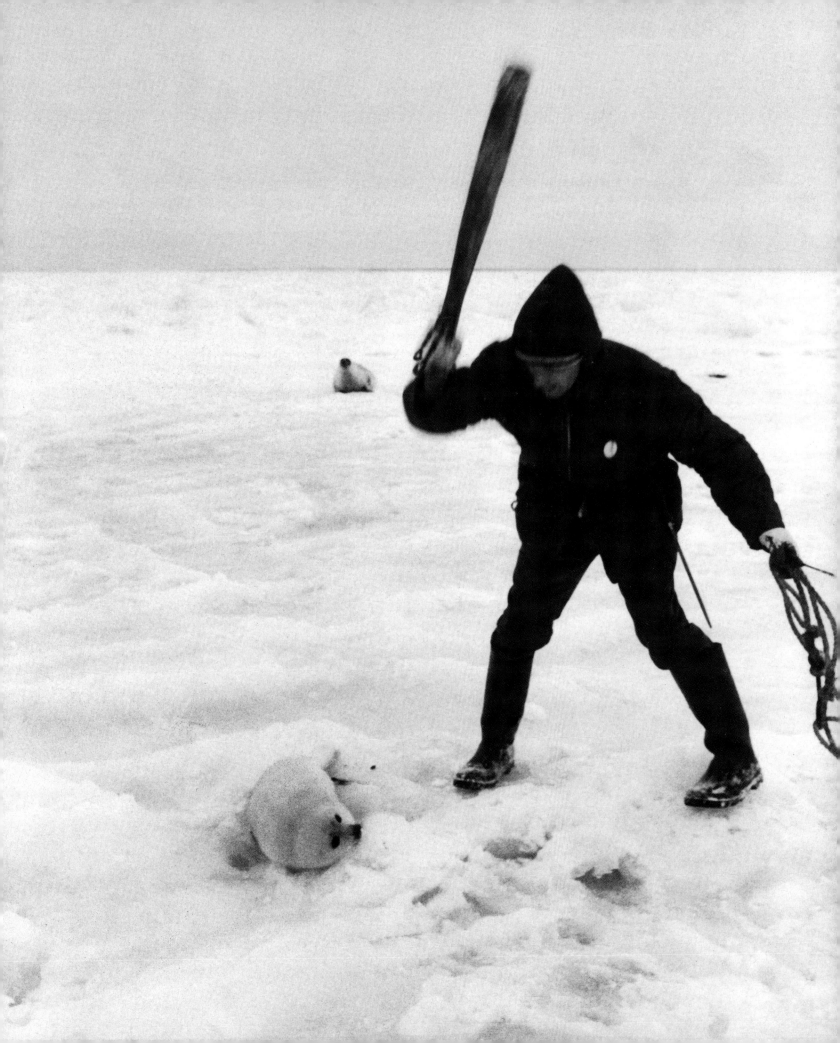

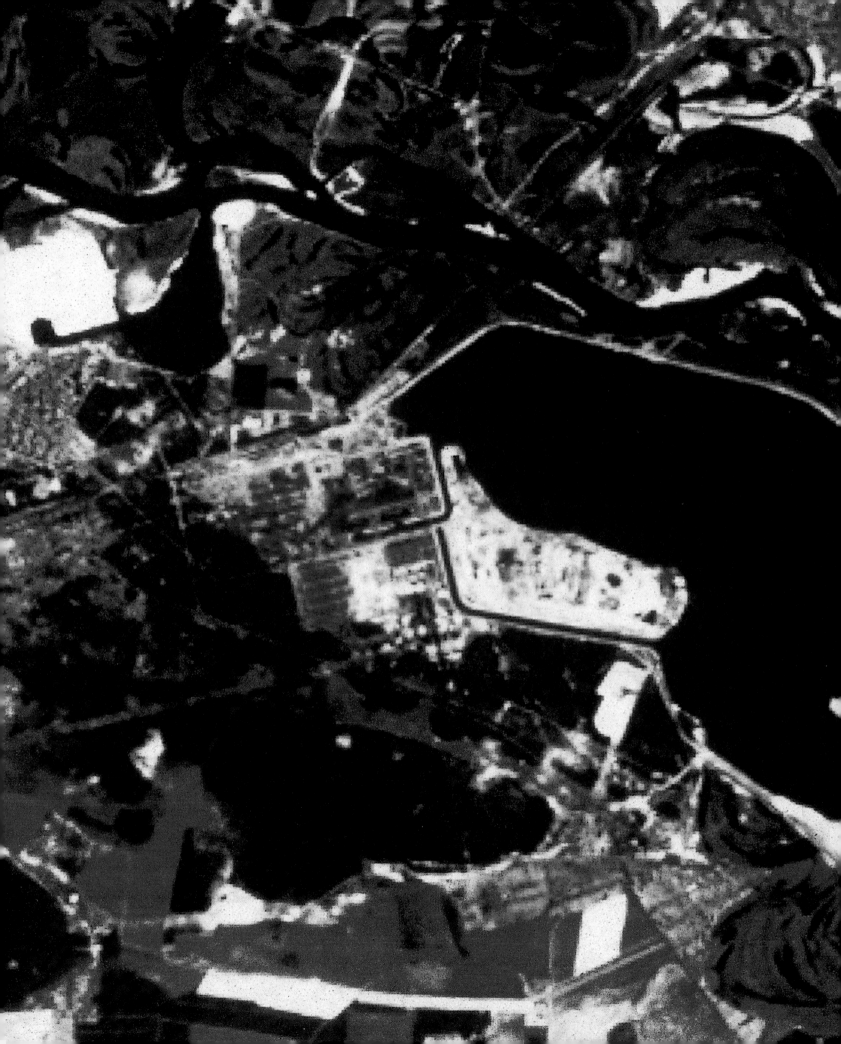

Chernobyl 1986

The Soviet Union first denied anything was wrong when Nordic countries confronted them with evidence that a radioactive cloud from there was wafting over Europe. The Soviets then admitted to a small accident at the Chernobyl nuclear plant in northern Ukraine. They said it was under control and that only two people had died. In the surrounding region, people were given little information, but American scientists, armed with satellite photos, reported that a fire was raging free. As a precaution, one European nation banned the sale of new milk, another country ordered pregnant women and young kids indoors, and handed out iodine solutions 24 hours a day. "The Soviets owe the world an explanation," President Ronald Reagan said of history's largest nuclear accident. At least 30 people died in the blast, and another 4,000 in the aftermath. The ultimate death toll remains uncertain, but is growing. Millions will be affected for decades.

Photograph from NASA

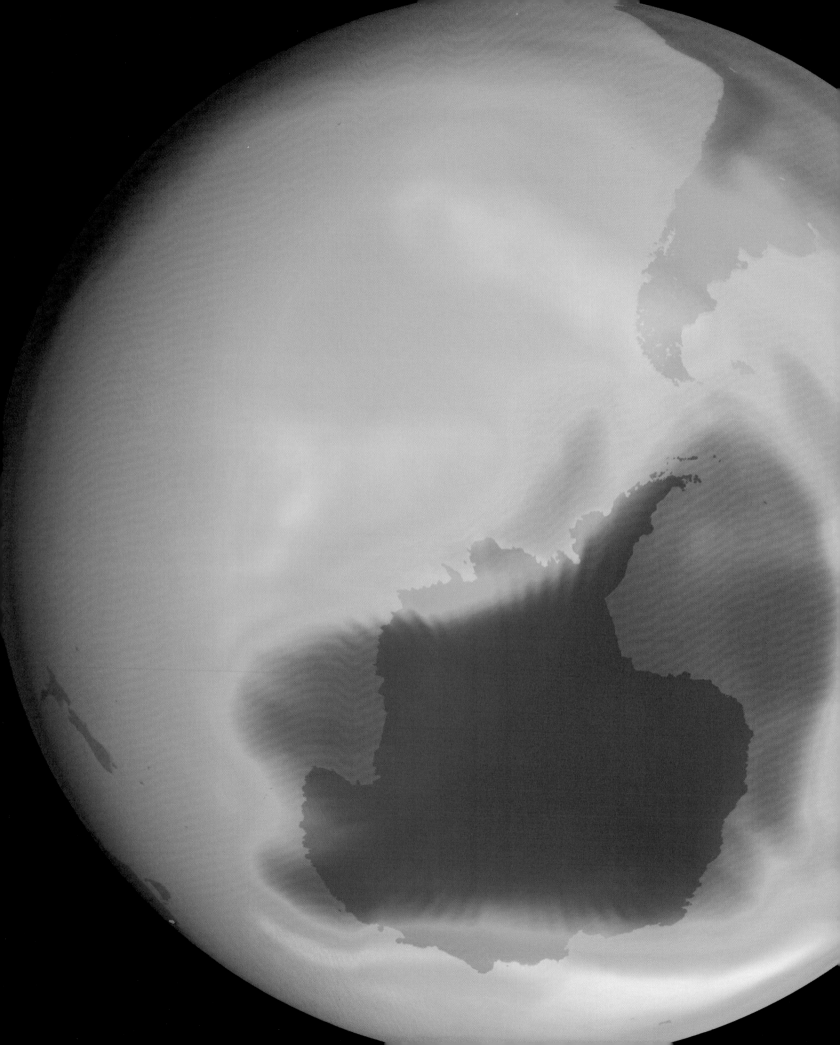

The Ozone Hole 1985

The ozone layer of Earth's atmosphere provides a sheltering veil from ultraviolet light, which causes cancer and damages essential phytoplankton. Decades ago scientists began to notice changes in the layer, then were shocked in 1985 when Joe Farman of the British Antarctic Survey found a thinning in the layer over the polar continent. The so-called ozone hole was a local springtime depletion exacerbated by such chemicals as chloroflourocarbons. Two years after Farman's find, most nations signed a pact to phase out CFCs, which may linger for a century. By 2000, the "hole" had grown to three times the size of the United States, but is now shrinking as CFC levels decline.

Photograph by **NASA GSFC** Total Ozone Mapping Spectrometer

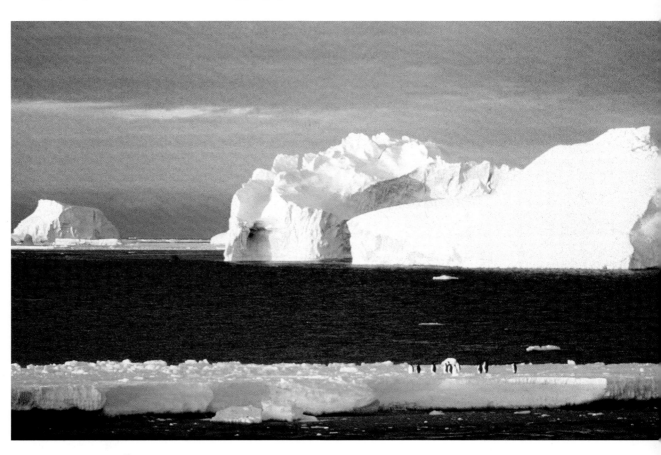

Giant Iceberg 1995

When this photo appeared in *Time* and other influential publications, some advocates of the greenhouse theory, e.g., that industrial-waste gases are raising global temperatures, seized the moment as gargantuan evidence that the future contains the specter of serious catastrophic results, such as coastal flooding, drought and species extinction. However, scientists are far from certain that this iceberg the size of Connecticut, broken free from the Antarctic peninsula, validates any notion of global warming. Nevertheless, for those sure that global warming is nigh, the photo gave the means to an end, drawing the attention of the general public to the issue.

Photograph by **Dr. Hans Oerter** British Antarctic Survey

Milk Carton 1984

Johnny Gosch was a 12-year-old from West Des Moines who vanished while delivering papers in 1982. Juanita Estevez, 15, of Yuba City, Calif., disappeared on her way to school in 1984. These were the first two kids to be pictured on a milk carton. Child abduction was becoming a growing nightmare, and families and authorities were eager to try any method. Since then, postcards with photos of missing children have been widely distributed by mail, and have proved fruitful: One in six of the kids in these and other photo efforts are recovered. As for Juanita and Johnny: She escaped from her abductors in 1986; he is still missing.

Photograph by **Robert Frieder**

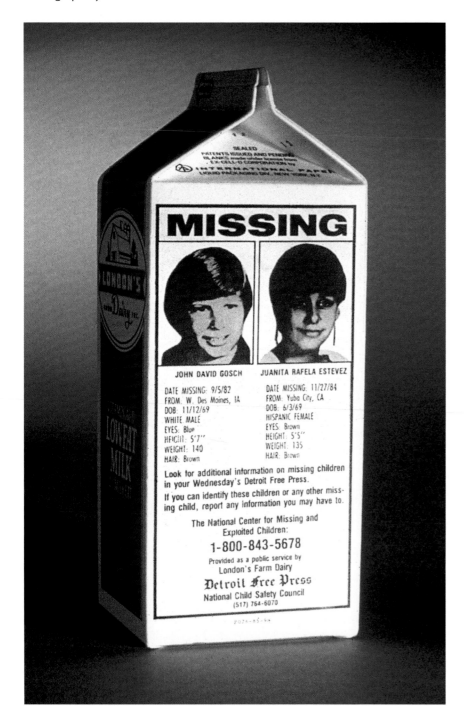

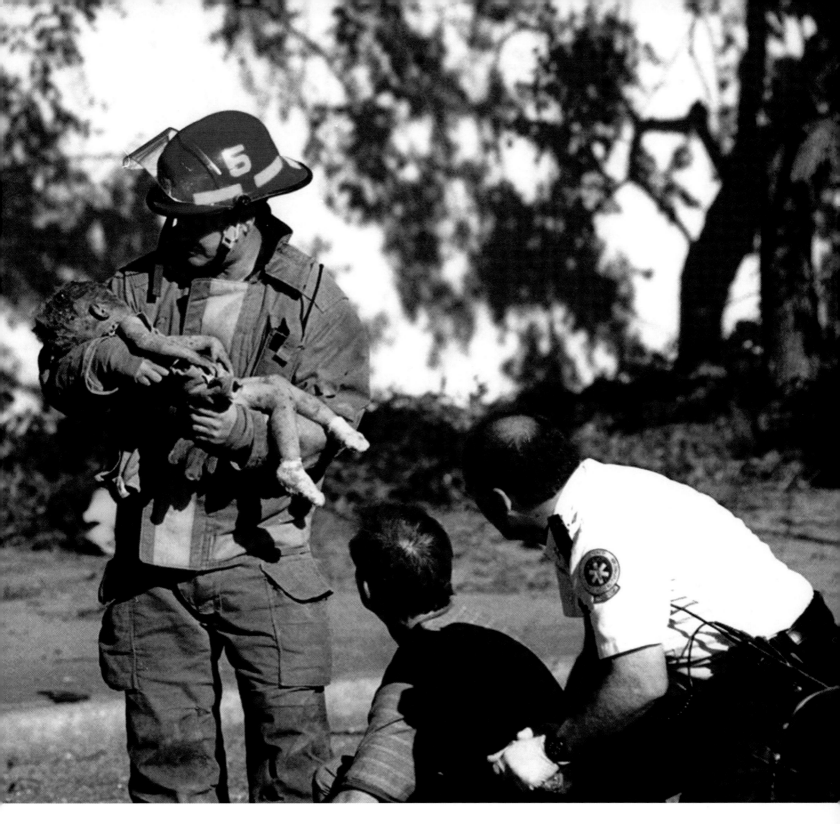

Oklahoma City 1995

One of the blackest moments in American history came when a terrorist bomb destroyed the federal building in Oklahoma City at 9:02 a.m. on April 19, 1995. Of the 168 people killed, 19 were children. That the innocent were slain by their countryman made it all the more unbearable. In this Pulitzer Prize–winning photo, firefighter Chris Fields holds one little victim, Baylee Almon, who the day before had celebrated her first birthday. The man who took the picture was a utility worker. Because he was on company time, and using a company camera, ownership was initially disputed.

Photograph by **Charles Porter** Corbis Sygma

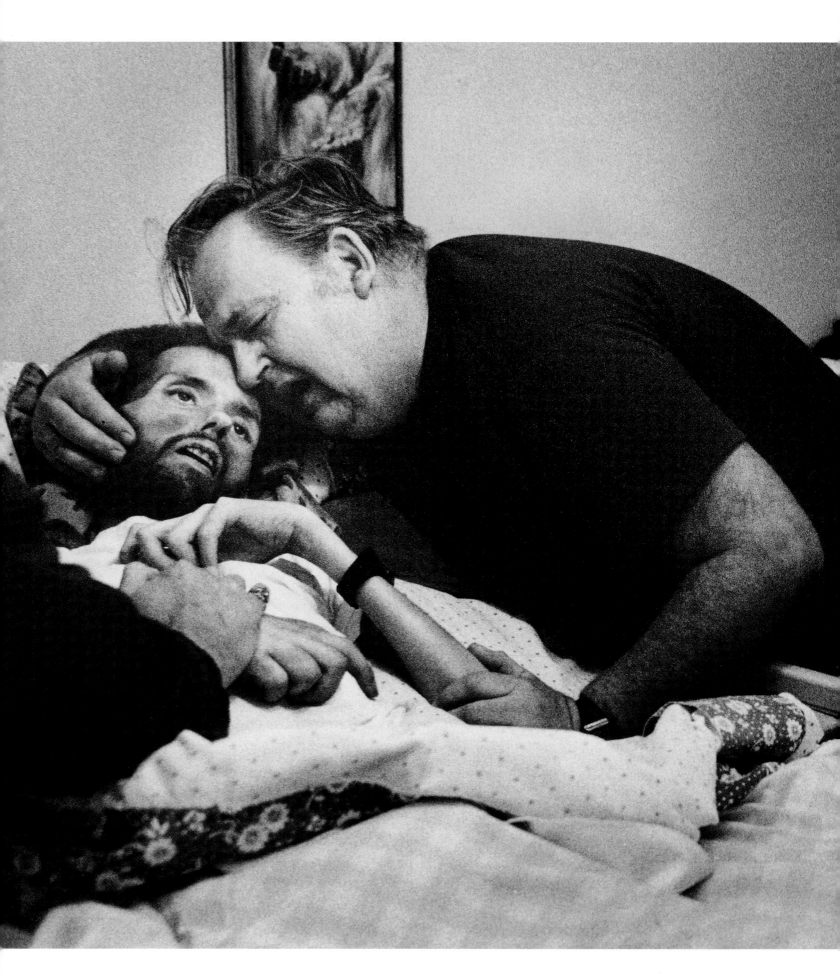

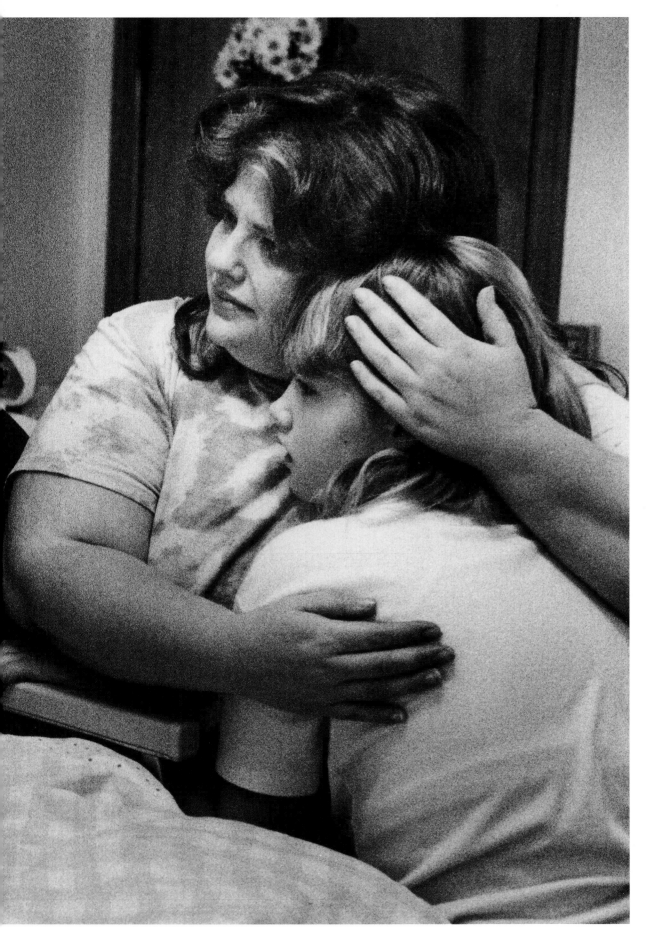

David Kirby
1990

When LIFE ran this photo of AIDS activist Kirby, visited at his deathbed by family members, the magazine was credited with destigmatizing a plague. Kirby's father, William, was impressed by the reaction to the picture—"Nobody had ever seen, publicly, how bad it was toward the end"—and the family subsequently allowed the Italian clothing company Benetton to use the image in an ad. Designer Tibor Kalman colorized Frare's photograph, and the company said the intent of its stylized presentation was to force the world to think about the epidemic. But whereas LIFE had been applauded for humanizing AIDS, Benetton was criticized in many corners for exploiting misery for commercial gain.

Photograph by
Therese Frare

Breast Cancer 1993

The artist Matuschka was diagnosed with breast cancer in 1991. Only after surgery did she learn her mastectomy was unnecessary. "So I lost a breast, and the world gained an activist," she said. This jarring self-portrait appeared on a 1993 *New York Times Magazine* cover along with the words, "You Can't Look Away Anymore." A gauntlet had been cast, and the action created precisely the desired effect. Said one advocate for the cause: "Her cover did more for Breast Cancer than anyone else in the last 25 years."

Photograph by **Matuschka**

Another Landmark Image

This is C.H. Long, a 39-year-old foreman at the JA ranch in the Texas panhandle, a place described as "320,000 acres of nothing much." Once a week, Long would ride into town for a store-bought shave and a milk shake. Maybe he'd take in a movie if a western was playing. He said things like, "If it weren't for a good horse, a woman would be the sweetest thing in the world." He rolled his own smokes. When the cowboy's face and story appeared in LIFE in 1949, advertising exec Leo Burnett had an inspiration. The company Philip Morris, which had introduced Marlboro as a woman's cigarette in 1924, was seeking a new image for the brand, and the Marlboro Man based on Long boosted Marlboro to the top of the worldwide cigarette market.

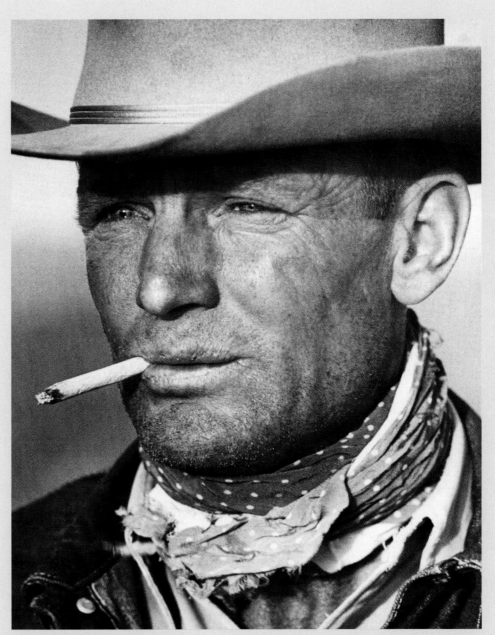

Clarence Hailey Long, 1949
Photograph by **Leonard McCombe**

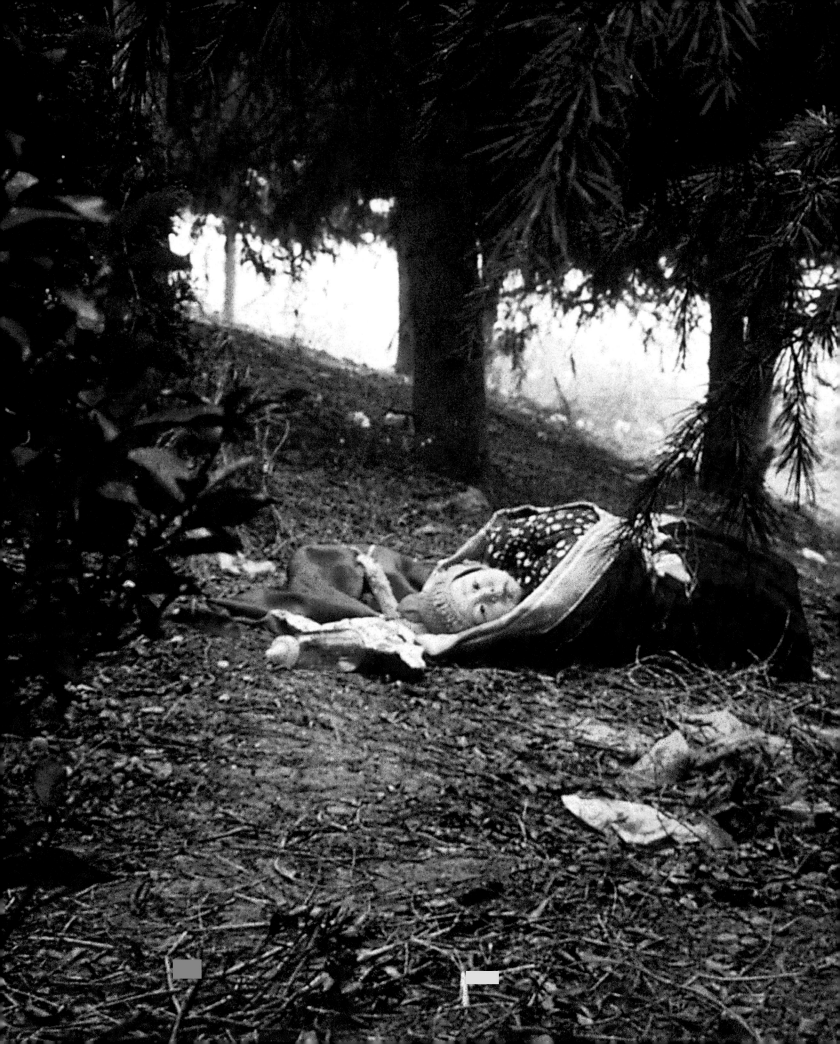

Chinese Baby
1997

A group of Americans came upon this abandoned boy on a path in Fuyang and took him to a local hospital, where they were told by a staffer, "You should have left it where it was." A day later, another baby was found in the same spot, and the day after that, the first child, suffering from pneumonia and a deformed heart, died anonymously. This picture and the accompanying story caused an uproar, as human rights activists placed the blame for a plague of abandonment and infanticide squarely on the government's One Couple, One Child policy. Baby girls were at greater risk than boys, who might one day be of more use in the fields: Some estimates held that more than 1.5 million girls, out of the 13 million children born in China each year, were being abandoned. Though the government countered that parents with "feudal ideas" were causing the problem, it eventually relaxed the One Child policy—a little.

Photograph by **Jeff Abelin**

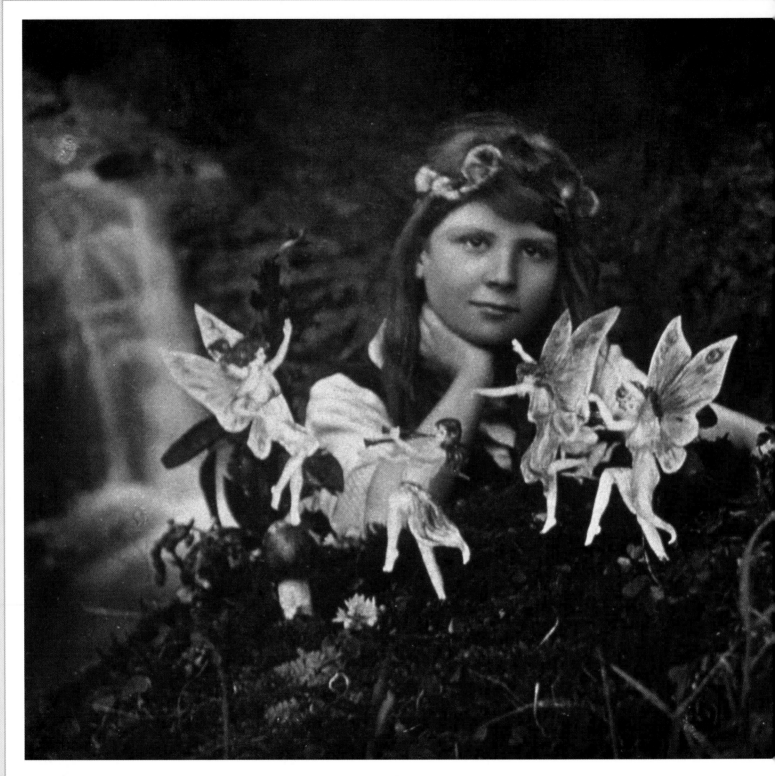

Elsie Wright

Frances Griffiths with Fairies c. 1916

Two young girls in the village of Cottingly borrowed a camera and took a few photos that tapped directly into English society's borderline-perverse fascination with fairies. Sir Arthur Conan Doyle certified the pictures' authenticity: "Matter as we have known it is not really the limit of our universe." In 1983 the naughty Elsie finally fessed up: The fairies were cutouts.

Trick Photography

If these were real photographs of real things, they would certainly have changed the world. As it is, they are either exposed or yet-to-be-exposed pictures of the supernatural. They are hoaxes and jokes, and they have been part of the easily manipulated medium of photography since the beginning. Some of these images have attracted legions of believers, and in this they have changed the world, making it a far more spiritual place.

BBC Publications

Photographer Unknown
Young Girl with Ghost c.1860

Ghosts have a long tradition of popping into pictures, and spooky photos were all the rage during the late-1800s age of spiritualism.

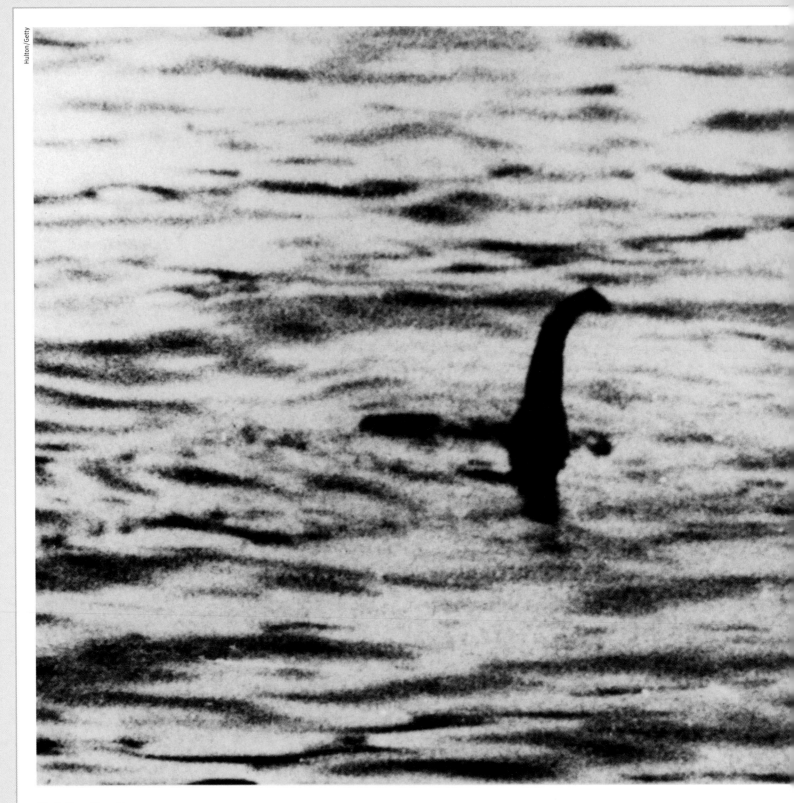

Christian Spurling

The Loch Ness Monster **1934**

The *London Daily Mail* hired big-game hunter M.A. Wetherell to shoot the storied Nessie—on film.
All he found in Scotland were some prankster's fake footprints, but he subsequently conspired with
modelmaker Spurling to customize a monster out of a toy sub, then floated this famous image.

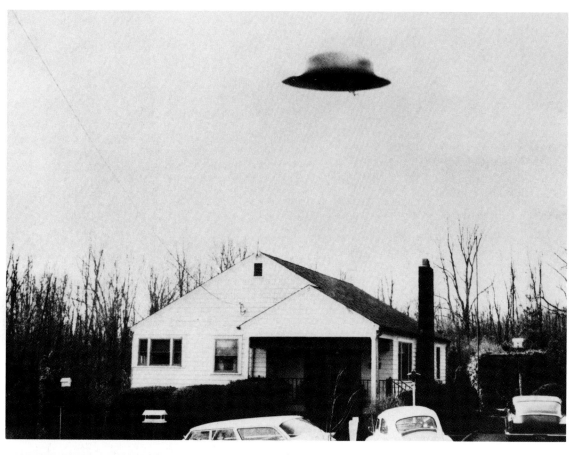

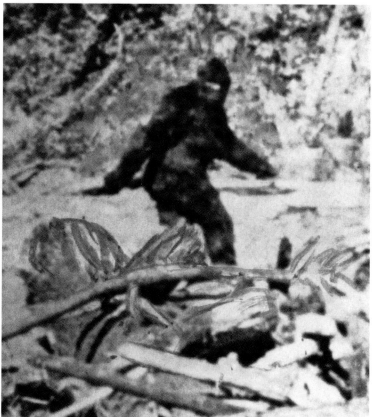

Bettmann/Corbis

Ralph Ditter
Unidentified Flying Object 1967

It's a bird! It's a plane! It's a . . . flying saucer?!? Ditter, a Zanesville, Ohio, barber, said he took this picture from his home. UFOs are prime candidates for camera tricksters. Or are they?

Roger Patterson
Bigfoot 1967

A.k.a. Sasquatch, a big, hirsute creature, part human, part God-knows-what, that roams the forests of the Pacific Northwest. Except that when Ray Wallace died in 2002, his family admitted that he had started the hoax in 1958 with fake footprints, and, later, a Bigfoot suit.

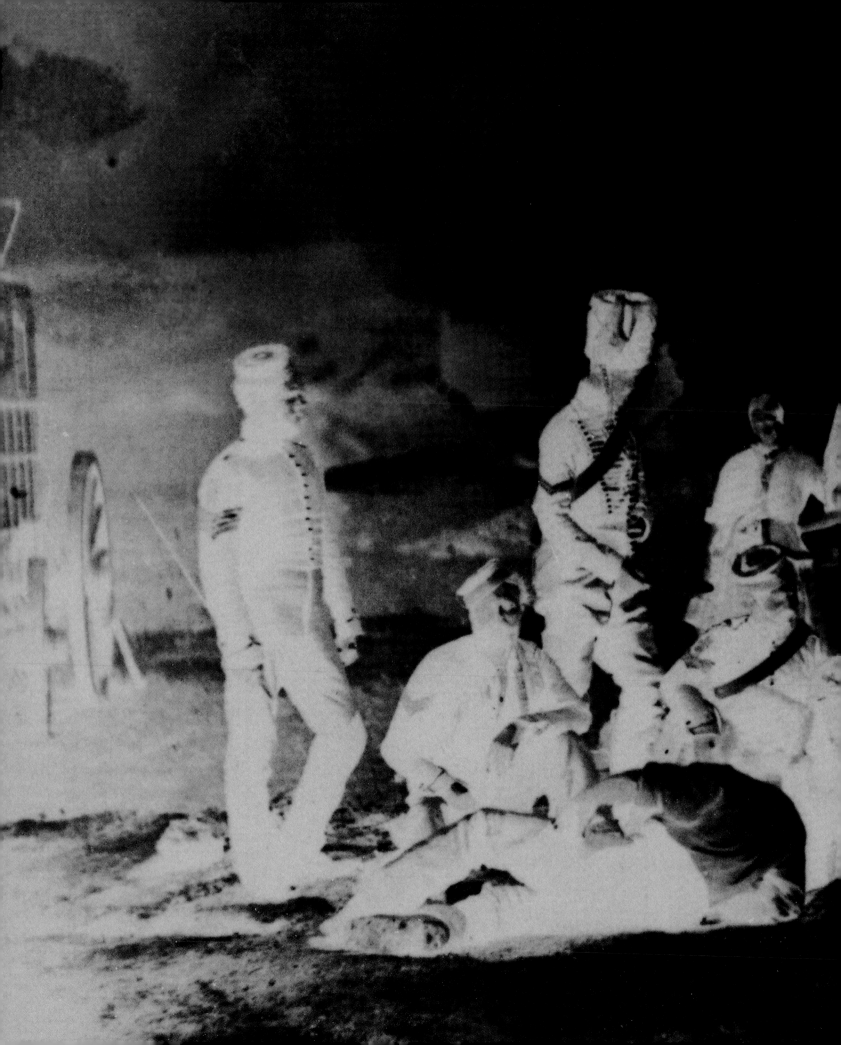

War & Peace

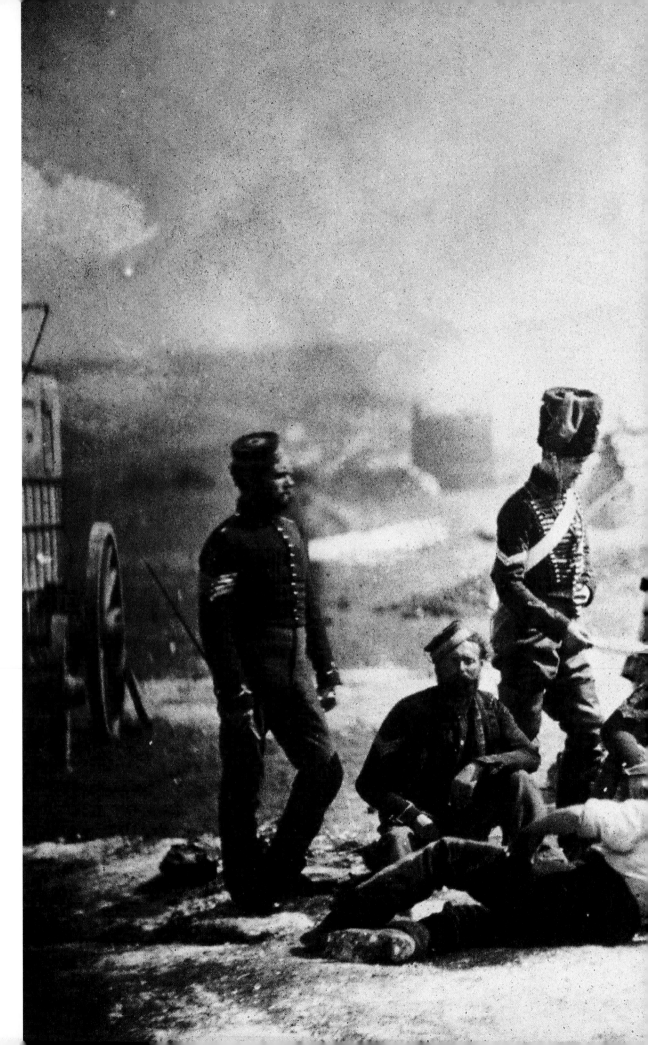

The Crimean War 1855

A British solicitor with an artistic bent, Roger Fenton took up the paintbrush and then, after seeing photography on display at the Great Exhibition in Hyde Park in 1851, the camera. Fenton shot landscapes and portraits, and pictures of Queen Victoria's children at Windsor Castle in 1854. The next year, he was assigned by a print dealer to cover the Crimean War, being waged by England and France against Russia. Thus the war became the first conflict with any substantial photographic record. Battling cholera and broken ribs, lugging his developing lab on a horse-drawn carriage, Fenton produced 350 images. They are stately and sedate for war photography, since neither the queen nor Fenton's sponsors wanted to see carnage or any evidence of a war that was progressing badly.

Photograph by
Roger Fenton

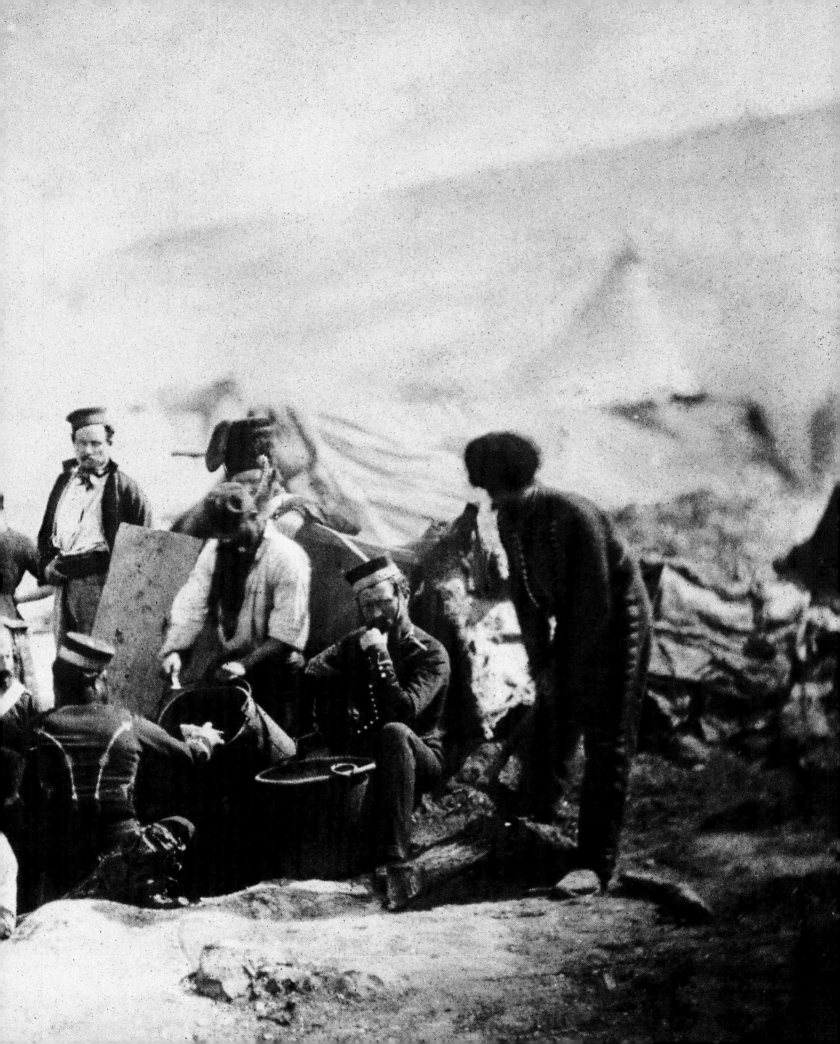

Gettysburg
1863

Photographer Gardner worked for the renowned Mathew Brady, whose firm had been granted access to Civil War battlefields by the Union. Gardner wrote that photographs of dead soldiers meant to convey to the viewer "the blank horror and reality of war, in opposition to its pageantry . . . Here are the dreadful details! Let them aid in preventing another such calamity falling upon the nation." His images certainly conveyed horror and therefore had an astonishing impact on the public consciousness, but the pictures' relationship to reality was strained. In *The Home of a Rebel Sharpshooter, Gettysburg,* for instance, the dead Confederate soldier has been moved to his resting place in Devil's Den from elsewhere on the battlefield, and a rifle has been positioned just so to create a perfect composition.

Photograph by **Alexander Gardner**
National Archives

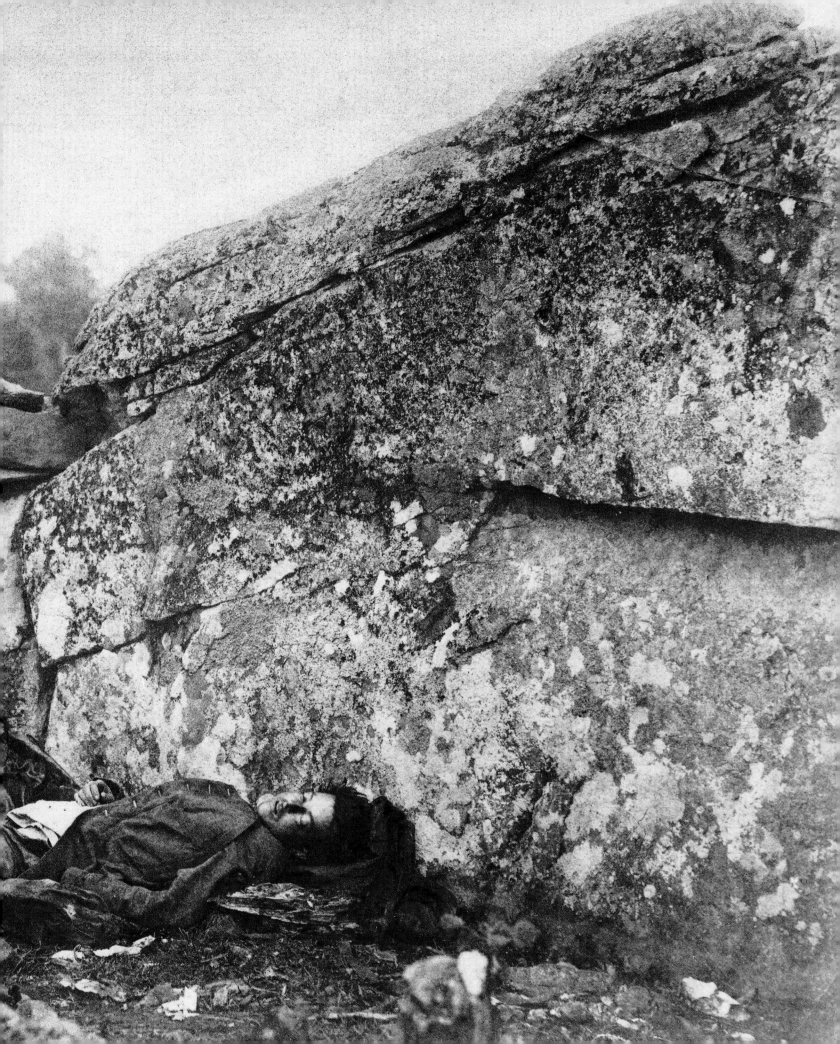

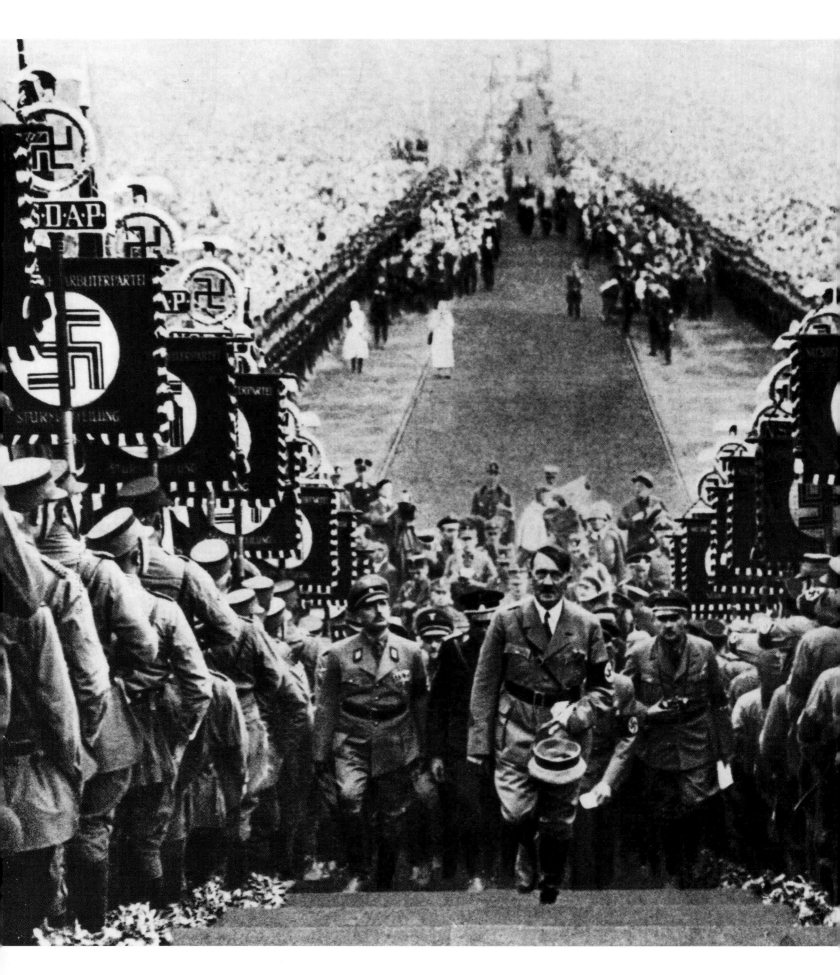

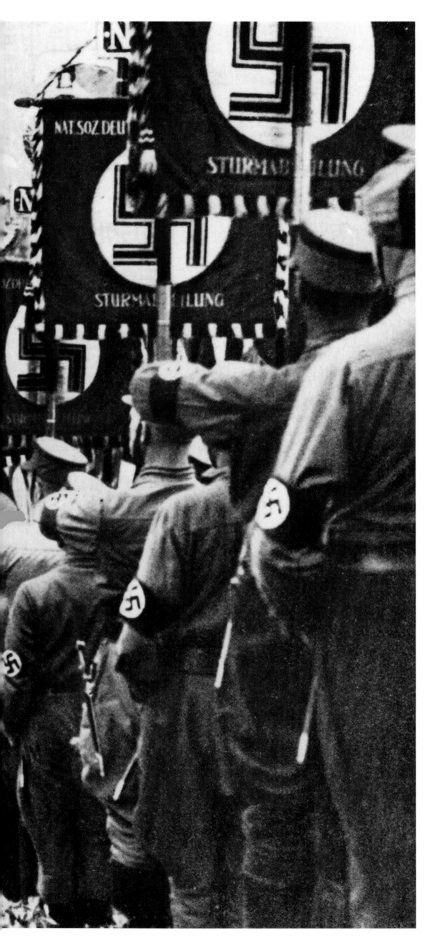

Hitler 1934

No other person in the 20th century so realized and successfully employed propaganda as Adolf Hitler. His rise to power and explosive, horrific tenure were awash in psychological flummery, potent imagery and hypnotic oratory. For a country crushed less than two decades earlier in a world war, for a hungry, once proud people, the avatar had come . . . and here, with intensity already flooding his countenance, he rises toward the podium to deliver a speech at Bückeburg. This image could, and would, kill.

Photograph by **Heinrich Hoffmann**

Another Landmark Image

Mao Zedong had for some time let others run the Chinese Communist Party when, in 1966, he decided to retake the reins. To show that he was physically strong, he and a few of his cronies swam in the Yangtze River, all the while exchanging jokes with the gathered masses. The Chinese media, of course, took all this in thirstily, and Mao scored a major victory that helped him kick off his Cultural Revolution.

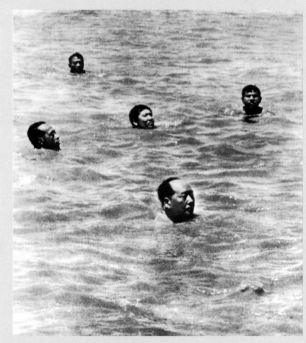

The Yangtze River, 1966
Photograph from Eastfoto/Xinhua News

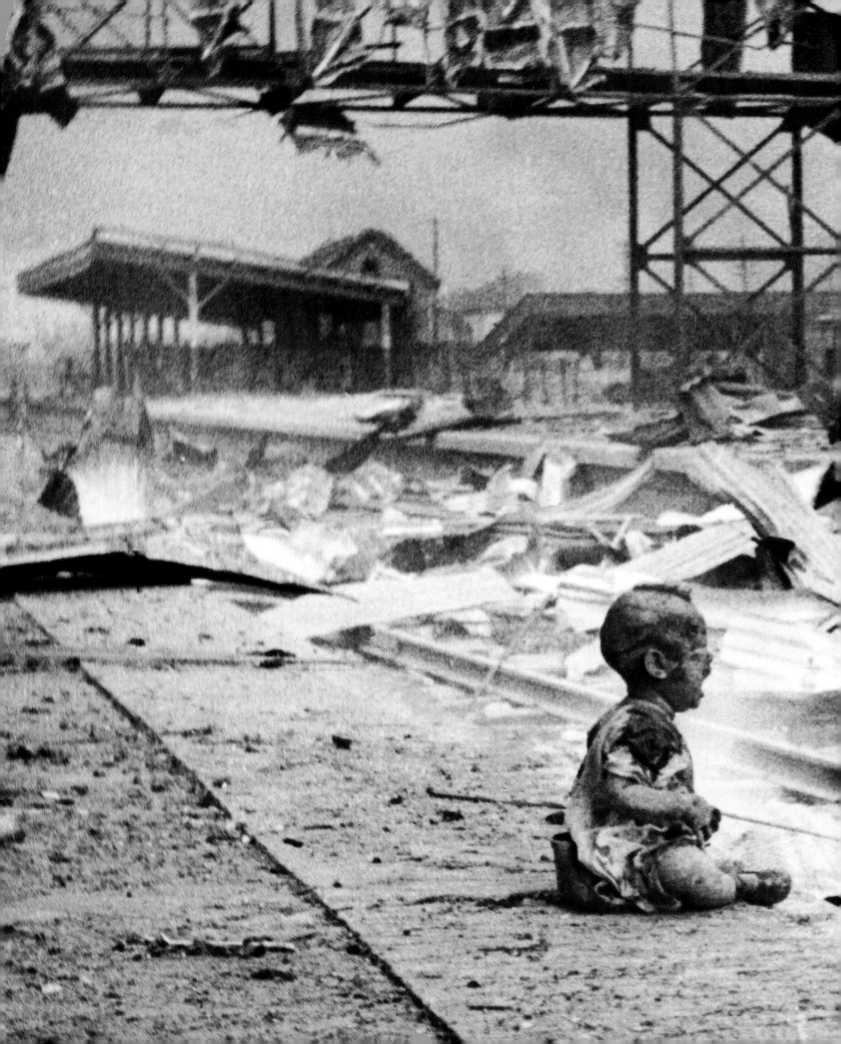

Shanghai Bombed
1937

Japan launched its bid to annex China in July 1937, following years of planning. The bombing of Shanghai on August 14, "Bloody Saturday," was appalling in the price paid by helpless civilians. The photo of this child deserted at the train station jarred its beholders, and with the Rape of Nanking four months later— a barbaric massacre of as many as 300,000 Chinese—the image of the quiet, tea-drinking Japanese was forever altered. It was later learned that the photographer may have staged the train station picture, but the damage, in every sense, had been done. This early awareness of Japanese war atrocities helped fuel the subsequent American revulsion at—and response to—the attack on Pearl Harbor.

Photograph by **H. S. Wong**
National Archives

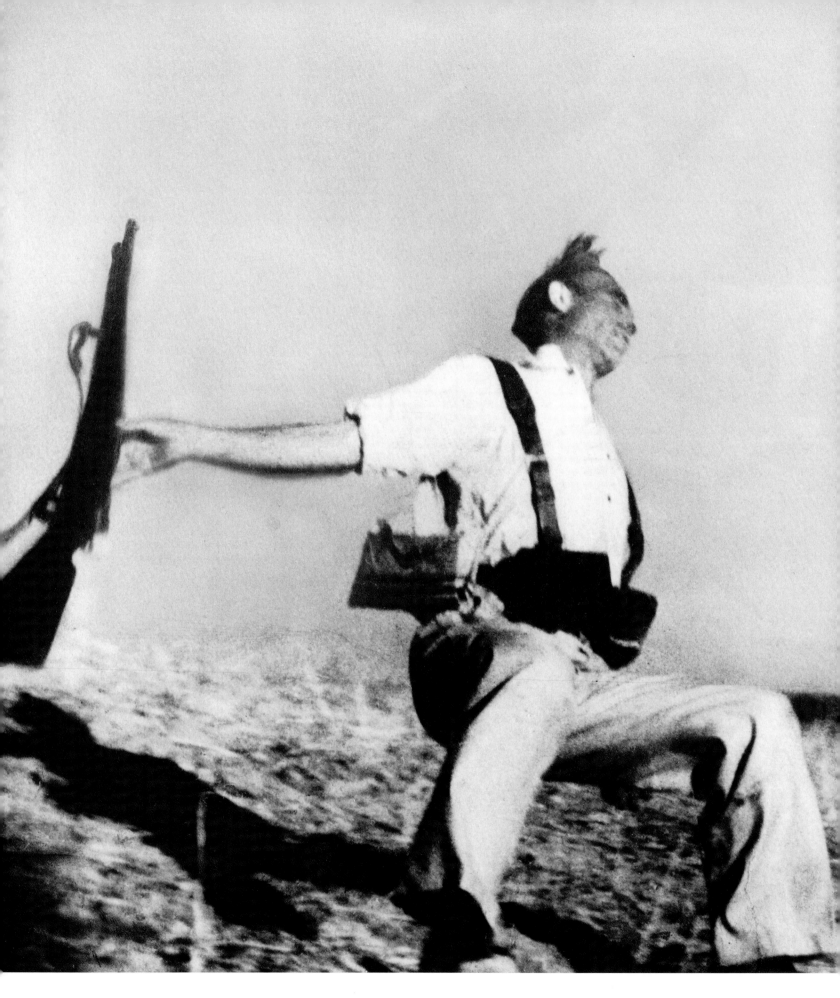

The Falling Soldier
1936

It is perhaps the most famous war photograph of all time and it is certainly one of the most controversial. *Loyalist Militiaman at the Moment of Death, Cerro Muriano, September 5, 1936* is either a shockingly intimate depiction of a Spanish Republican soldier breathing his last during his country's civil war, as LIFE believed in '37 and most observers still maintain, or it is staged, as a British historian first argued in 1975. Either way, the image has long had a massive impact. In his 2002 biography of the storied Capa, Alex Kershaw wrote that the "truth" of the photo resides in its presentation of death: "The Falling Soldier, authentic or fake, is ultimately a record of Capa's political bias and idealism . . . Indeed, he would soon come to experience the brutalizing insanity and death of illusions that all witnesses who get close enough to the 'romance' of war inevitably confront."

Photograph by
Robert Capa Magnum

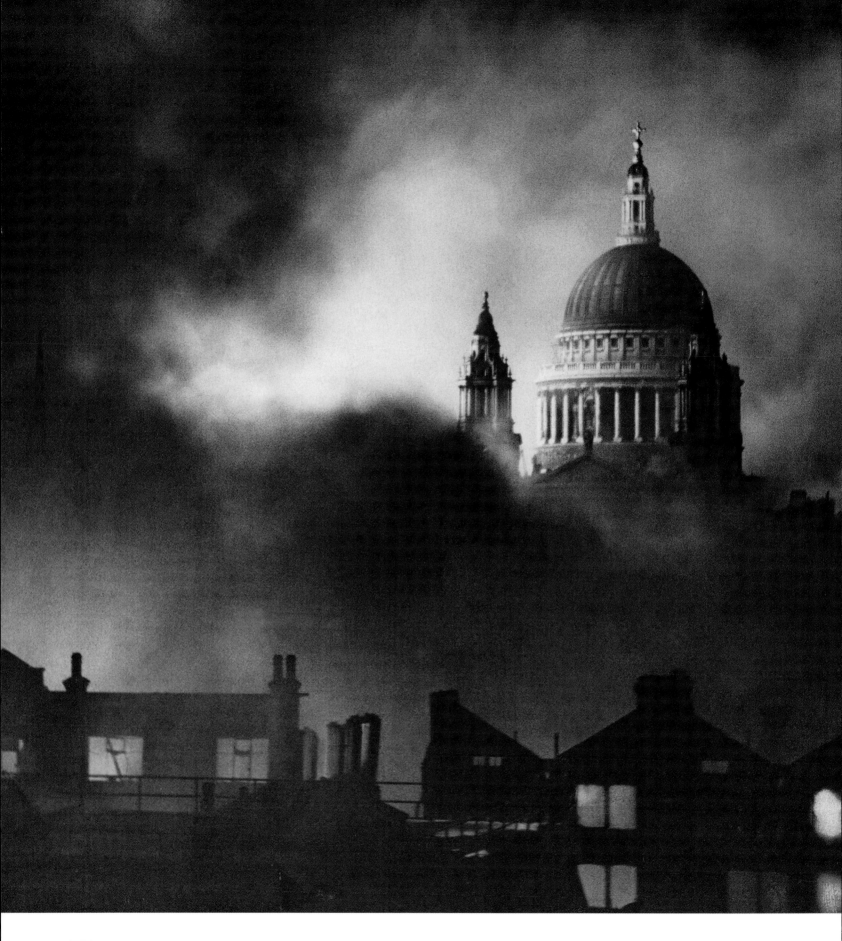

Saint Paul's During the Blitz 1940

The German Luftwaffe began a withering campaign against Great Britain in July 1940. Initially designed as a preinvasion attack, the shelling focused on London and other cities in September. From the seventh day of that month, the capital city was bombed 57 nights in a row; in all, some 10,000 Londoners were killed. Saint Paul's was designed by Christopher Wren and built hundreds of years earlier. This image of the ancient cathedral surviving in the midst of mayhem gave solace, and strength, to a weary people.

Photograph by **John Topham** International News Photos/Corbis

Another Landmark Image

The Blitz had brought pain and destruction to the East End of London, home to industry and poor folk. Queen Elizabeth and King George VI lived in Buckingham Palace, in the West End. Before September 13, 1940, the palace had been unscathed, but that night bombs fell within the grounds (here the royal couple, at left, inspect the ruins). Aligning herself squarely with her struggling subjects, Elizabeth said, "Now we can look the East End in the face."

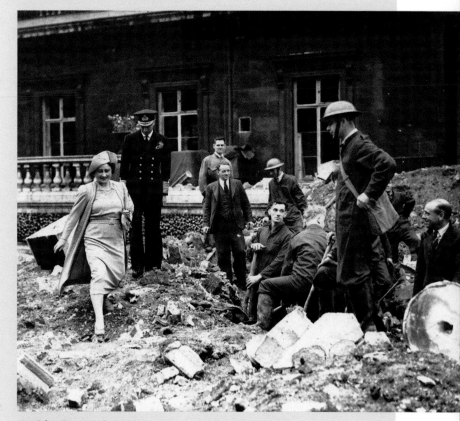

Buckingham Palace, 1940
Photograph from AP

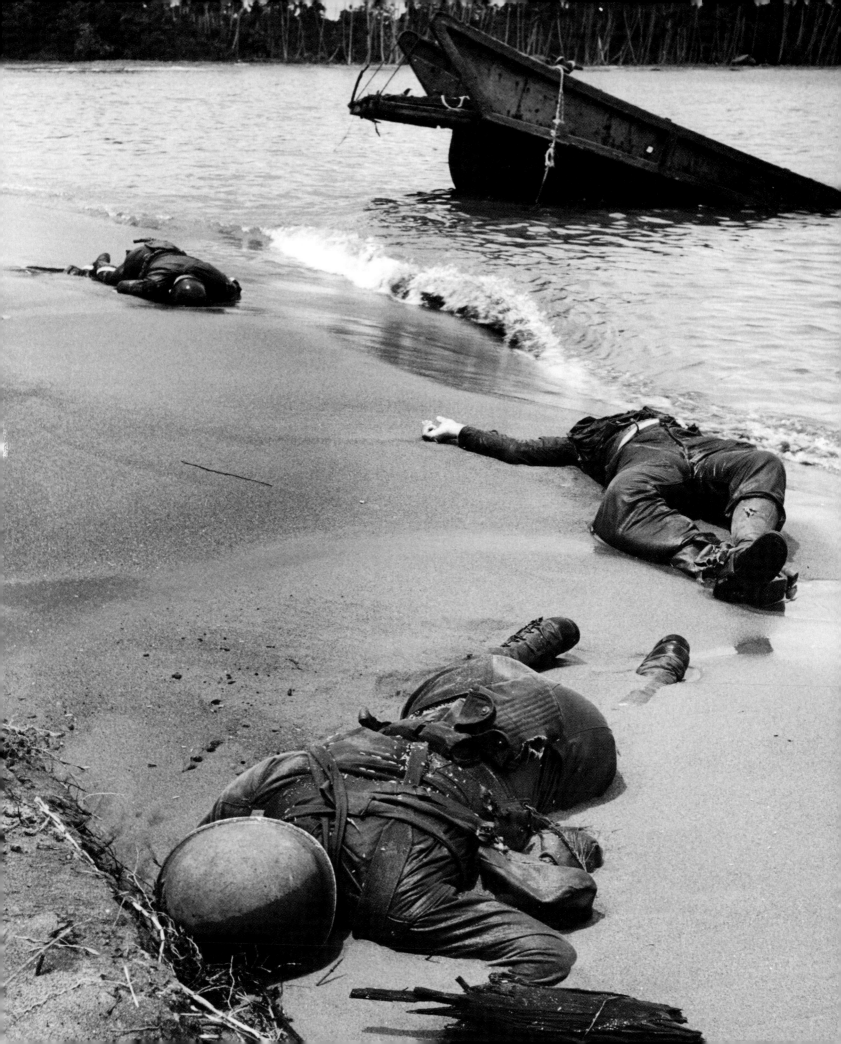

Dead on the Beach 1943

When LIFE ran this stark, haunting photograph of a beach in Papua New Guinea on September 20, 1943, the magazine felt compelled to ask in an adjacent full-page editorial, "Why print this picture, anyway, of three American boys dead upon an alien shore?" Among the reasons: "words are never enough . . . words do not exist to make us see, or know, or feel what it is like, what actually happens." But there was more to it than that; LIFE was actually publishing in concert with government wishes. President Franklin D. Roosevelt was convinced that Americans had grown too complacent about the war, so he lifted the ban on images depicting U.S. casualties. Strock's picture and others that followed in LIFE and elsewhere had the desired effect. The public, shocked by combat's grim realities, was instilled with yet greater resolve to win the war.

Photograph by **George Strock**

Another Landmark Image

Robert Capa, who once famously observed that "If your pictures aren't good enough, you're not close enough," was on the shore with the first wave on D-Day, working for LIFE. He shot four rolls of soldiers slogging onto Omaha Beach, storming the cliffs, hunkering down. Then, a photo assistant in London ruined all but a dozen images. Their grainy, shell-shocked feel defined the tension and texture of the Longest Day. Years later, they informed the look of Steven Spielberg's *Saving Private Ryan*.

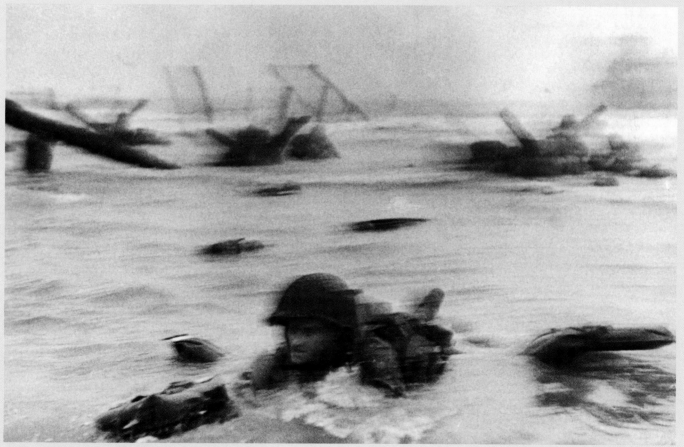

Omaha Beach, D-Day, 1944
Photograph by **Robert Capa** Magnum

Saipan 1944

When Japan threw its best punch on December 7, 1941, the United States knew it was in for a hell of a time in the Pacific. That turned out to be all too true. The Navy struck back quickly at Midway, and the long island-hopping campaign had begun: Americans had to go in on the ground and fight to the death with defenders who had been preparing for years. But, despite all the bloodshed, despite the many atrocities, one look at this Marine on Saipan told the folks back home, "It's tough, but we're gonna lick them!"

Photograph by **W. Eugene Smith**

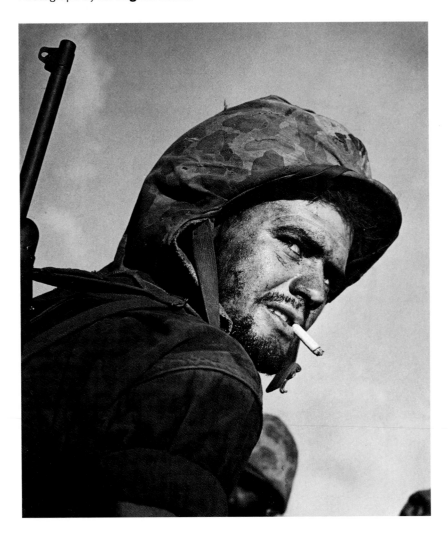

Yalta 1945

The leaders of the main Allied powers met at Yalta on the Crimean Peninsula in February to hash out two matters: how to engineer Germany's final defeat, and, perhaps more pressing at this stage, how to occupy the defeated land. So, in this picture, there are two wars afoot, and each man already has his game face on for the next one. If Churchill, Roosevelt and Stalin evinced togetherness, it was strictly for the camera and for the Allied peoples. They were, of course, photographed sitting down because of FDR's polio.

Photograph from U.S. Army Signal Corps

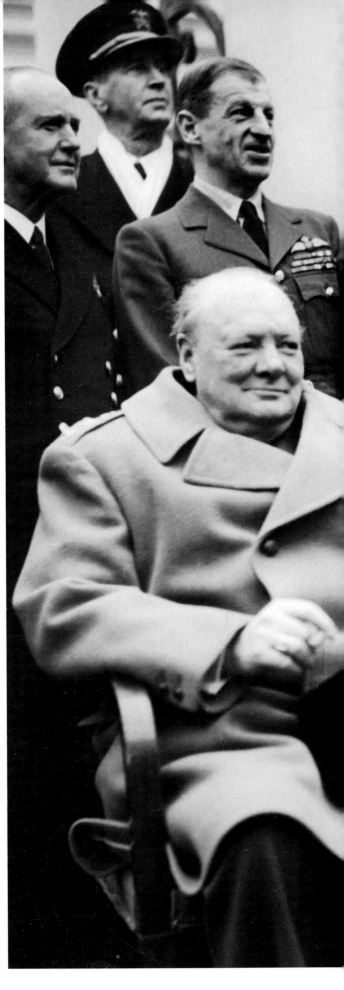

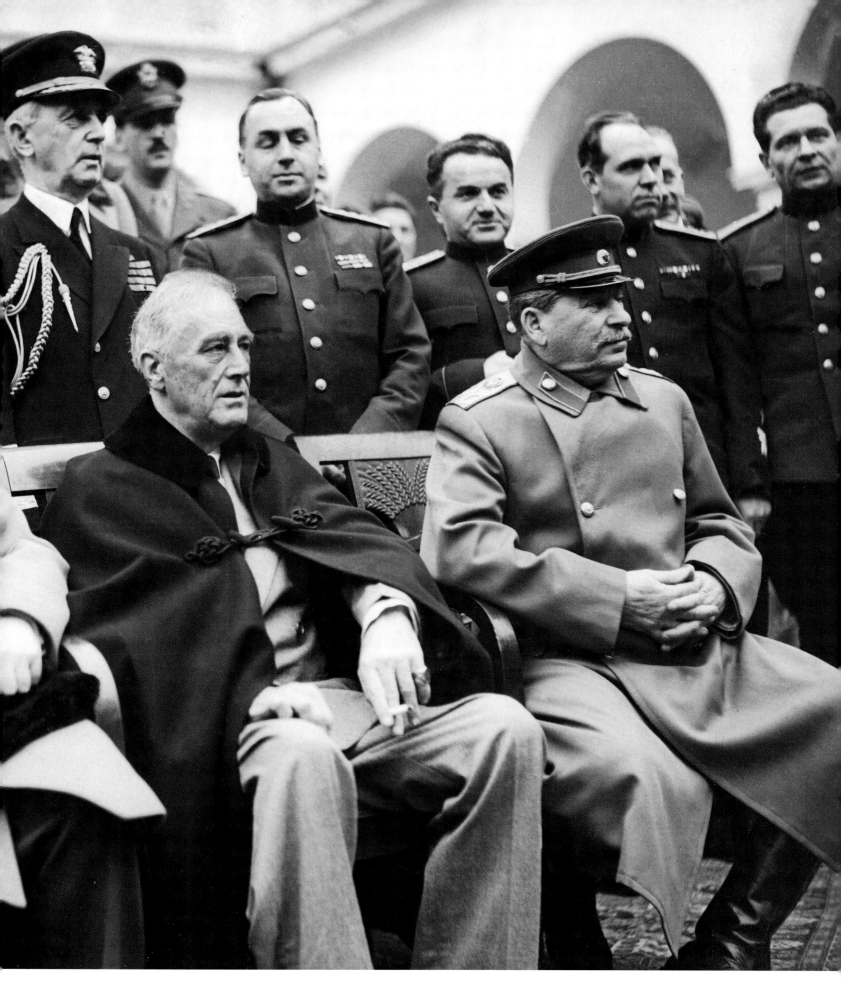

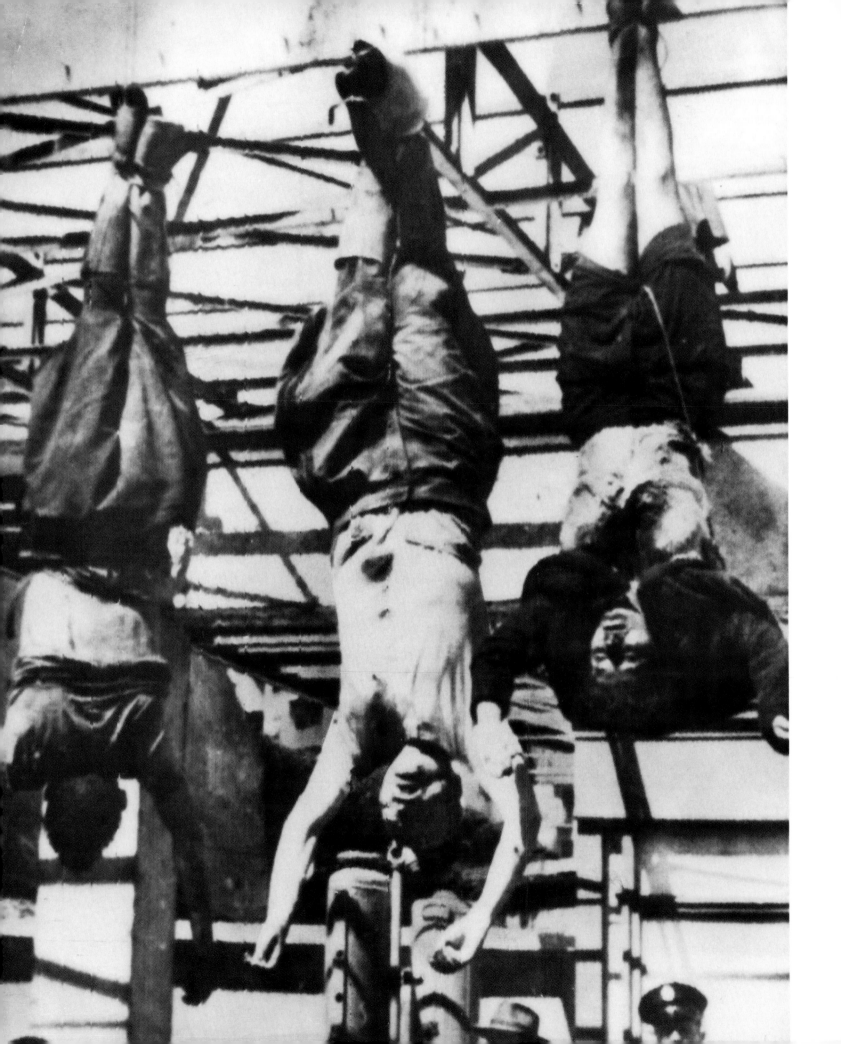

Benito Mussolini

1945

He was the man who made the trains run on time, but over time, he wore out his welcome. One of the most charismatic leaders of the century, he rose from rather humble beginnings to become in 1922 the youngest prime minister (he was 39) in Italian history. Hitler quite admired him but proved his undoing when Il Duce saw the spoils accruing to Hitler and caught the fever: In 1940 he dragged his totally unprepared nation into WWII. Fascism would become a dirty word in Italy, and the man who sought to be the next Caesar was caught trying to flee the country in a German greatcoat. He, his mistress Claretta Petacci and others were shot dead and hanged from the heels in Milan's Piazza Loreto. A radio broadcast from the scene: "It is interesting to see the hate, the fury . . . They want the bodies to stay there for six months . . . This is a good example."

Photograph by
12th Combat Camera Crew

Another Landmark Image

For a quarter century, Nicolae Ceausescu ran Romania with secret police, Mao-like economic plans, and a cult of personality. His downfall was as brutal and bizarre as his regime. Generals called in to quash a protest switched sides, and Ceausescu then called a rally of 100,000, which turned on him. He and his wife fled in a helicopter, were apprehended, tried and then executed on Christmas Day, 1989. Confusion and violence reigned until the bodies were displayed.

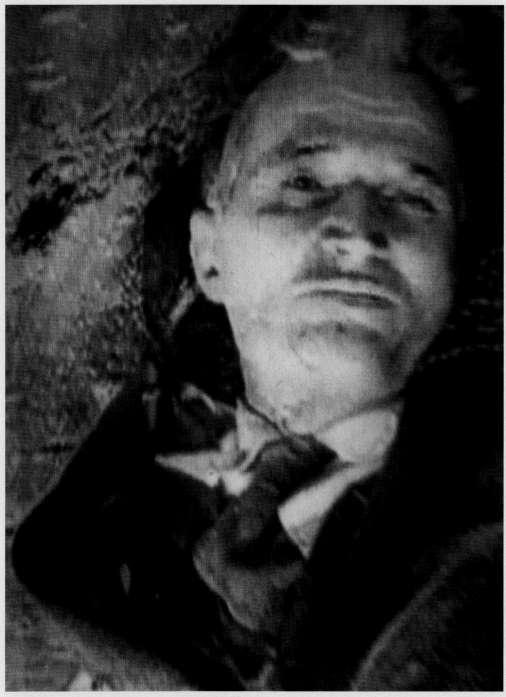

Nicolae Ceausescu, 1989
Photograph by **AFP**

Anne Frank 1941

Six million Jews died in the Holocaust. For many throughout the world, one teenage girl gave them a story and a face. She was Anne Frank, the adolescent who, according to her diary, retained her hope and humanity as she hid with her family in an Amsterdam attic. In 1944 the Nazis, acting on a tip, arrested the Franks; Anne and her sister died of typhus at Bergen-Belsen only a month before the camp was liberated. The world came to know her through her words and through this ordinary portrait of a girl of 14. She stares with big eyes, wearing an enigmatic expression, gazing at a future that the viewer knows will never come.

Photographer Unknown

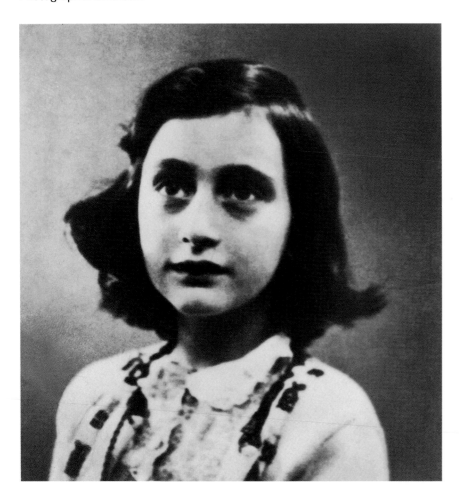

Buchenwald 1945

LIFE photographer Margaret Bourke-White was with Gen. George Patton's troops when they liberated the Buchenwald concentration camp. Forty-three thousand people had been murdered there. Patton was so outraged he ordered his men to march German civilians through the camp so they could see with their own eyes what their nation had wrought. Bourke-White's pictures carried the horrible images to the world. In America the pictures proved that reports of the Nazi's methodical extermination of the Jews were true, and the country began a long process of rethinking its behavior, such as the decision not to bomb the camps.

Photograph by **Margaret Bourke-White**

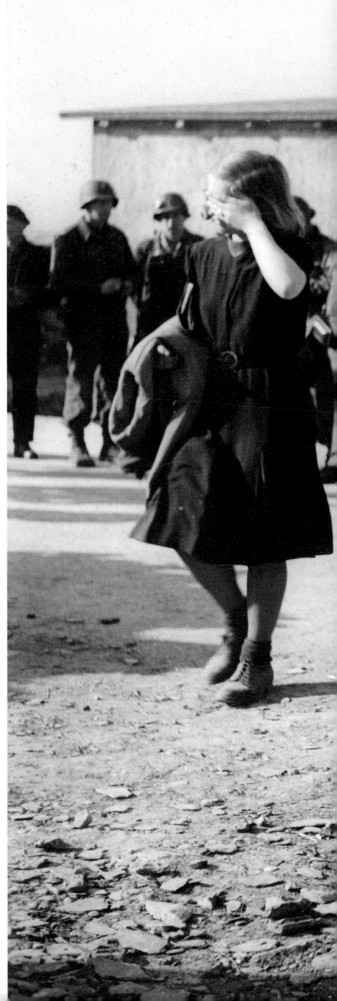

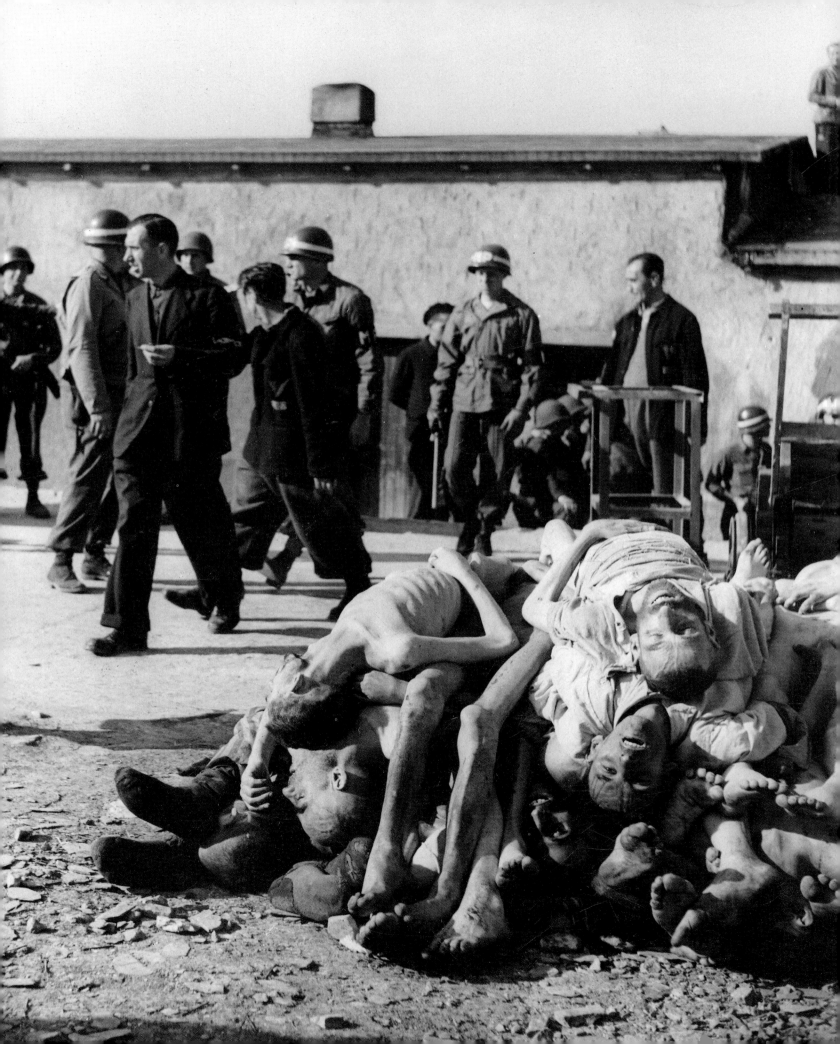

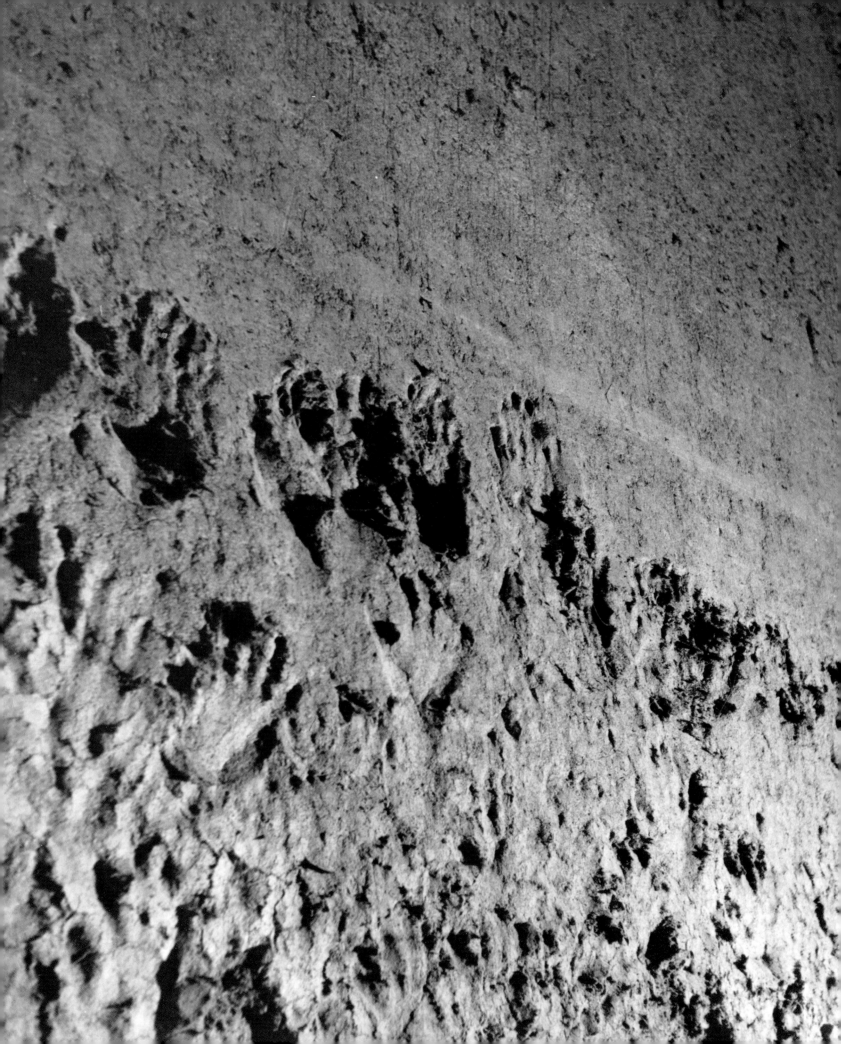

Prisoners' Hand Marks 1944

The camera is a masterly tool for documenting some of the vilest of incidents, ones where words fail. This photograph was taken after the German occupation of France during World War II. It depicts the wall of a torture chamber on the Boulevard Victor in Paris. The desperate hands of prisoners have inflicted themselves into the asbestos as the effects of electrical current became more than they could bear. Such happenings may be forgiven but cannot be forgotten, not with this document. The Parisian Roger Schall had been allowed by the Nazis to photograph life there during the war, but with the liberation, he took very different kinds of pictures—like this one—and his work was used in postwar prosecutions. Schall's brother published a book of such pictures at war's end, and it became a mandatory buy in Paris.

Photograph by **Roger Schall**

Another Landmark Image

French soldiers and civilians are being processed at the border of the American and Soviet occupation zones for their return home when, suddenly, one woman denounces another as a Gestapo stool pigeon. Vengeance was primal. It was also tribunal: At the first international war-crimes trial in Nuremberg, Germany, 11 Nazis were sentenced to death, seven sent to jail and three acquitted.

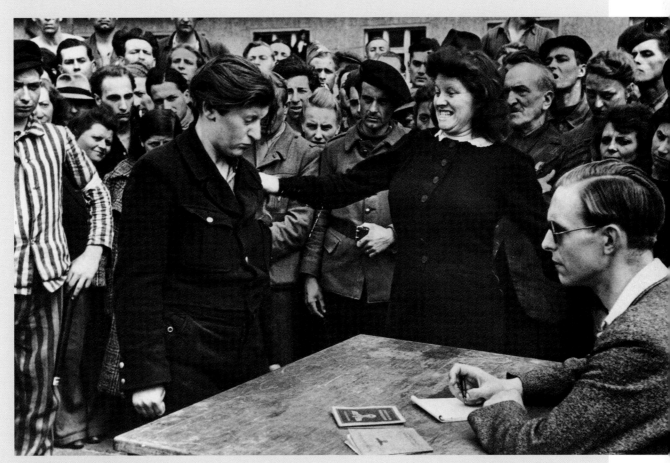

Vengeance in Dessau, 1945
Photograph by **Henri Cartier-Bresson** Magnum

Iwo Jima 1945

U.S. Marines raised the flag atop Iwo Jima's Mount Suribachi on February 23, 1945, and AP photographer Rosenthal made one of the most iconic pictures ever. (Another shot of the same incident taken from a different angle by a Marine photographer is not as compelling, nor as famous, but proves beyond doubt that Rosenthal's shot was not staged.) The photo, which showed emphatically just who was on the ascent in the Pacific theater, had a pure, inspirational quality. In the States, work began instantly on a statue based upon this tableau.

Photograph by **Joe Rosenthal** AP

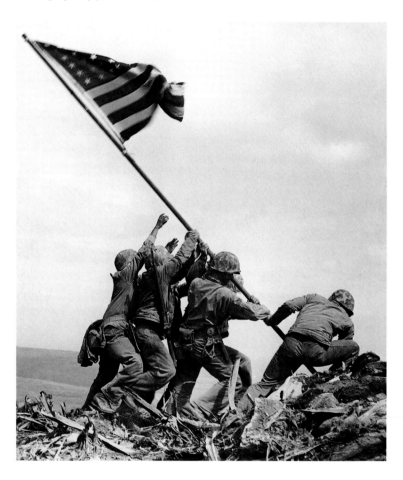

MacArthur Returns 1945

When Japan attacked Pearl Harbor in 1941, it also invaded the Philippines, where Gen. Douglas MacArthur was based. It was surely painful for this most zealous of soldiers when President Roosevelt ordered him to evacuate to Australia. When he arrived in Adelaide, MacArthur said to reporters, "I shall return." In October 1944, he did so, to great fanfare. The image that remains indelible, however, was actually taken three months later when his old friend Carl Mydans recorded his arrival at another beachhead, in Luzon. MacArthur, of course, preferred the grander image—as did the world at large.

Photograph by **Carl Mydans**

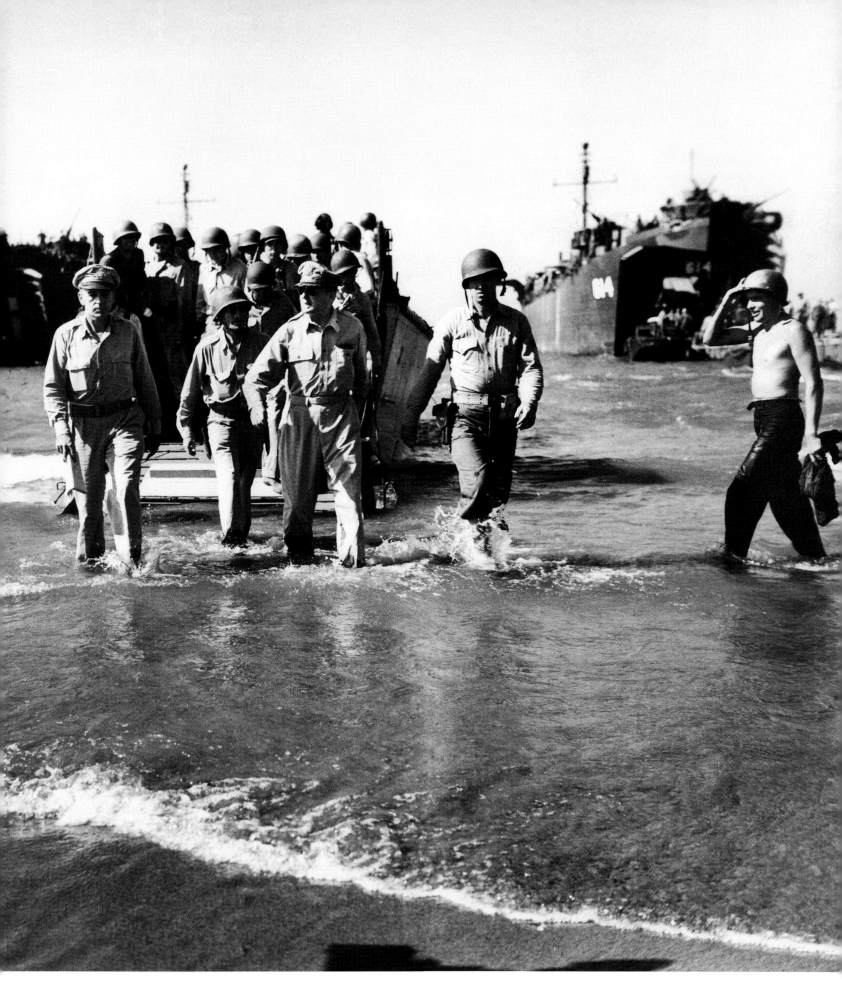

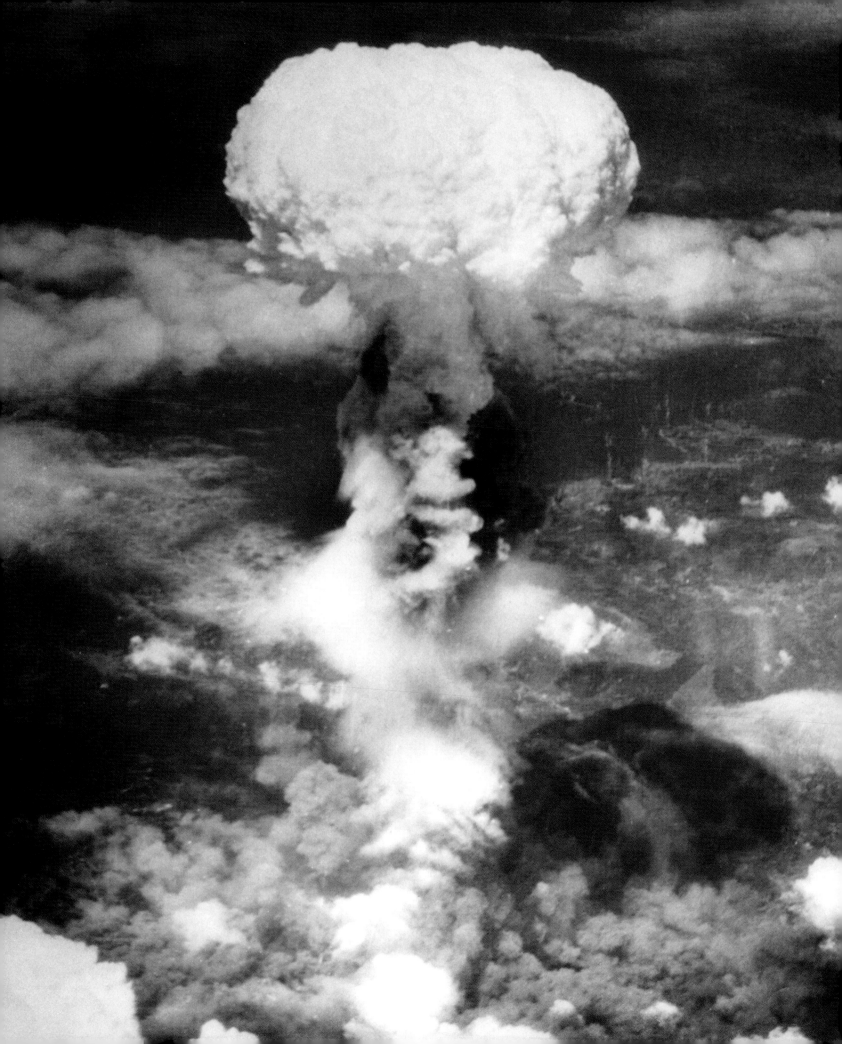

Nagasaki
1945

Nothing like the mushroom cloud had ever been seen, not by the general public. It was a suitably awesome image for the power unleashed below. On August 6 the first atomic bomb killed an estimated 80,000 people in the Japanese city of Hiroshima. There was no quick surrender, and three days later a second bomb exploded 500 meters above the ground in Nagasaki. The blast wind, heat rays reaching several thousand degrees and radiation destroyed anything even remotely nearby, killing or injuring as many as 150,000 at the time, and more later. As opposed to the very personal images of war that had brought the pain home, the ones from Japan that were most shocking were those from a longer perspective, showing the enormity of what had occurred.

Photograph from U.S. Air Force

Another Landmark Image

Americans—and everyone—had heard of the bomb that "leveled" Hiroshima, but what did that mean? When the aerial photography was published, that question was answered. For many, the promise of an end to the war overwhelmed considerations about tomorrow. But, slowly, the devastation of Hiroshima and Nagasaki sank in, and a thought emerged: We can blow up the world.

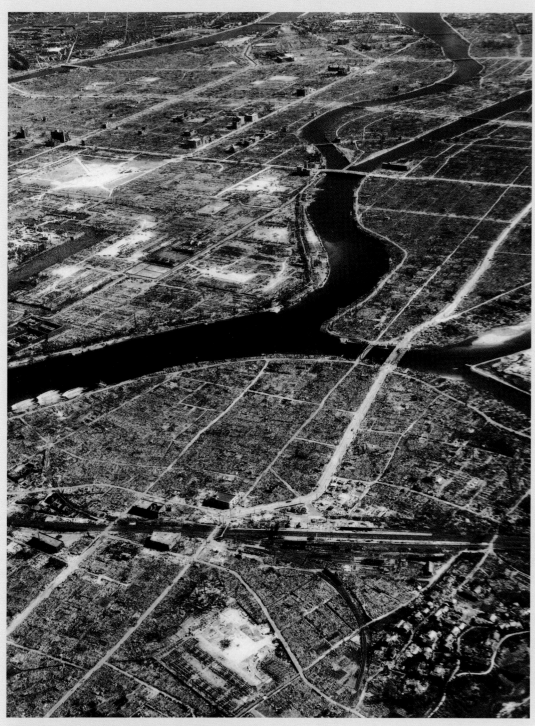

Hiroshima, Three Weeks After the Bomb, 1945
Photograph by **George Silk**

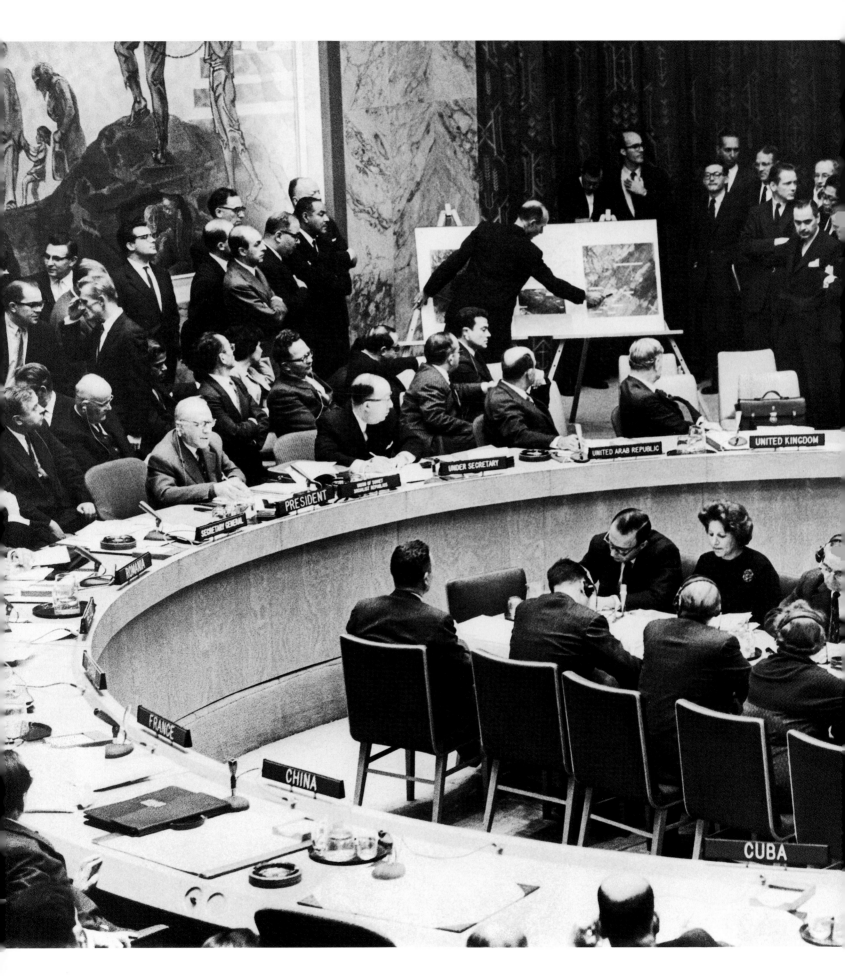

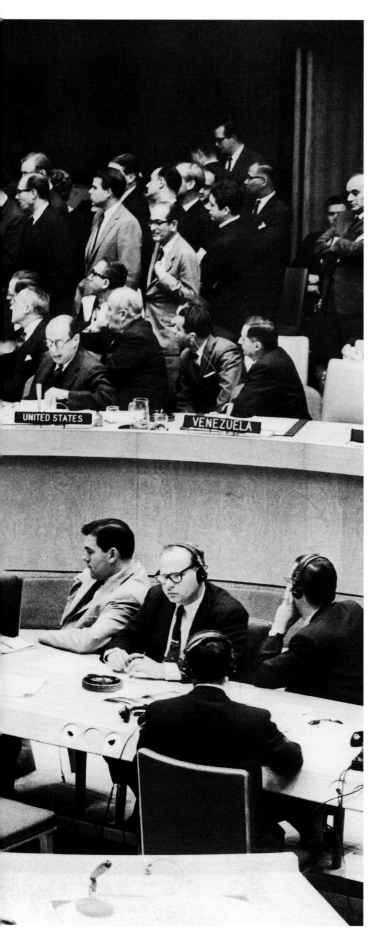

U-2 1960

At first, the United States did not admit to spying on the U.S.S.R., despite the fact that the Soviets said they had shot down a U-2, which was an American spy plane. But the evidence in this photo of captured pilot Francis Gary Powers finally forced President Dwight D. Eisenhower to acknowledge—and suspend—the program. The incident made the cold war colder: A summit meeting collapsed after Ike refused to apologize. Powers was sentenced to 10 years, but was brought home after nearly two years in a dramatic exchange for a Soviet spy on a Berlin bridge.

Photograph by
Carl Mydans

Cuban Missile Crisis 1962

On October 22, 1962, after accusing the U.S.S.R. of installing nuclear missiles on Cuba, President John F. Kennedy ordered a blockade of the island. When the Soviet ambassador to the U.N. refused to deny the charge, U.S. ambassador Adlai Stevenson confronted him with these photos of missile sites taken by the high-flying spy plane, the U-2, and the Soviets were compelled to back down. The presentation of seemingly incontrovertible evidence would become known as an "Adlai Stevenson moment." Robert F. Kennedy later admitted that he and his brother found the grainy images quite baffling, and banked on the interpretation proffered by the CIA: "I, for one, had to take their word for it."

Photograph by **Neal Boenzi** The New York Times

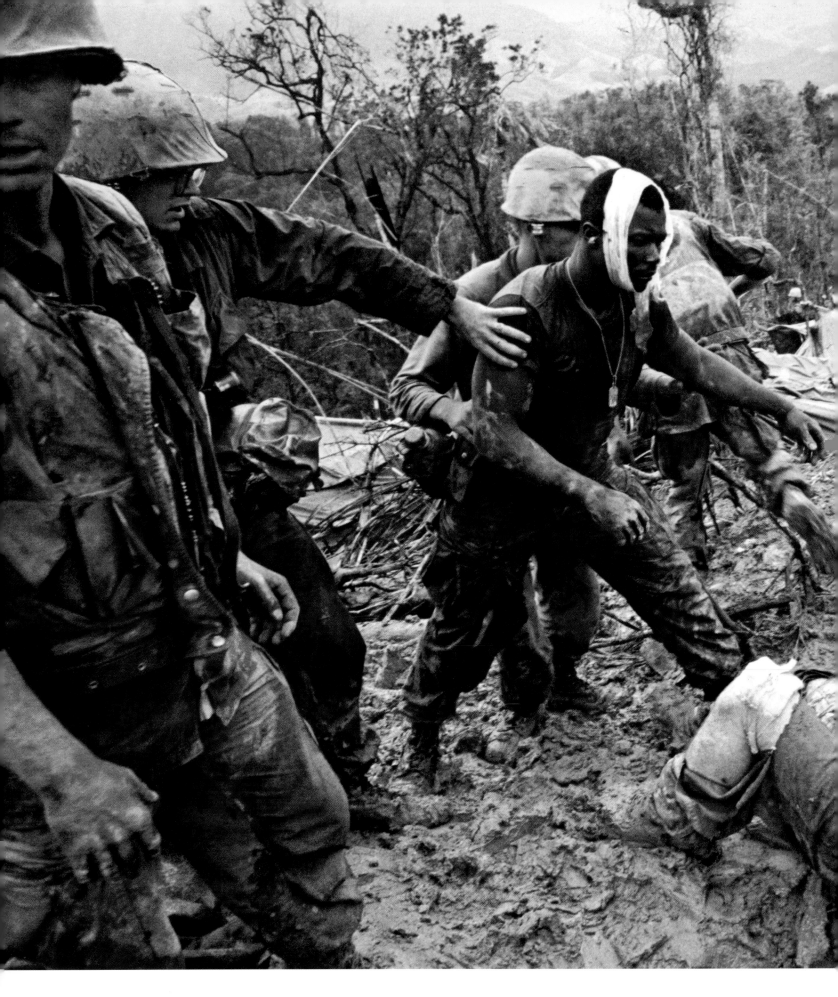

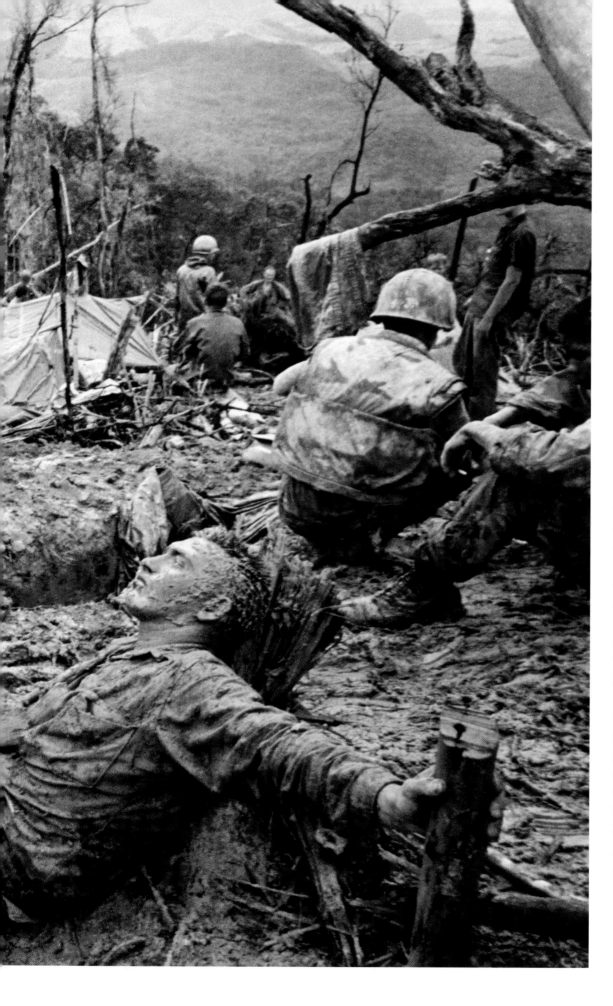

South of the
DMZ 1966

Contrary to the constraints that were put upon the press in subsequent conflicts, and even to the embedded program used in the recent Iraqi war, correspondents and photographers in Vietnam could, as Walter Cronkite wrote in LIFE, "accompany troops to wherever they could hitch a ride, and there was no censorship . . . That system— or lack of one—kept the American public well informed of our soldiers' problems, their setbacks and their heroism." *Reaching Out* is a quintessential example of the powerful imagery that came out of Vietnam. "The color photographs of tormented Vietnamese villagers and wounded American conscripts that Larry Burrows took and LIFE published, starting in 1962, certainly fortified the outcry against the American presence in Vietnam," Susan Sontag wrote in her essay "Looking at War," in the December 9, 2002, *New Yorker*. "Burrows was the first important photographer to do a whole war in color—another gain in verisimilitude and shock." Burrows was killed when the helicopter he was riding in was shot down over Laos in 1971.

Photograph by
Larry Burrows

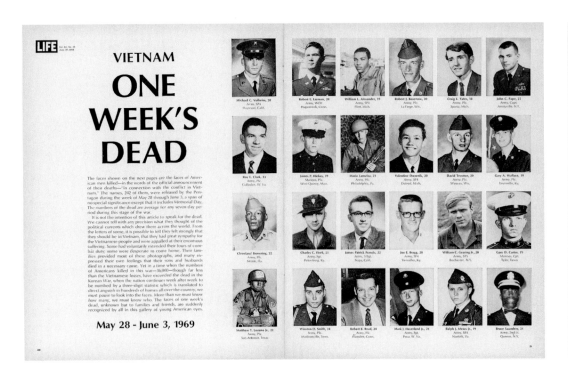

One Week's Dead May 28–June 3, 1969

By 1969, Americans were dying in Vietnam each week by the hundreds. Total losses had reached a staggering 36,000. To personalize the figures, LIFE ran the name, hometown and picture of each serviceman whom the Pentagon said was killed during the Memorial Day week. Their families sent most of the photos, usually the timeless military portrait. But then, Patrick Hagerty, 19, of Youngstown, Ohio, was climbing a pole and Johnnie Brigman, 23, of North, S.C., was suavely posing by a car. Some families said the war was just; others said their sons had been desperate to come home. LIFE, over 12 pages that became part of the national conversation, just wanted Americans to know their 242 countrymen: "When the nation continues week after week to be numbed by a three-digit statistic, which is translated to direct anguish in hundreds of homes all over the country, we must pause to look into the faces . . . the faces of one week's dead."

LIFE June 27, 1969

During the week of May 20–June 3 these men were also reported killed in action

My Lai 1968

A company commander told his forces that My Lai was a Viet Cong stronghold. Encountering little if any resistance, they destroyed the village anyway. Some 500 civilians were killed, huts burned, livestock slaughtered and a well poisoned with a corpse. However, the Army treated My Lai as routine combat until the truth came out the following fall. LIFE ran Army photographer Ron Haeberle's documentation of the massacre, including this shot of a mother sheltering her 13-year-old daughter from molestation by GIs, just moments before both were slain. The savagery nauseated Americans, turning them further against the war.

Photograph by **Ronald S. Haeberle**

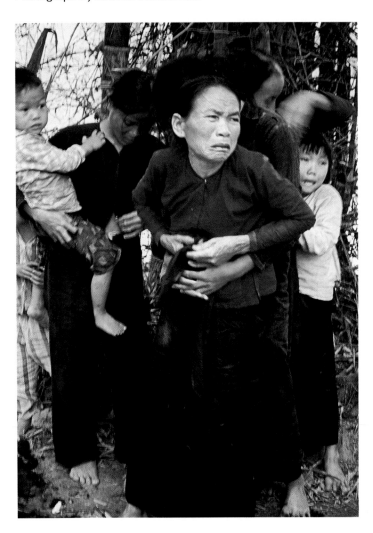

Kent State 1970

When President Richard Nixon said he was sending troops to Cambodia, the nation's colleges erupted in protest. At Kent State some threw rocks. The Ohio National Guard, called in to quell the turmoil, suddenly turned and fired, killing four; two were simply walking to class. This photo captured a pivotal moment: American soldiers had just killed American kids. Student photographer John Filo won the Pulitzer; the event was also memorialized in a Neil Young song and a TV movie. The girl, Mary Ann Vecchio, turned out not to be a Kent State student, but a 14-year-old runaway. She was sent back to her family in Florida.

Photograph by **John Paul Filo** Valley Daily News/AP

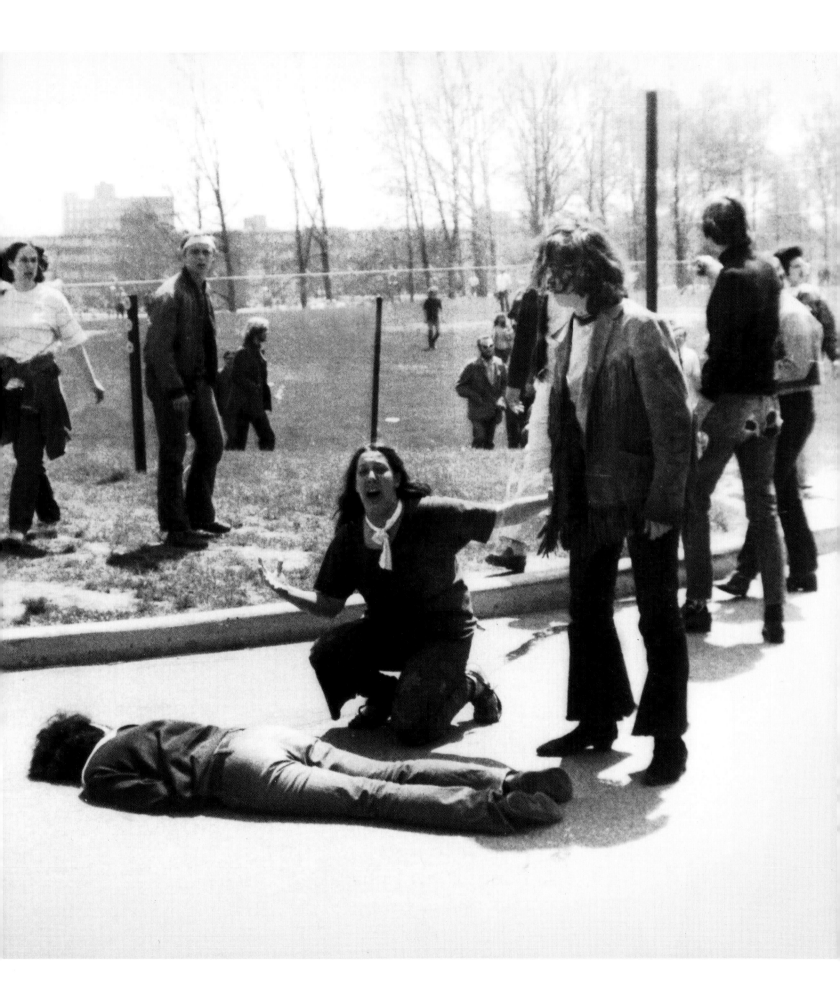

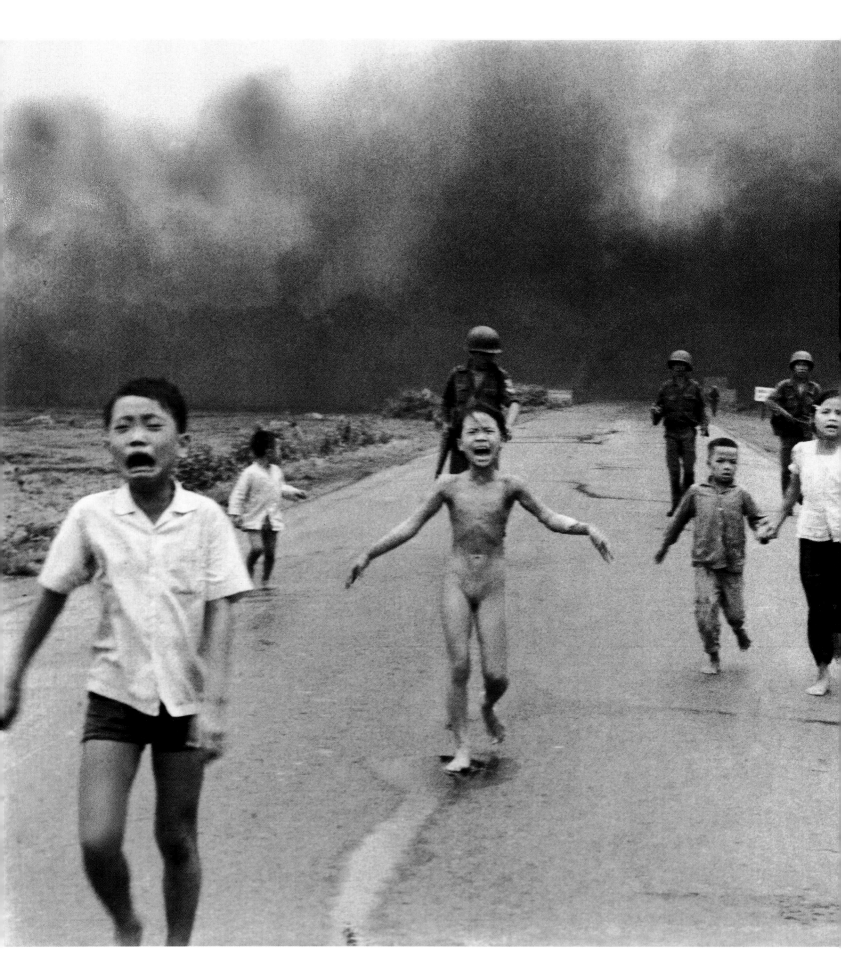

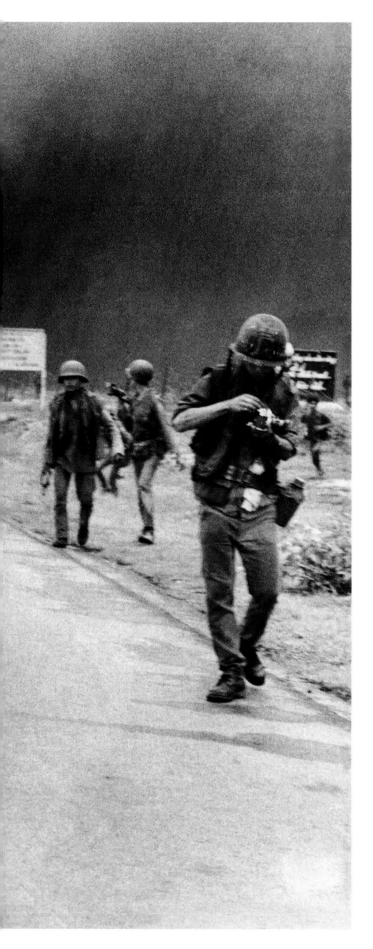

Execution of a Viet Cong Guerrilla 1968

With North Vietnam's Tet Offensive beginning, Nguyen Ngoc Loan, South Vietnam's national police chief, was doing all he could to keep Viet Cong guerrillas from Saigon. As Loan executed a prisoner who was said to be a Viet Cong captain, AP photographer Eddie Adams opened the shutter. Adams won a Pulitzer Prize for a picture that, as much as any, turned public opinion against the war. Adams felt that many misinterpreted the scene, and when told in 1998 that the immigrant Loan had died of cancer at his home in Burke, Va., he said, "The guy was a hero. America should be crying. I just hate to see him go this way, without people knowing anything about him."

Photograph by **Eddie Adams** AP

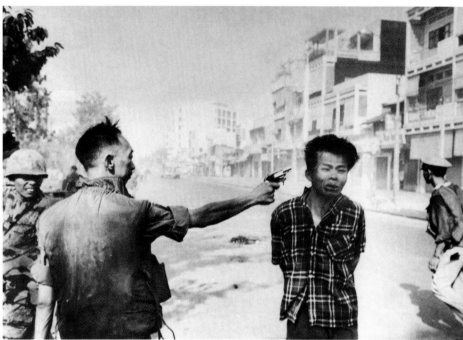

Napalm Strike 1972

Another complicated image showed South Vietnamese children burned by napalm, which had accidentally been dropped by South Vietnamese planes. The details notwithstanding, the photograph horrified. After taking it, Nick Ut, who was born in South Vietnam, doused the naked Kim Phuc with water and rushed her to a hospital. Phuc, who lives in Toronto, credits Ut with saving her life. The picture won a Pulitzer, and after the war, Ut moved to AP's Los Angeles bureau. In 2002, tapes were released that had President Nixon wondering to H.R. Haldeman about whether the "napalm thing . . . was a fix."

Photograph by **Nick Ut** AP

Vietnam 1975

President Richard Nixon talked of getting out of Vietnam, but carefully used the phrase "peace with honor." By April 1975, however, it was apparent that South Vietnam was about to fall, and emergency evacuation plans were put into action. Dignity was scrapped as Americans (and a small number of South Vietnamese) fought to get aboard the last transit out. Here, U.S. pilot Robert Hedrix punches a South Vietnamese army deserter trying to force his way onto a DC-6 departing Nha Trang. In the U.S., images such as these said: America, previously invincible, has lost a war and is sneaking out of town.

Photograph by **Khac Chuong Thai** Bettmann/Corbis

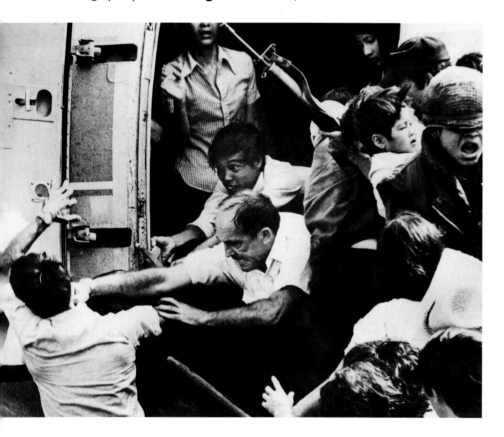

Cambodia 1979

The world did not know the extent of the genocide that dictator Pol Pot had heaped on Cambodia until it was overrun by Vietnam. Then, in 1979, mass graves and fastidiously stacked skulls were discovered. Some four years earlier, Pot's Khmer Rouge had taken power partly on anti-U.S. sentiment generated by American air strikes there from 1969 to '73. But it was becoming obvious that Pot had executed the educated and built an economy out of agrarian slave labor, sending a peaceful and civilized country back to the stone age. Perhaps a quarter of Cambodia's population was dead, either from execution or starvation.

Photograph by **Jay Ullal Stern** Black Star

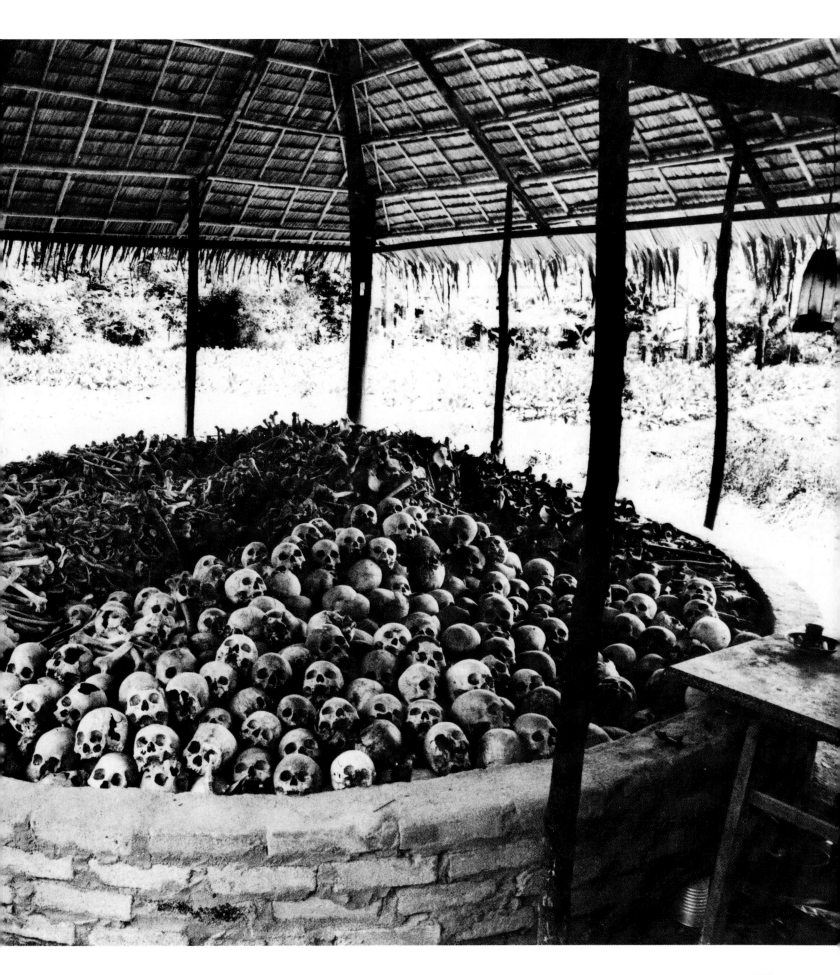

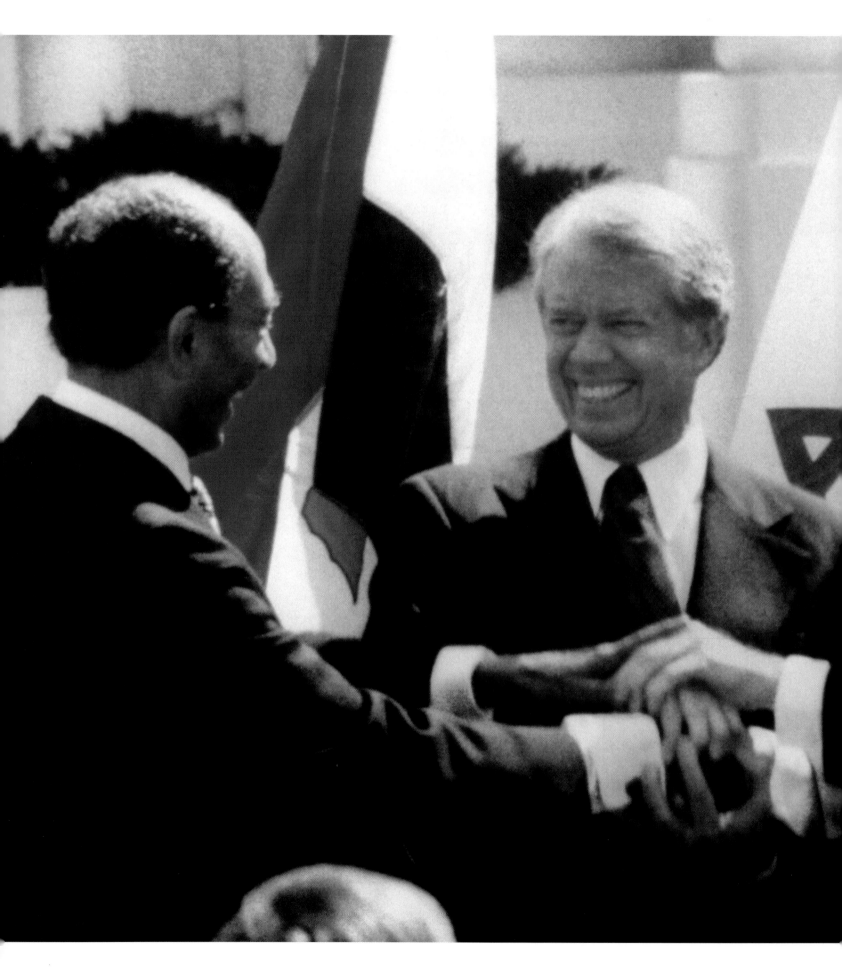

Nixon in China 1972

It was the most populous nation on the planet, one very far from the United States both in distance and in philosophy. Richard Nixon had fashioned a political career out of being a hard-liner on communism, but he also was respected, even by his critics, as a top-drawer student of international affairs. So there was a certain irony, if not surprise, when he was all smiles with Mao Zedong at the beginning of his historic 1972 visit to China. Nixon had put an end to decades of silence between the two nations.

Photograph from AP

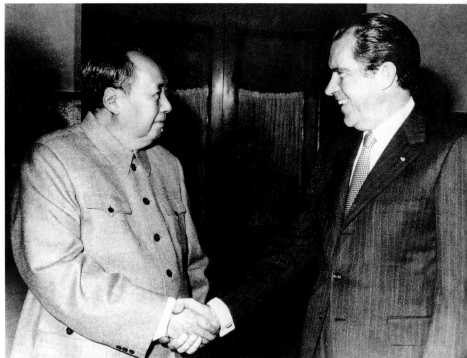

Peace Treaty 1979

For many years, peace in the Middle East had seemed unattainable. Jews claimed a right to Israel by history, the Bible and the U.N.; surrounding and displaced Arabs vowed to push the new country into the sea. Then, in 1979, President Jimmy Carter managed to wrangle Israeli Prime Minister Menachem Begin and Egyptian President Anwar Sadat into a handshake and a deal. Israel would give up the Sinai Peninsula, occupied in 1967's Six-Day War, and Egypt would become the first Arab state to recognize Israel. The accord also gave Palestinians some self-determination. Still, the Arab world was furious and this famous handshake cost Sadat his life: He was assassinated in 1981.

Photograph by **Bob Daugherty** AP

Other Landmark Images

Facing a gun down may be the ultimate act of civil disobedience. In 1967, hundreds of thousands of protesters gathered in Washington, D.C., to express their views on the war in Vietnam. Phil Strang from the University of Illinois strode up to National Guardsmen for this memorable scene. The next year, a worker in Bratislava bared his chest before a Soviet tank after Moscow decided to put a lid on Alexander Dubcek's attempt in Czechoslovakia to make communism a less totalitarian state.

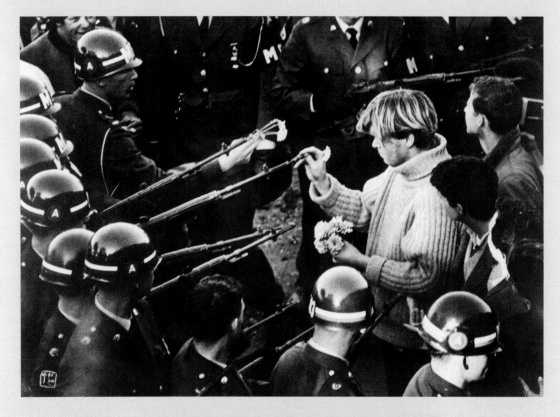

Vietnam War Protest, 1967
Photograph by **Bernie Boston**

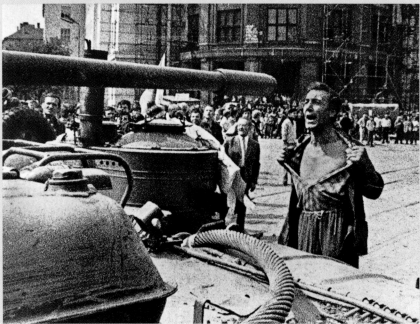

Bratislava, 1968
Photograph from Stern

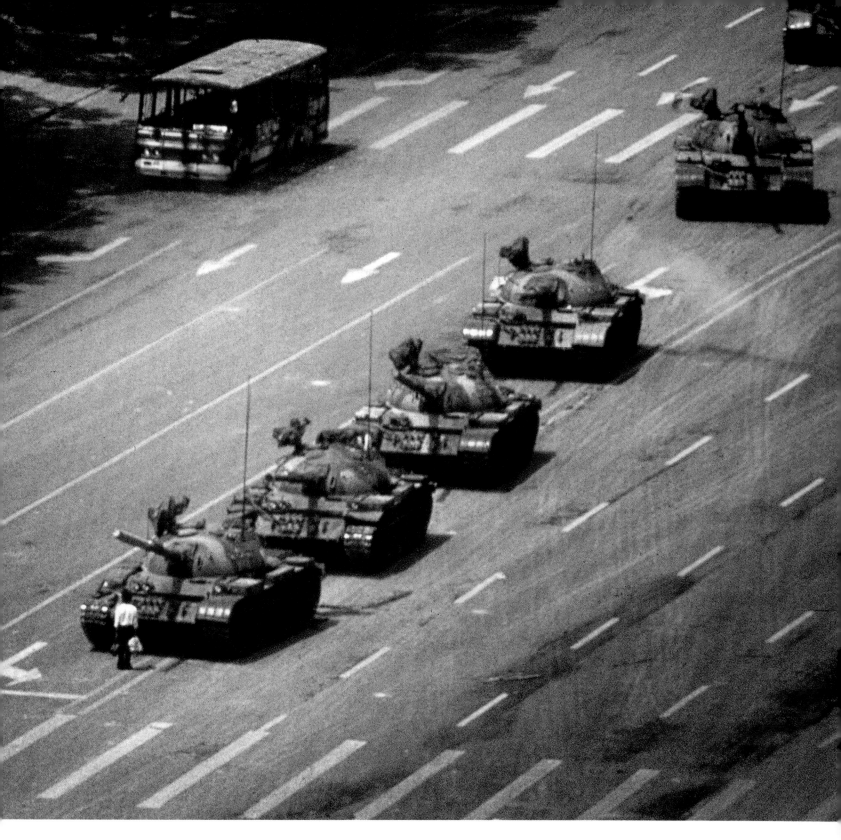

Tiananmen Square 1989

A hunger strike by 3,000 students in Beijing had grown to a protest of more than a million as the injustices of a nation cried for reform. For seven weeks the people and the People's Republic, in the person of soldiers dispatched by a riven Communist Party, warily eyed each other as the world waited. When this young man simply would not move, standing with his meager bags before a line of tanks, a hero was born. A second hero emerged as the tank driver refused to crush the man, and instead drove his killing machine around him. Soon this dream would end, and blood would fill Tiananmen. But this picture had shown a billion Chinese that there is hope.

Photograph by **Stuart Franklin** Magnum

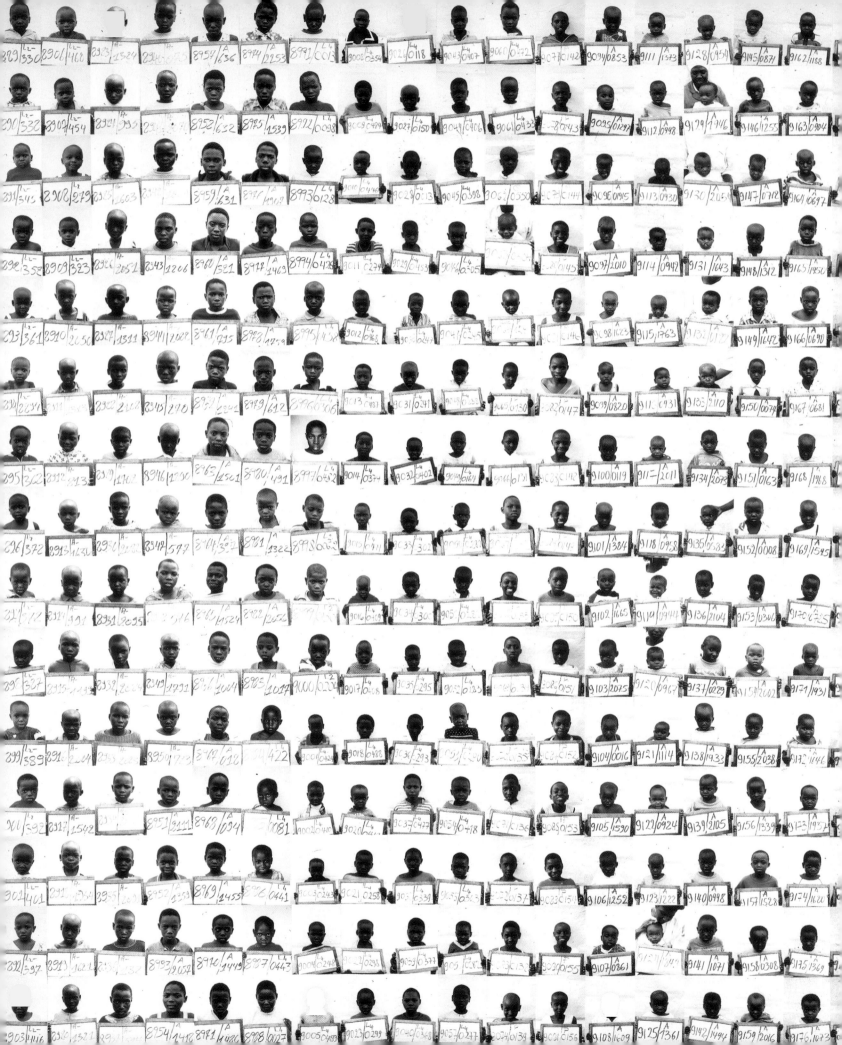

Rwandan Children
1994

Seamus Conlan went to Rwanda as a photojournalist to cover a war—the ethnic battle between Hutu and Tutsi—and was moved by the hundreds of thousands of "unaccompanied" children who had lost their parents—either permanently to death or temporarily in the chaos. Conlan gave each child a number, sorted 21,000 of them by region and displayed their pictures in refugee camps. Although many of the kids remained orphaned, thousands of families were reunited, and aid groups have now adopted Conlan's photo system.

Photograph by
Seamus Conlan & Tara Farrell
WorldPictureNews

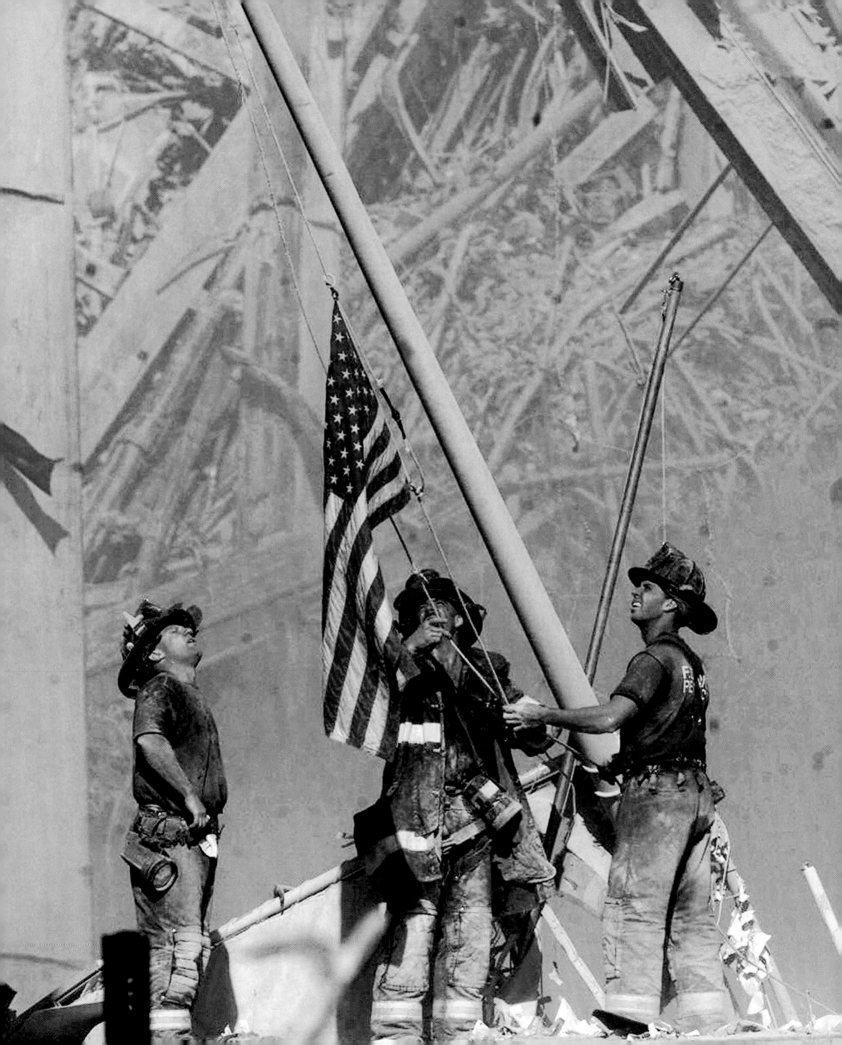

September 11, 2001

There are memorable images of Old Glory from the Revolutionary War, the Civil War, World War II. On this day we found ourselves in yet another war, this time against terrorism. Much of the attack is familiar from oft-seen TV footage, but this photo has come to represent our ensuing pride of place. The flag then embarked on a mysterious journey. It flew from the USS *Theodore Roosevelt* near Afghanistan and was later given to New York, but at some point (perhaps in the confusion at Ground Zero) the flag had been replaced by a larger one.

Photograph by **Thomas E. Franklin** The Record

Another Landmark Image

The toppling of a 40-foot-high Saddam Hussein statue in Baghdad's Firdos Square on April 9, 2003, was said by some to be little more than a photo op. But these events have impact. The world saw, emphatically, that a tyrant's reign was at an end. The Arab world, much of which had swallowed Iraq's account of the war's progress, saw a graphic, shocking display of American might.

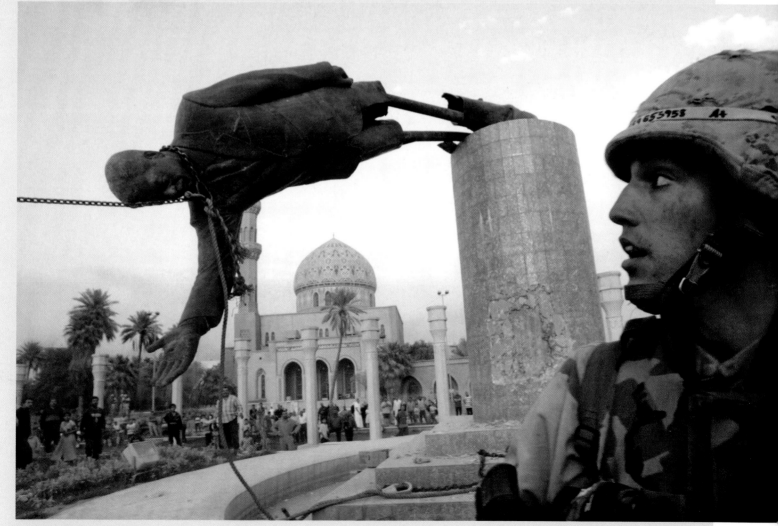

Saddam Toppled, 2003
Photograph by **Goran Tomasevic** Reuters/Landov

Stop Action

By this point in *100 Photographs That Changed the World,* at least some readers may be asking, "What about the Kennedy assassination?" "Where are the Twin Towers?" Those images, which are seared into our collective memory, were excerpts from film or video footage. In the modern era, selected moments "grabbed" from moving pictures can often provide the power that is commonly the province of still photography.

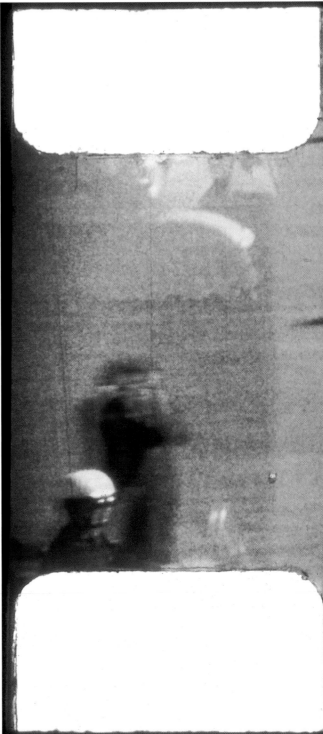

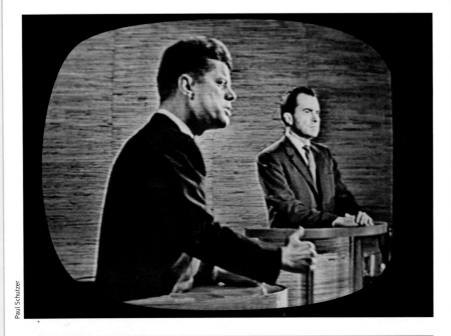

Paul Schutzer

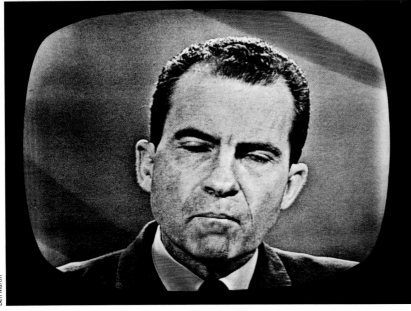

Ben Martin

ABC, CBS, NBC

Televised Presidential Debate **1960**

Candidates John F. Kennedy and Richard M. Nixon debated four times, and many who were listening on the radio felt Nixon won, while TV viewers saw the smooth, telegenic JFK far outshine the shady Nixon.

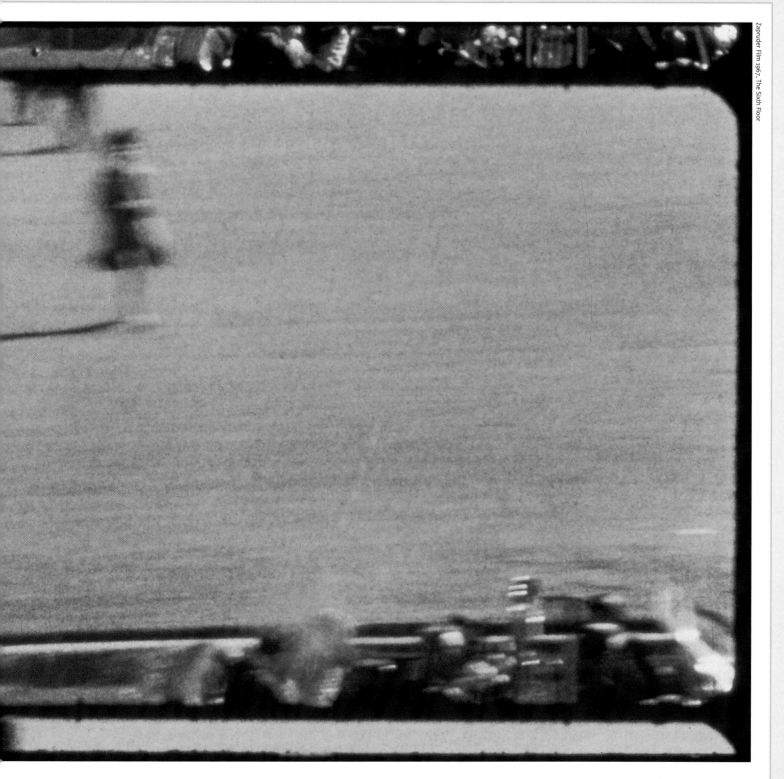

Abraham Zapruder
Dallas **1963**

As President John F. Kennedy's motorcade turned onto Elm Street, Zapruder trained his Bell & Howell Zoomatic on the limo. LIFE bought the rights to print frames from the film, and conspiracy theorists everywhere were able to join the FBI, Secret Service and Warren Commission in studying the Zapruder film in an attempt to learn if there had been more than one shooter.

Hibernia Bank
Patty Hearst
1974

On April 15, five robbers entered a San Francisco bank, wounded two bystanders and escaped with more than $10,000. Police were stunned to learn from the videotape that one suspect was Patty Hearst, the granddaughter of publishing tycoon William Randolph Hearst. She had been kidnapped two months earlier by a group called the Symbionese Liberation Army. She later claimed to have been brainwashed, but was convicted and sentenced to seven years.

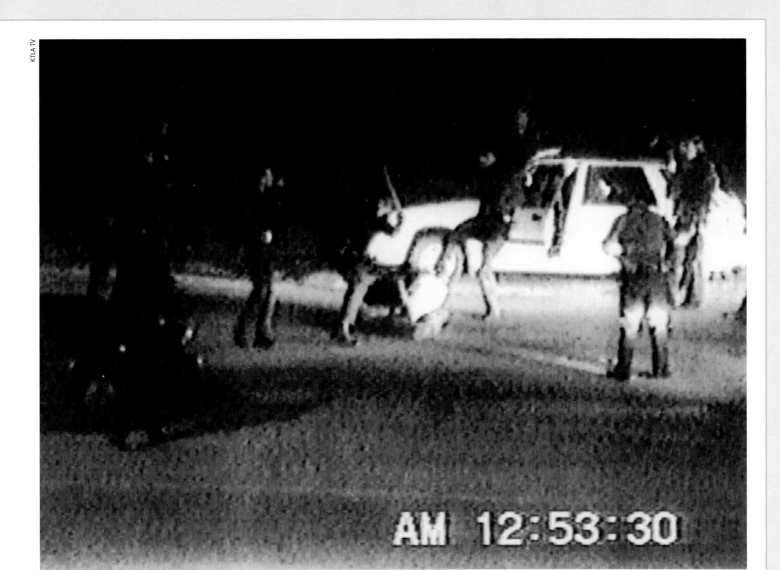

AM 12:53:30

George Holliday

L.A. Police Beating Rodney King 1991

After a car chase, the police inflicted a feral beating on King. The footage from amateur photographer Holliday startled and worried a nation already weary of police brutality. Despite the video, a jury acquitted the four police officers.

Jules Naudet

The First Plane Hits the World Trade Center 2001

The world is about to change, as of 8:46 a.m. on September 11, 2001: American Airlines Flight 11, laden with 20,000 gallons of jet fuel, has crashed into the World Trade Center. The French filmmaking brothers Jules and Gedeon were there to record it.

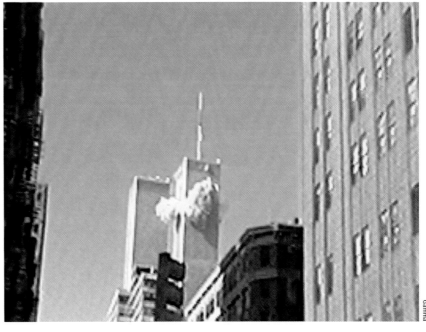

Science & Nature

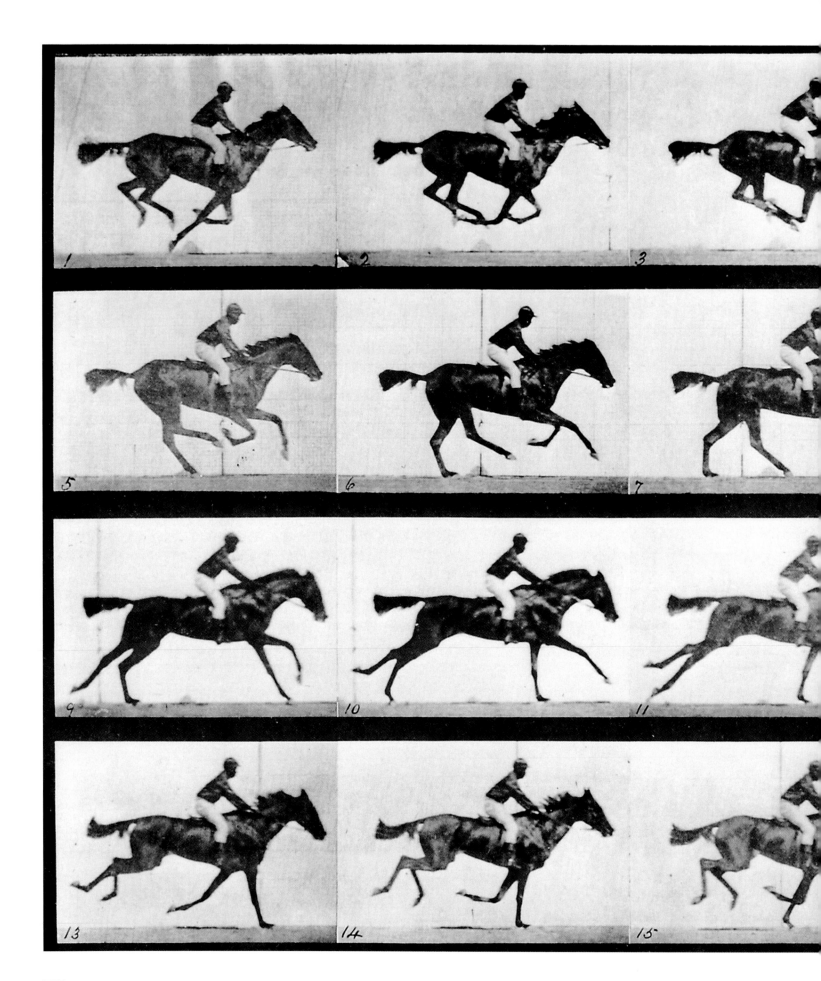

Galloping Horse 1878

Was there a moment midstride when horses had all hooves off the ground? Leland Stanford, the railroad baron and future university founder, bet there was—or at least that's the story. It was 1872 when Stanford hired noted landscape photographer Eadweard Muybridge to figure it out. It took years, but Muybridge delivered: He rigged a racetrack with a dozen strings that triggered 12 cameras. Muybridge not only proved Stanford right but also set off the revolution in motion photography that would become movies. Biographer Rebecca Solnit summed up his life: "He is the man who split the second, as dramatic and far-reaching an action as the splitting of the atom."

Photographs by **Eadweard Muybridge**

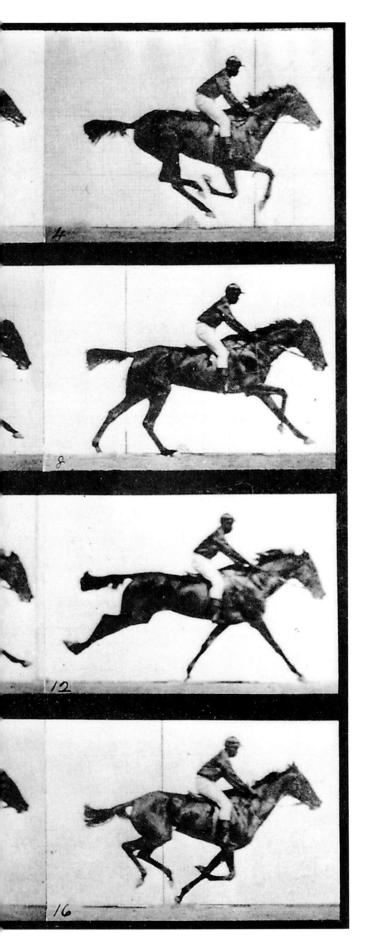

Another Landmark Image

Camera shutters and film can move only so fast; the world moves faster. To capture on film what happens inside a machine, M.I.T. engineering professor Harold Edgerton developed the technique of strobe photography. His fascinating pictures found their way into art museums, but Edgerton's discoveries also had practical implications for those who studied ballistics, biomechanics and fluid dynamics.

Milkdrop Coronet, 1931
Photograph by **Harold Edgerton** ©Harold & Esther Edgerton Foundation, 2003, courtesy Palm Press, Inc.

Boston from a Captive Balloon 1860

Nadar, the pioneering French celebrity photographer, was a pioneering aerial photographer as well. But the few fruits of his earliest experiments from a balloon, undertaken in 1858, are lost, and he didn't return to the air until 1868 when he took scenics of Paris from on high. Meanwhile, in the United States, James Wallace Black, a painter-turned-photographer, employed an interesting method to give his viewers a fresh perspective of their world. He used kites and small balloons to carry his camera as high as 1,200 feet, then opened the shutter from the ground with a thin rope.

Photograph by **James Wallace Black** Gilman Paper Company Collection

Another Landmark Image

Aerial reconnaissance photographs were taken from balloons during the American Civil War, but it wasn't until Wilbur Wright shot pictures from a plane in 1909 that the military realized just how valuable scouting from the air might prove. In World War I, reconnaissance missions were the "eyes of the army" from the get-go, as two-seater planes carrying a pilot and an observer flew over enemy lines to report on positions. In 1918, French aerial units were producing as many as 10,000 photographs a day.

German Trenches near Reims, France, 1914
Photograph from the Museum of Modern Art

Chicago Fire 1871

The summer had been bone-dry, and on the evening of October 8, wind whipped wildly through the Windy City. Whether Mrs. O'Leary's cow kicked the lantern, or a visitor dropped his pipe, or a cinder from a neighbor's chimney landed on the roof, the barn belonging to Pat and Catherine O'Leary of 137 De Koven Street was soon engulfed, and when gusts blew the flames northward, so was much of Chicago. A third of the city was lost, including the downtown area; more than 200 were killed. Urban scientists began to rethink their largely wooden infrastructures, and the notion of charity drives for the victims of disaster took hold.

Photograph from Corbis

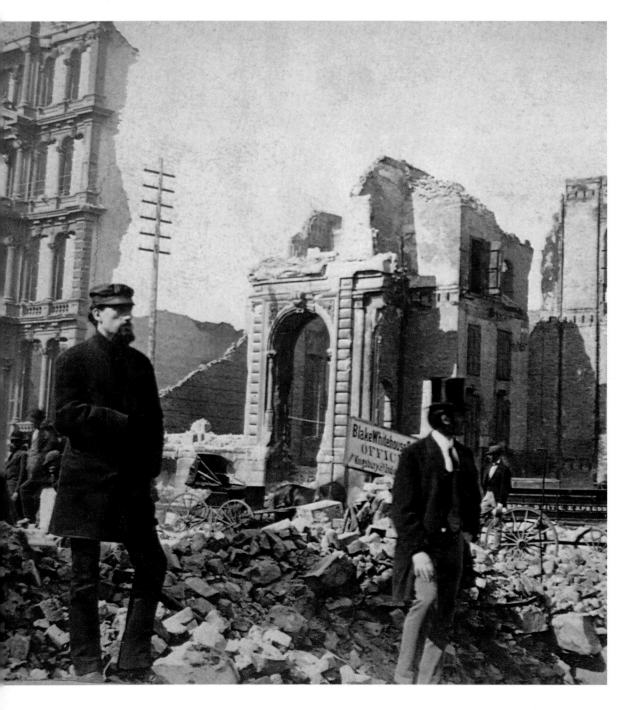

San Francisco Earthquake 1906

A little after five a.m. on April 18, 1906, a giant earthquake rocked the city of San Francisco. Felt from Oregon to southern California, the quake ruptured some 270 miles of the San Andreas fault. The epicenter was near San Francisco, severing gas mains, snapping electrical wires and setting fires throughout the city. Jack London, 40 miles away, described a "lurid tower" of fire; by the time he got there, the scene convinced him that the city was "gone." These folks on Russian Hill seem to be taking the event a bit less dramatically. In any case, 3,000 people were killed and 200,000 left homeless. Important lessons in building construction were learned from the disaster.

Photograph by
Arnold Genthe
Fine Arts Museum
of San Francisco

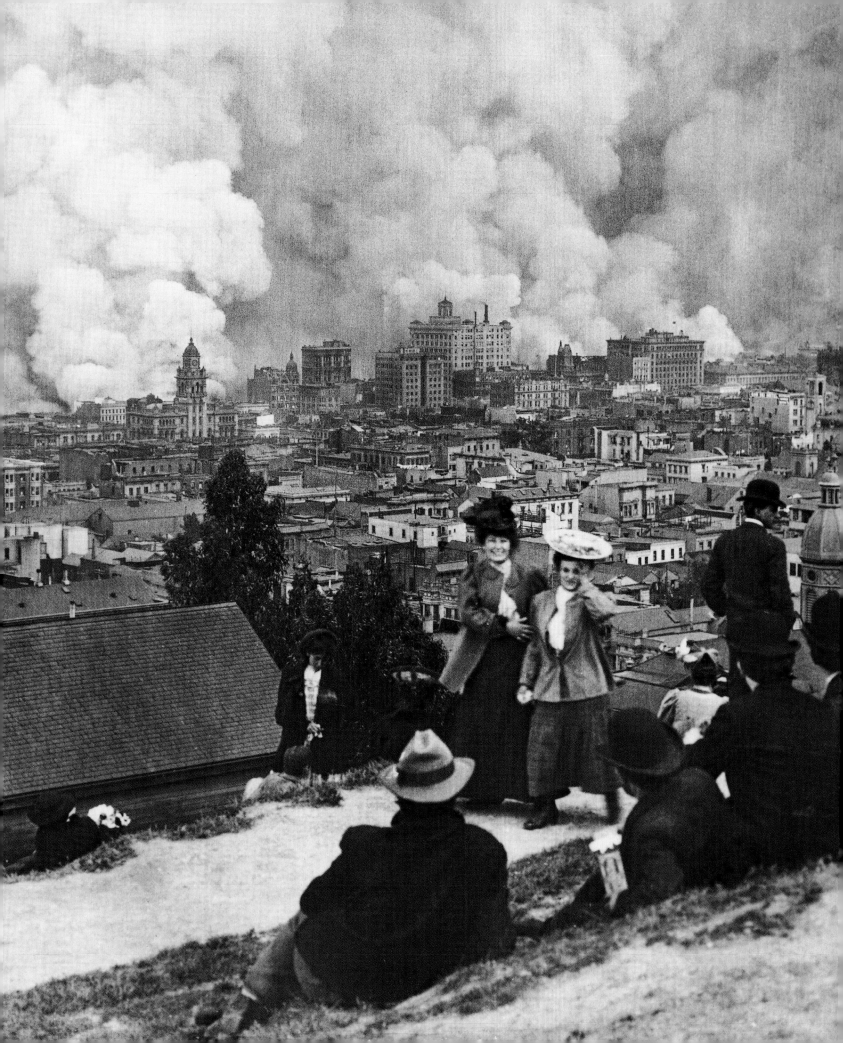

Old Faithful
c. 1871

In 1870, Henry Dana Washburn, a former general in the Union Army, led an expedition to find the headwaters of the Yellowstone River. He and his men were so impressed by the lakes, valleys and particularly the geysers in the region that they began lobbying Congress to preserve the wondrous land straddling the Wyoming and Montana territories as a park. Washburn's reports interested Washington, but it wasn't until legislators received portfolios of William Henry Jackson's photographs of the strange, exciting land that acclamation was general: This place must be protected. In 1872, Yellowstone became the first national park anywhere in the world. Today more than 100 countries have national parks or reserves, and the U.S. National Park Service has nearly 400 holdings.

Photograph by
William Henry Jackson
Daniel Wolf Inc.

Another Landmark Image

The titanic nature photographer Ansel Adams was a crusader with his camera every bit as much as Rachel Carson was with her pen. While he used subtle persuasion on the general public with his images, he had blunt words for bureaucrats and politicians; he once told President Gerald R. Ford, "What we need is women's liberation intensity as far as preservations of our parks is concerned."

Half Dome, Yosemite, 1960
Photograph by **Ansel Adams**

Everest
1953

A Himalayan peak of 29,035 feet, the world's highest, had resisted conquest for decades. Some thought the task impossible, but when New Zealand beekeeper Edmund Hillary and Sherpa Tenzing Norgay, both climbing as part of a British expedition, reached the top on May 29, 1953, they redrew the limits of human capability. Hillary's photo of Tenzing on the summit was proof of success and, later, made others wonder if there might be another evidentiary photo lost on Everest. Englishman George Mallory had been carrying a folding Kodak when he and Andrew Irvine were lost near the top in 1924. Were they still on their way up, or coming back down, when they had died? A 1999 U.S. expedition sought the answer and did find Mallory's body—but not his camera.

Photograph by
Sir Edmund Hillary
Royal Geographical Society

Other Landmark Images

Photography is persuasive when you're dealing with a mountaintop, less so as proof of polar conquest. U.S. explorer Robert E. Peary's photo of his happy crew does not prove that he is at the North Pole on April 6, 1909—and, in fact, Peary's claim has been disputed. The picture of Norwegian Roald Amundsen taking a sighting at the South Pole in December 1911 is authentic: A month later, ill-fated Englishman Robert Falcon Scott came upon the flag at precisely 90 degrees south latitude.

The North Pole, 1909
Photograph from
Hulton Archive/Getty

The South Pole, 1911
Photograph by
Bjorn Finstad, Oslo
Courtesy Olav Bjaaland

First Human X-ray 1896

To know something like the back of your hand is a timeless concept, one taken yet further by Wilhelm Konrad Roentgen. While working on a series of experiments with a Crookes tube, he noticed that a bit of barium platinocyanide emitted a fluorescent glow. He then laid a photographic plate behind his wife's hand (note the wedding rings), and made the first X-ray photo. Before that, physicians were unable to look inside a person's body without making an incision. Roentgen was the recipient of the first Nobel Prize for Physics in 1901.

Photograph by
Wilhelm Roentgen
Courtesy General Electric Co.

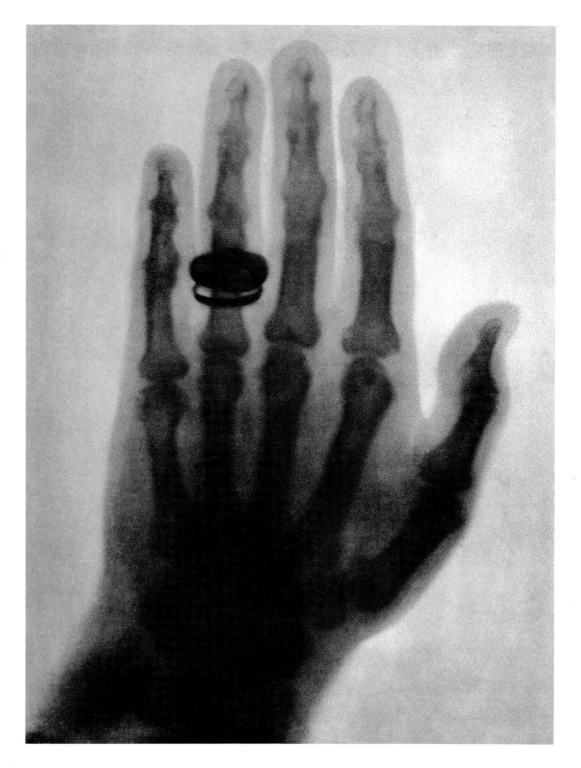

First Satellite Picture 1959

Goaded by the Soviets' successful launch of Sputnik 1 in 1957, America shot its first satellite, Explorer 1, into orbit the next year. The space race was on, and by the time of Explorer 6, NASA was able to get the first image of Earth from a satellite. It was less than revelatory. You would never know it, but this crude blur captured from 17,000 miles above Mexico on August 14, 1959, actually shows sunlight hitting clouds over the central Pacific Ocean. Undeterred, in 1960, NASA launched the Tiros program and proved the technique useful for weather forecasters. Other scientists—and spies—also put space photos to work.

Photograph from NASA

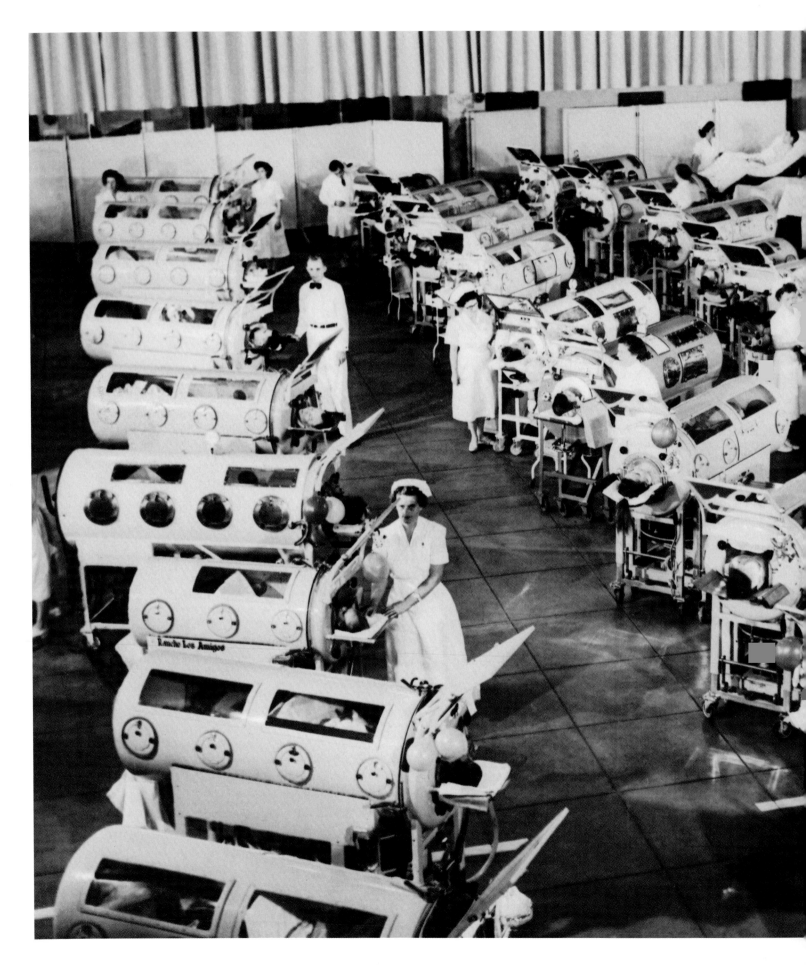

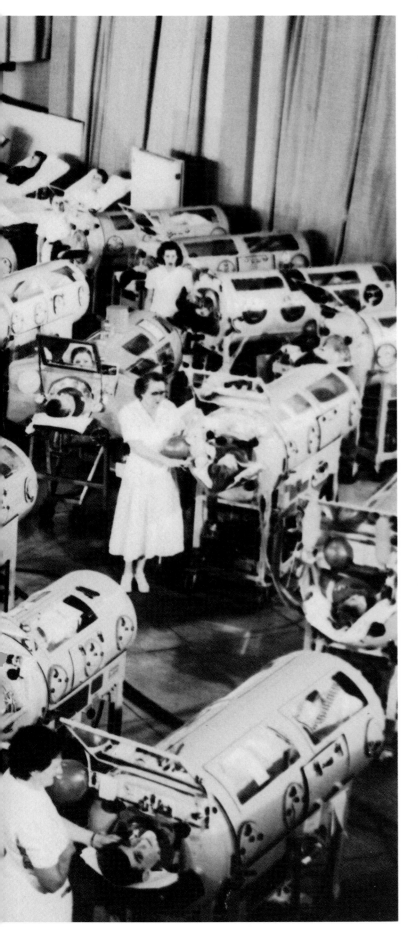

Iron Lung Polio Patients 1950

A monstrous breathing machine aptly called the iron lung was once the only way to keep some polio victims from suffocating. Pictures of kids doomed to the frightening contraptions proved to be very effective in getting people to take safety precautions—and, soon, polio shots. Said Dr. Edward Rothstein, an adviser to the American Academy of Pediatrics, "I remember how the fear of polio changed our lives—not going to the swimming pool in summer, not going to the movies . . . I remember pictures of wards full of iron lungs, hundreds in a room, with kids who couldn't breathe in them. It affected daily life more than AIDS does today." Lacking a similarly repellent photographic image, some parents today eschew vaccination because they think the health risks outweigh benefits.

Photographer Unknown

Thalidomide 1962

A drug called thalidomide was first marketed in Germany in 1957 as a sedative. Tests had been done on the drug, but procedures were not as thorough as today. Believed safe, it was given to pregnant women around the world as a way to contend with morning sickness. Before too long, a terrible development was observed: Babies were being born with pronounced limb deformation. Images of children with abbreviated arms were seen everywhere, but the tragedy that involved some 20,000 children did at least serve to change the way drug information is distributed to governments.

Photograph by **Stan Wayman**

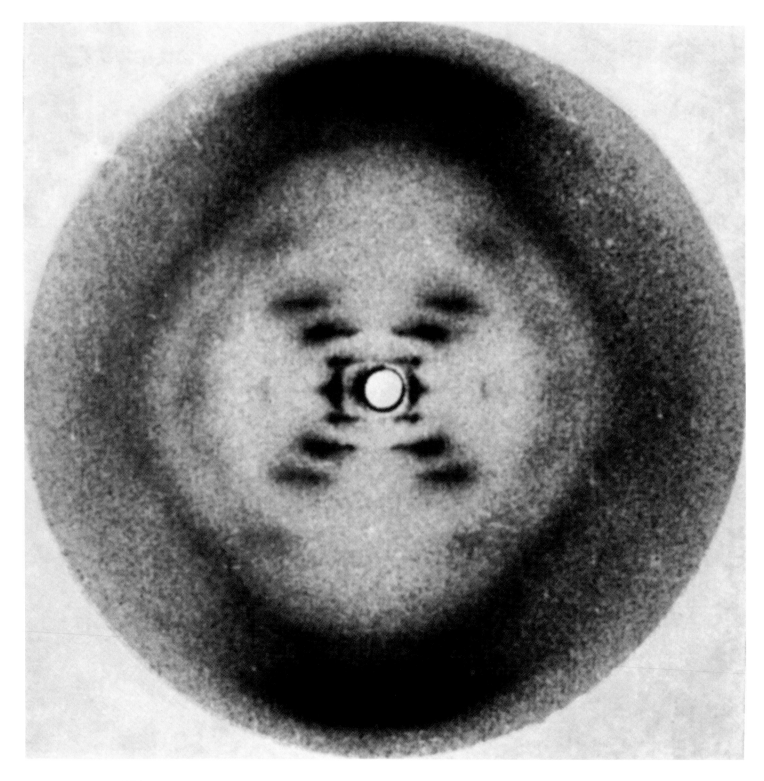

Exposure 51 1952

Scientists were in a heated race in May 1952 to be the first to discover the cellular basis of heredity. At King's College, Rosalind Franklin exposed crystalline strands to 100 hours of radiation in a series of X-rays. Her colleague Maurice Wilkins privately showed her work to molecular biologists James Watson and Francis Crick, who used one X-ray, Exposure 51, to decode the double helix of DNA—the blueprint for all living things. "The instant I saw the picture, my mouth fell open and my pulse began to race," said Watson. In 1958, Franklin died of cancer in relative obscurity—likely from radiation she was exposed to in her work. The three men shared a 1962 Nobel Prize.

Photograph by **Franklin, R. and Gosling, R.G.** Nature

The Integrated Circuit 1959

By the late '50s, electronics was steadily moving from vacuum tubes to transistors, but workers still had to use tweezers to clumsily fashion together wire, transistor, platform and so on. Then, at nearly the same time, two computer-industry inventors, Jack Kilby and Robert Noyce, independently created the IC; Noyce's first circuit was literally photographed onto the chip. Today, 125 million transistors can fit within one square inch, and the computer revolution that evolved from their relatively simple discovery has, for better or worse, permeated every aspect of human existence. Kilby went on to invent the portable calculator, while Noyce cofounded the chip giant Intel.

Photograph by **Robert Noyce** Courtesy Fairchild Semiconductor International

Holography 1948

The Hungarian-born electrical engineer Dennis Gabor was trying to improve electron microscopes when he created a hologram—a photographic recording of an image which organizes light into a three-dimensional representation of the subject. Gabor received the Nobel Prize for Physics in 1971 for his discovery, but it really wasn't until the development of the laser in the early '60s that holography (demonstrated here in 1966) realized its full breadth. Its applications are many, including the detection of structural strain in buildings.

Photograph by **Fritz Goro**

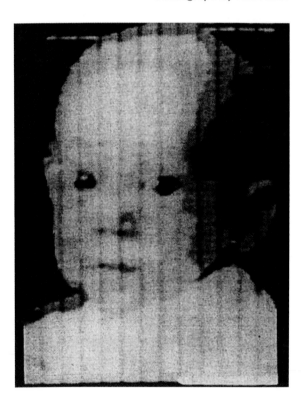

Digital Imaging 1957

The camera and the computer had yet to join forces when Russell Kirsch set out to create the first computerized photo. To achieve this, he invented the photographic scanner as well as computer-imaging software. The first image Kirsch scanned—apparently seeking a Kodak moment—was of his infant son, Walden. It was the initial step toward NASA's planetary pictures and, closer to home, today's increasingly popular digital snapshots.

Binary Scan by **Russell A. Kirsch**
Courtesy Russell A. Kirsch & NIST

How Life Begins
1965

In 1957 he began taking pictures with an endoscope, an instrument that can see inside a body cavity, but when Lennart Nilsson presented the rewards of his work to LIFE's editors several years later, they demanded that witnesses confirm that they were seeing what they thought they were seeing. Finally convinced, they published a cover story in 1965 that went on for 16 pages, and it created a sensation. Then, and over the intervening years, Nilsson's painstakingly made pictures informed how humanity feels about . . . well, humanity. They also were appropriated for purposes that Nilsson never intended. Nearly as soon as the 1965 portfolio appeared in LIFE, images from it were enlarged by right-to-life activists and pasted to placards.

Photograph by **Lennart Nilsson**

Earthrise 1968

The late adventure photographer Galen Rowell called it "the most influential environmental photograph ever taken." Captured on Christmas Eve, 1968, near the end of one of the most tumultuous years the U.S. had ever known, the Earthrise photograph inspired contemplation of our fragile existence and our place in the cosmos. For years, Frank Borman and Bill Anders of the Apollo 8 mission each thought that he was the one who took the picture. An investigation of two rolls of film seemed to prove Borman had taken an earlier, black-and-white frame, and the iconic color photograph, which later graced a U.S. postage stamp and several book covers, was by Anders.

Photograph by **William Anders** NASA

Another Landmark Image

Neil Armstrong was the first man on the moon in 1969, the one who delivered the memorable words: "One small step for man, one giant leap for mankind." (He later changed this to "One small step for *a* man.") Armstrong was also the guy with the camera, most of the time, and so the best images of *Apollo 11*'s historic mission, including this one, star the second man on the moon, Buzz Aldrin.

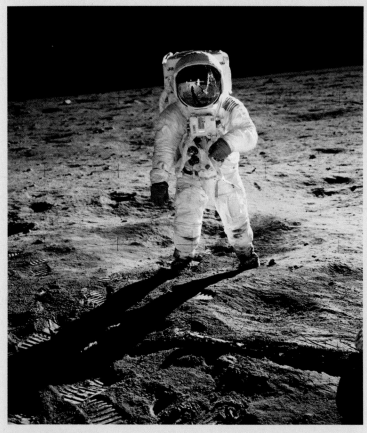

Buzz Aldrin, 1969
Photograph by **Neil Armstrong** NASA

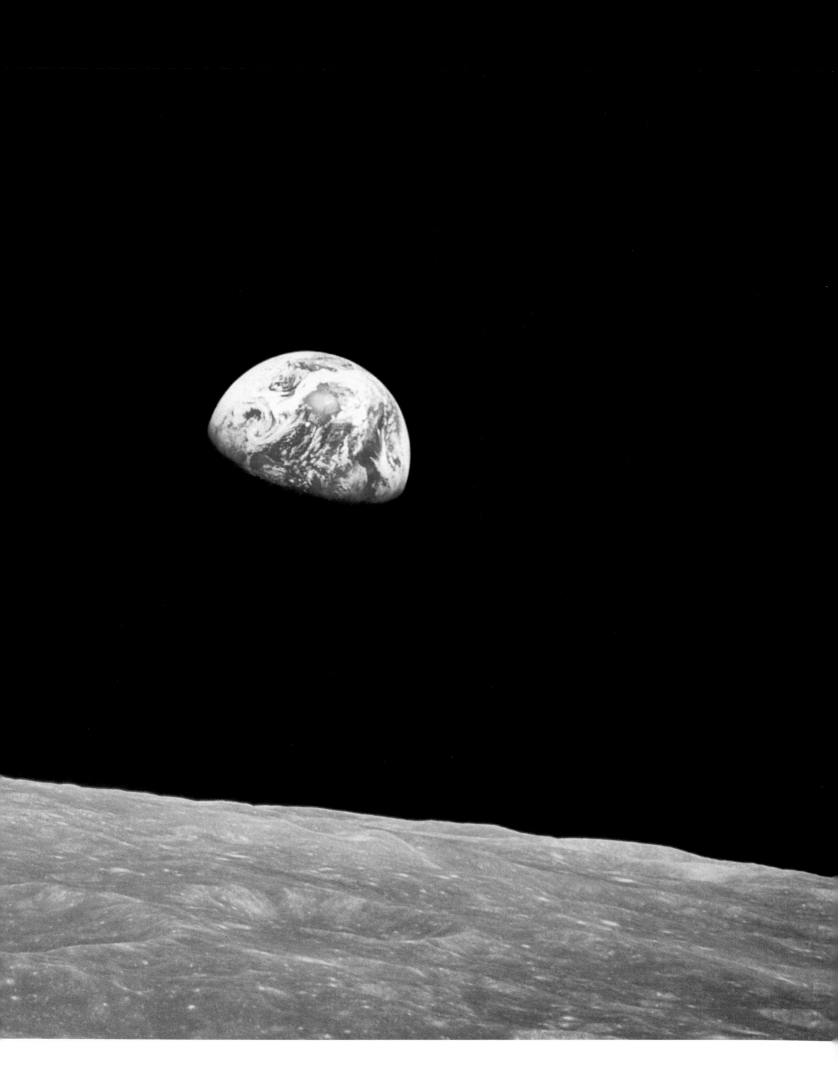

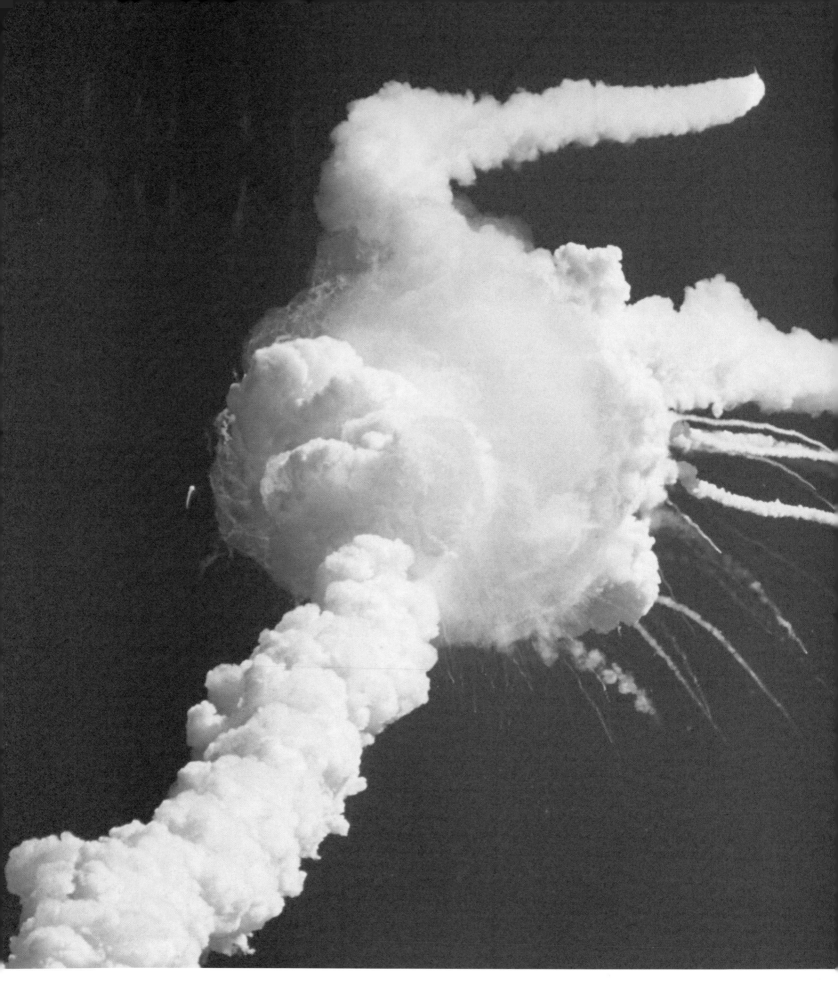

Challenger 1986

Having seen 24 space shuttle missions go forth and safely return, Americans were delighted when NASA invited high-school teacher Christa McAuliffe to fly on the next one. The New Hampshirite's son, daughter and students were eagerly watching at Cape Canaveral on the morning of January 28. Delayed seven times, the *Challenger* finally launched at 11:38 a.m. Then, 73 seconds into its flight, the craft disintegrated and swirled into the ocean in a cloud of white vapor. Despite expansive TV coverage, this still photograph became emblematic of a tragedy that saddened so many, and changed their views of space, rekindling the debate about whether man even belonged up there.

Photograph by **Michelle McDonald**

Another Landmark Image

Man has been gazing at Mars for ages: Who or what might be living next door? When NASA sent Viking 1 to the Red Planet in 1975, some wondered whether the lander would just sink into the surface or come upon teeming plant life. The next July, the probe beamed back the first images. The barren terrain showed no signs of life but proved that man could get an up-close look at a distant world.

Viking 1 Lander, 1976
Photograph from NASA

The Pencil Nebula 2003

Our 100th photograph that changed the world may never, in fact, do so, but it's a picture of a world changing. The Pencil Nebula is part of a vast remnant of a star that exploded approximately 11,000 years ago, and whose debris is still spreading outward. Perhaps when we explore the nebula a thousand years from now, this picture, released by NASA on June 5, will be seen as historic, influential. The linear nebula was given its name in the 1840s by British astronomer Sir John Herschel. He was a big fan of Talbot and Daguerre, by the way, and in an 1839 essay gave photography its name. He also coined the terms "negative," "positive" and even "snap-shot."

Photograph from NASA & The Hubble Heritage Team